CONTEMPORARY
CELTIC MOTIFS

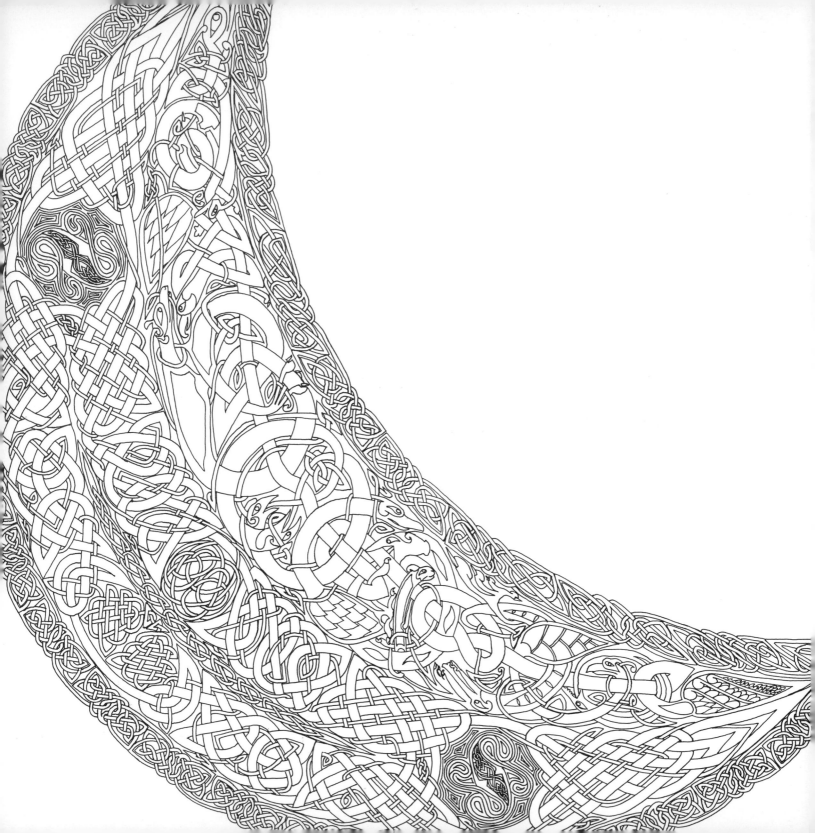

CONTEMPORARY CELTIC MOTIFS

ALEX SHERMAN

BATSFORD

For Rachy and Fin – my purpose and inspiration.

Thank you for your patience.

First published in the United Kingdom in 2007 by
Batsford
10 Southcombe Street
London W14 0RA

An imprint of Anova Books Company Ltd

ISBN-10: 0 7134 9061 6
ISBN-13: 978 0 7134 9061 9

A CIP catalogue record for this book is available from the British Library.

15 14 13 12 10 09 08 07
10 9 8 7 6 5 4 3 2 1

Printed by SNP Leefung Ltd, China

This book can be ordered direct from the publisher at the website:
www.anovabooks.com
Or try your local bookshop

CONTENTS

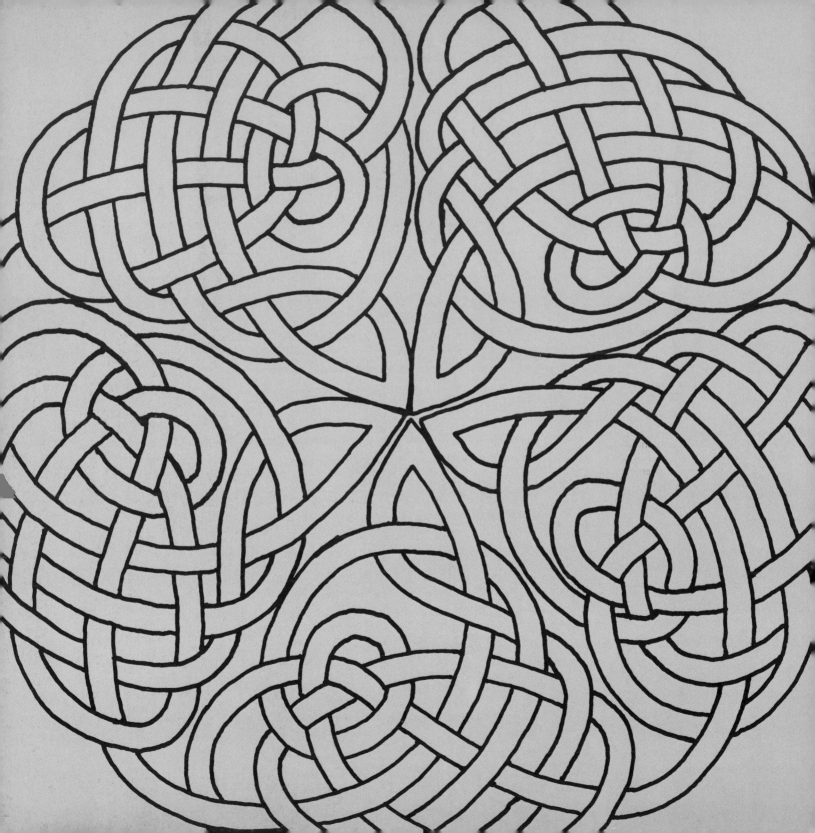

INTRODUCTION

Celtic knotwork and motifs are an art form that evolved over hundreds of years throughout England, France and other areas of Europe. Celtic design was originally a very basic art form, designed to be cut into stone and, perhaps, wood, and its complexity evolved as technology did. The earliest form of Celtic art was spiral work and indentation, and as time progressed this became more sophisticated according to the tools used and the medium available – stone, wood and, latterly, parchment and paper using pen and ink.

It was adopted as a way of illustrating manuscripts, especially religious manuscripts and documents. More recently, the Art Deco and Art Nouveau movements were influenced by Celtic knotwork, tessellation and spiral work, and many of the designs in this book are 'Celtic' in approach but also share the fluidity of Art Nouveau and the geometric shapes of Art Deco.

My feeling is that Celtic art is an evolving design form. This makes it possible to create new art forms in the same style, with knotwork, tessellation and spiral work as the basis. Knotwork has been interpreted in many ways, most famously with the Book of Kells and the Book of Lindisfarne. The styles are universally recognized, and have influenced some of the motifs in this book.

With some of the motifs shown here, I have played with the conventions. For example, I do not consider a standard line width to be an essential element, as you will see in my work throughout the book. A variable line width can give designs the appearance of graffiti, and provides a more fluid, urban feel.

Each of the motifs can be reproduced or replicated in other media, and will suit screen printing, lino printing, stencilling or even wood-carving. Indeed, I have used many of these designs in such ways myself. In addition, individual elements can be picked out and used on their own – as borders, for example.

Circles are an interesting element; a standard circle can be inserted into any circular space. The circle is an endless form and can be interpreted in any number of ways, as you will see in the various motifs displayed here.

LARGER DESIGNS

Interspersed throughout this book are a number of large motifs containing several different individual elements. These are shown as a whole and are also broken down to show some of their specific constituent parts. These larger motifs are the most interesting, as

they comprise so many elements of animal work, knotwork and tessellation. They also make the best use of space, a feature that is the hallmark of the best Celtic designs and which can be filled with detailed, symmetrical knotwork.

The more detailed of these pieces took a long time to create. All were hand-drawn and were, more often than not, created spontaneously, the elements being drawn 'in situ' as part of a whole. The time taken to complete a single design was sometimes as much as 150–200 hours, first pencilling in designs and detail and then completing them with pen and ink. They represent a union of varying styles, including the Lindisfarne style – characterized by the use of two lines together instead of one – circle work and tessellation, and draw inspiration from a variety of sources.

Many of the larger designs incorporate elements used elsewhere in the book, in borders or specifically shaped smaller motifs. These may themselves be manipulated or used in other drawings. The motifs generally all evolved in the same way, as a rudimentary shape that needed filling; border areas were then added and circles placed inside to offer greater detail. Some evolved further outwards when I felt a further layer could be added; others did not end up being as large as I originally envisaged, since I was happy with the design.

All these designs have been hand-drawn, initially using pencil (which allows for trial and error) and then using pen and ink. Many of the abstract motifs were designed to fill in pieces within larger designs, although some were not included in the larger design since they did not quite work. In addition, some of these motif elements were put together as ideas or as stand-alone small-scale designs.

Rhythm and symmetry are the two words that best describe the Celtic style. Indeed, these are what I find attractive about Celtic designs and motifs, and were the elements that first inspired me to draw my own motifs, moving on from the more classical pieces.

I hope you enjoy viewing and using these pieces as much as I enjoyed drawing them. Many have taken on elements that have evolved spontaneously in the design, such as the variable line width. The intricate nature reflects my interest in making things fit into a space, especially when it seems impossible, and I like the link with symmetry and motion that curves and segments provide.

At the end of the book (pages 161–177) I have included templates for some of the larger designs, which are suitable for tracing, enlarging and filling in. These are marked with a ◆ symbol within the main book. There are also longer captions for some of the more interesting designs – these appear on pages 178–187 and are marked with a ✐ symbol within the main book.

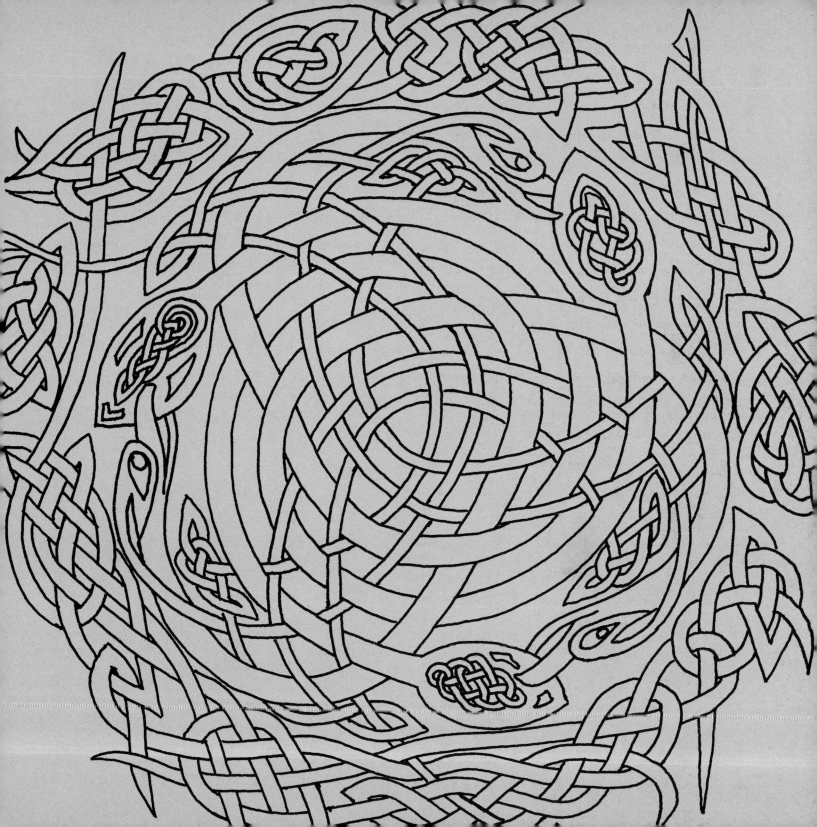

ANIMALS

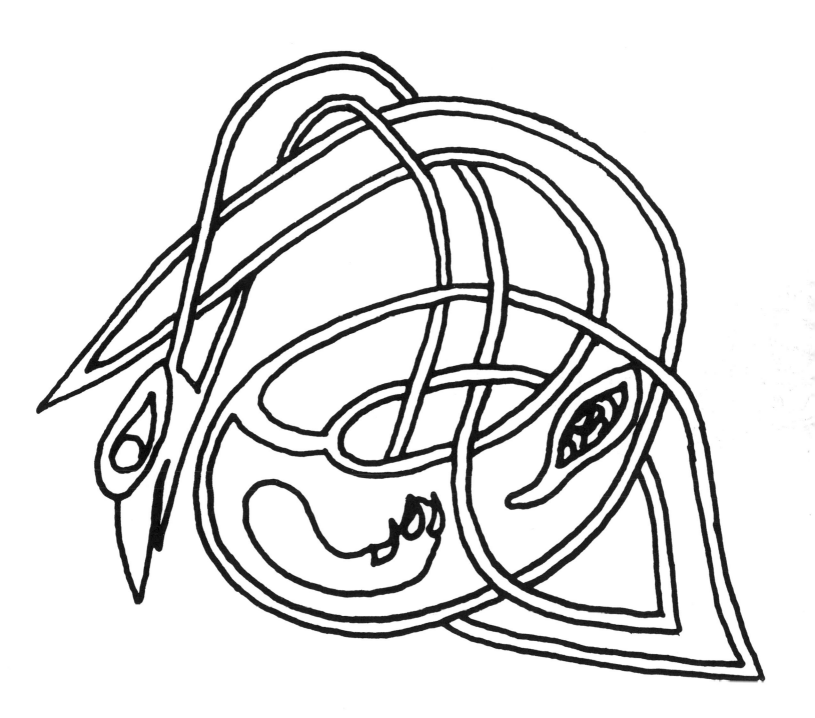

ANIMALS

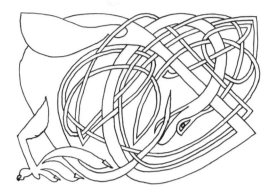

Animals and figure work are traditional features of Celtic designs, particularly in the later illustrated manuscripts and Bibles. They help to tell a story or represent a basic moral principle, such as the struggle between good and evil or right and wrong.

Some of my designs use quite basic animal work, either as a symbolic depiction or as an attractive in-fill. Animals from myths and fantasy, such as griffins or dragons, may be used, allowing a design to show a degree of variance and freehand approach. The outline of an individual animal sets up spaces to fill with knotwork or tessellation, and the limbs, tails, tongue and head feathers can be used as sources of lines for knotwork, symbolizing an interaction between the various parts of the animal.

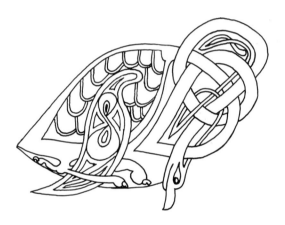

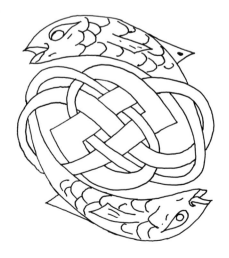

In large designs using more than one animal, each can either be an independent element – as seen in 'Harp' (page 24) – or the elements can work together, such as the arc of animals seen within 'Block' (page 131). Animal work differs markedly from knotwork, involving variable line widths and creating different spacing – it is also much less regimented in nature, allowing it to be moulded to virtually any shape.

On birds, dragons or winged creatures, the wings and body can become areas to fill with either symbolic or stylized feathers, tessellation or even knotwork. The point is to create attractive and appropriate shapes that can be filled with knotwork or an attractive design or motif.

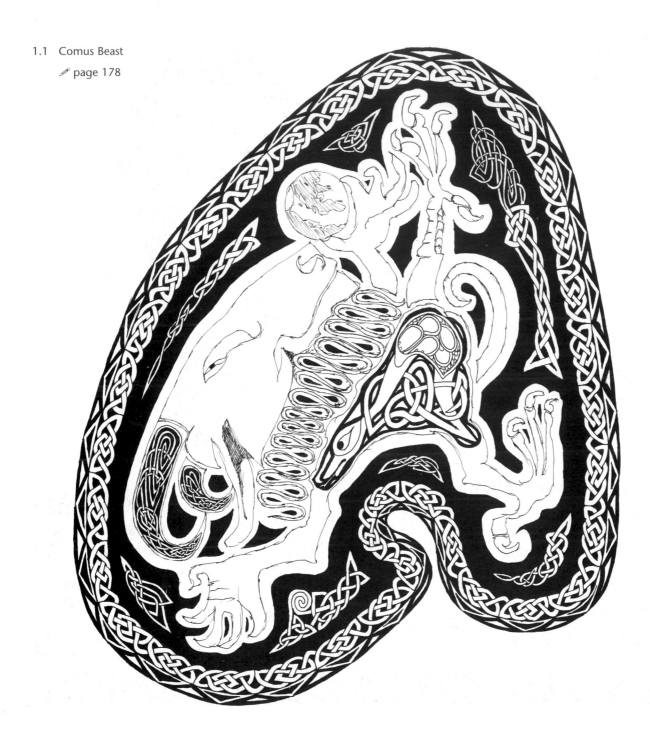

1.2 Comus Beast (detail 1)

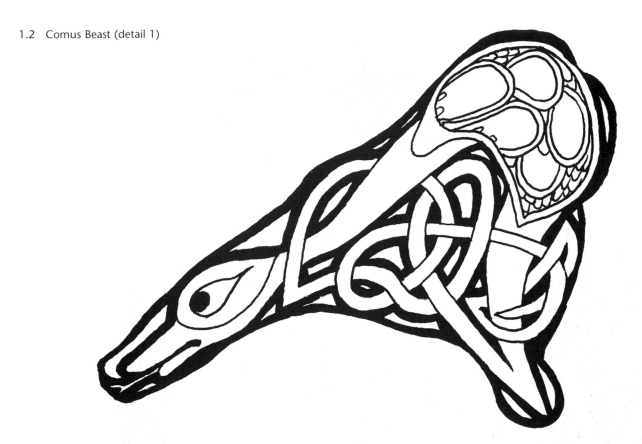

1.3 Comus Beast (detail 2)

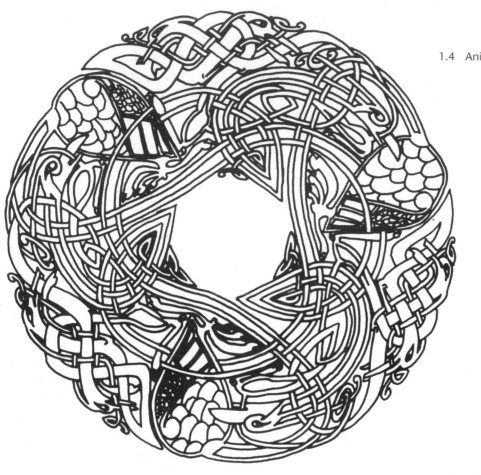

1.4 Animal Circle (detail 1)

1.5 Animal Circle (detail 2)

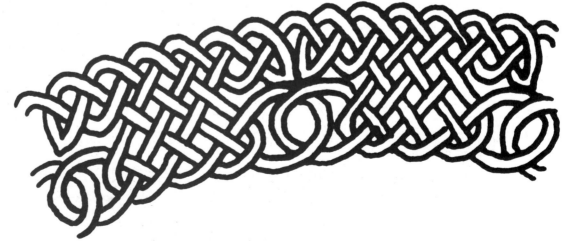

1.6 Animal Circle

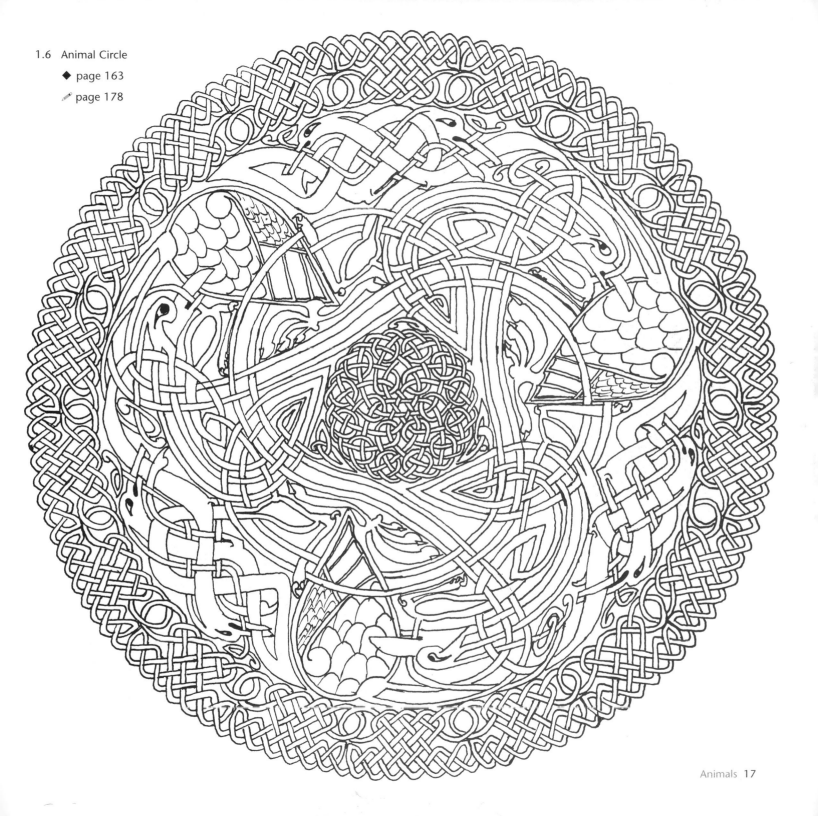

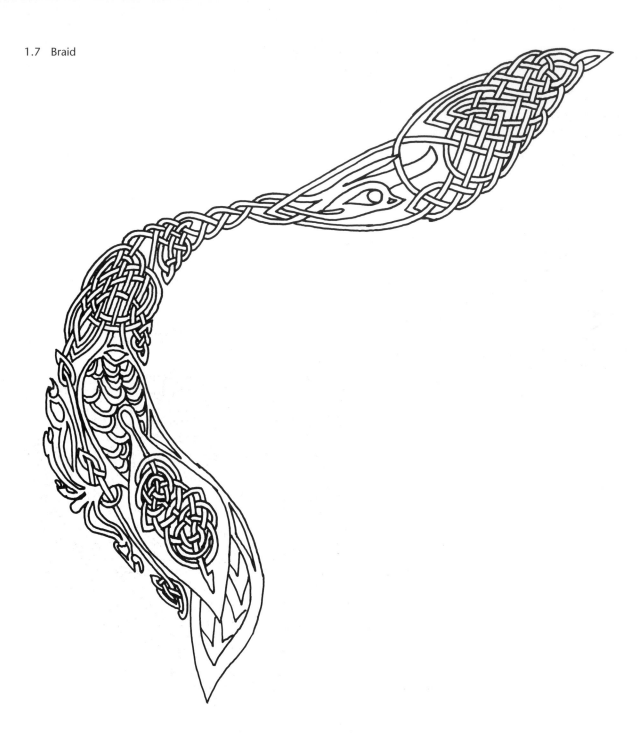

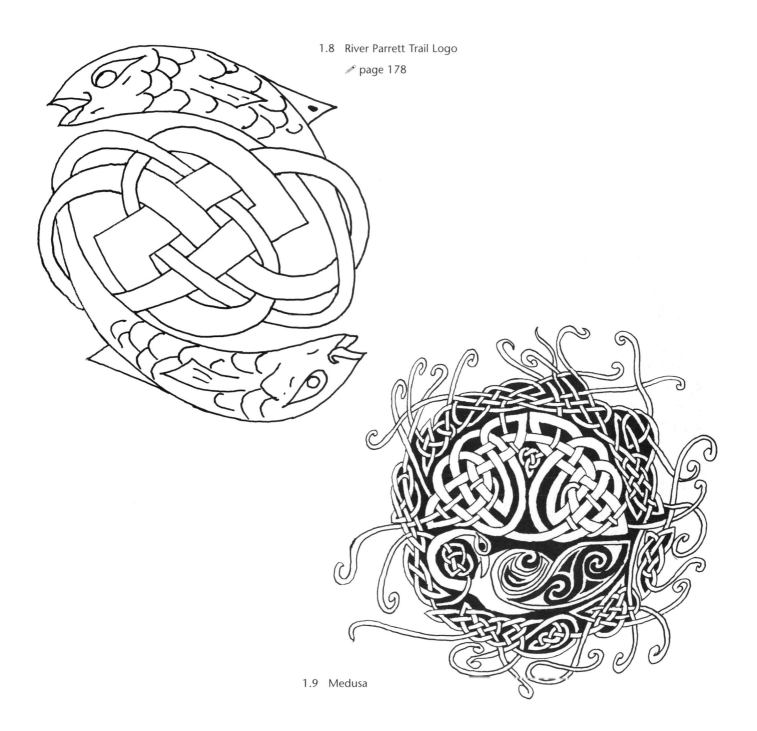

1.8 River Parrett Trail Logo

page 178

1.9 Medusa

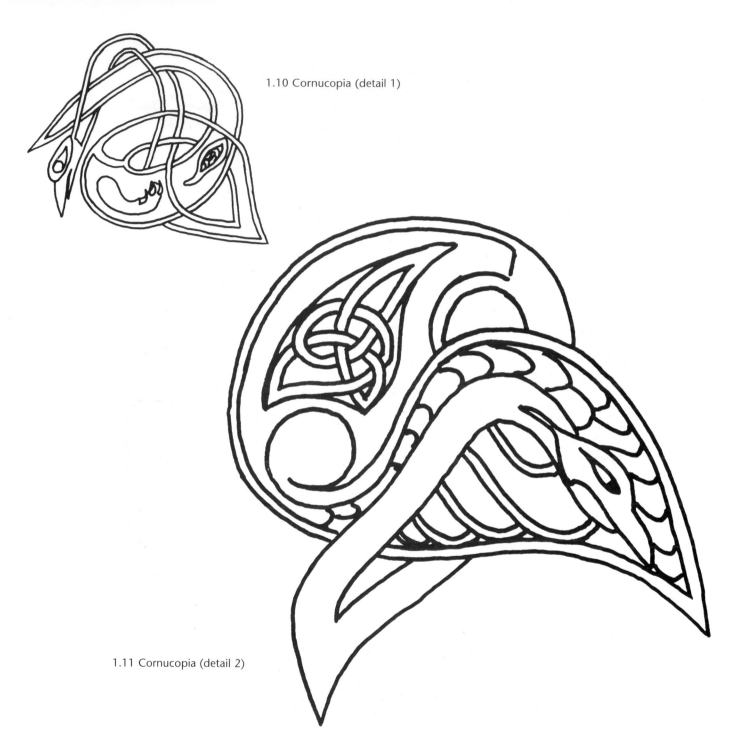

1.10 Cornucopia (detail 1)

1.11 Cornucopia (detail 2)

1.12 Cornucopia

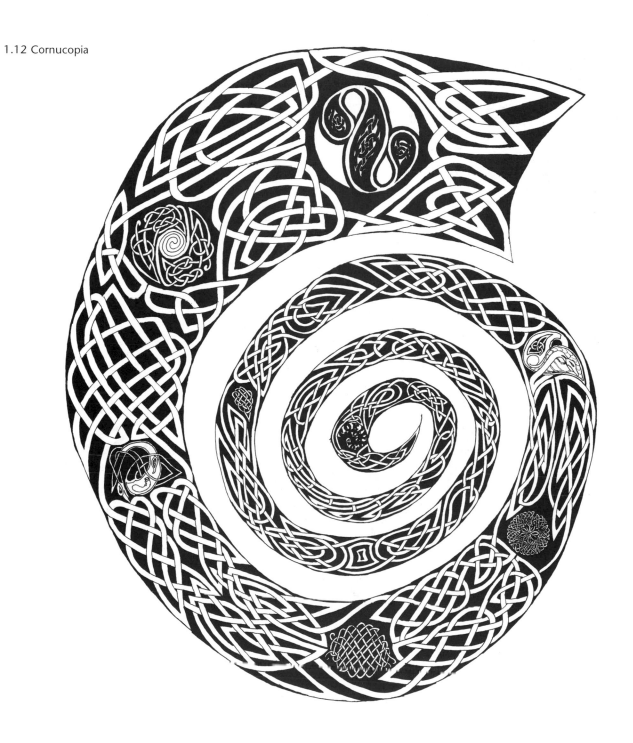

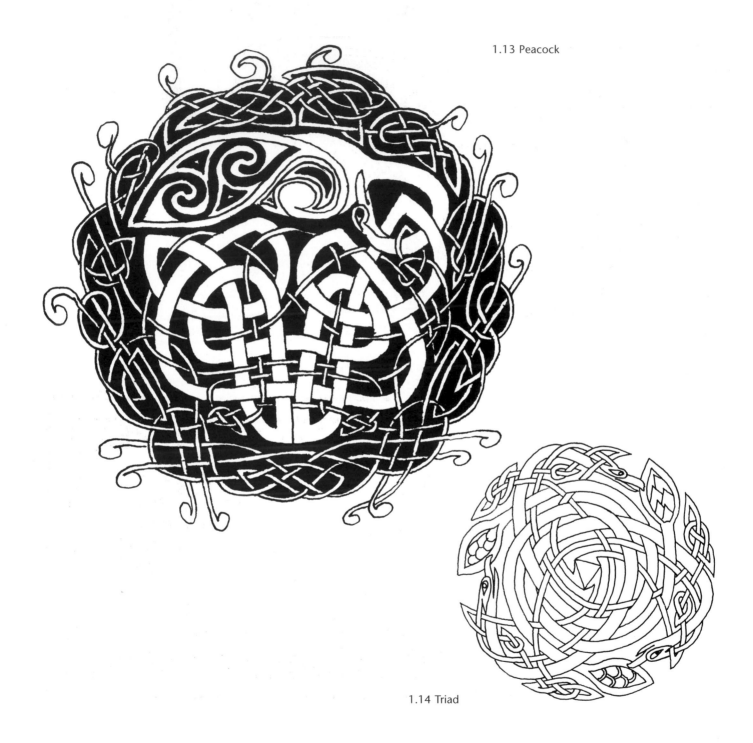

1.13 Peacock

1.14 Triad

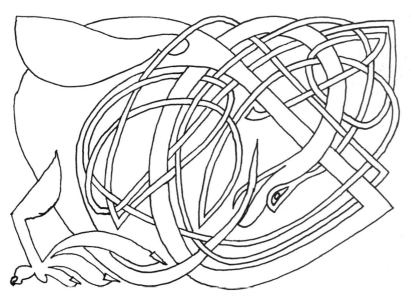

1.15 Bird Postcard

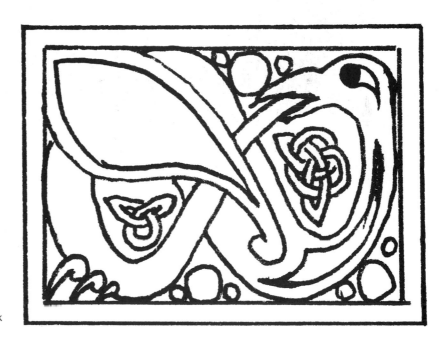

1.16 Bird Brick

1.17 Harp

◆ page 169
✎ page 178

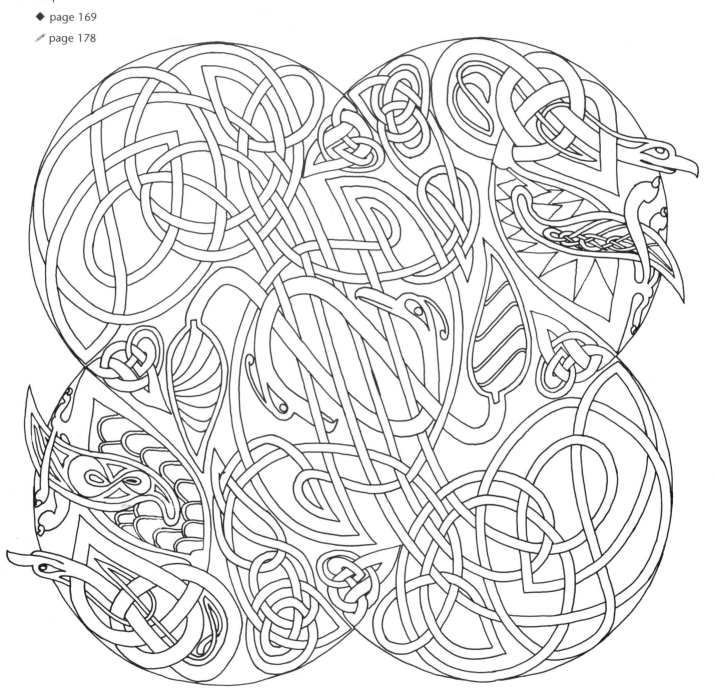

1.18 Harp (detail 1)

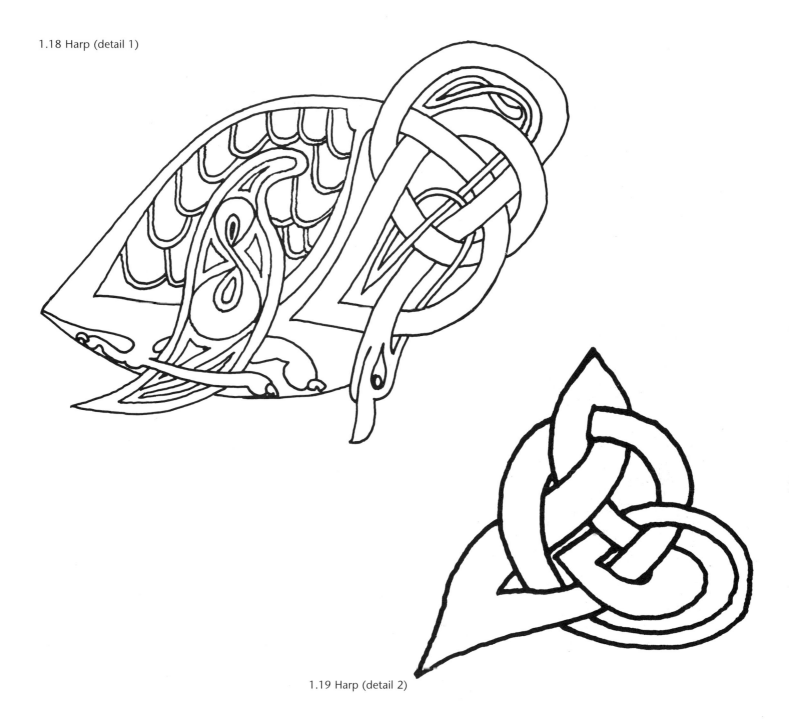

1.19 Harp (detail 2)

1.20 Celestial Flare (detail)

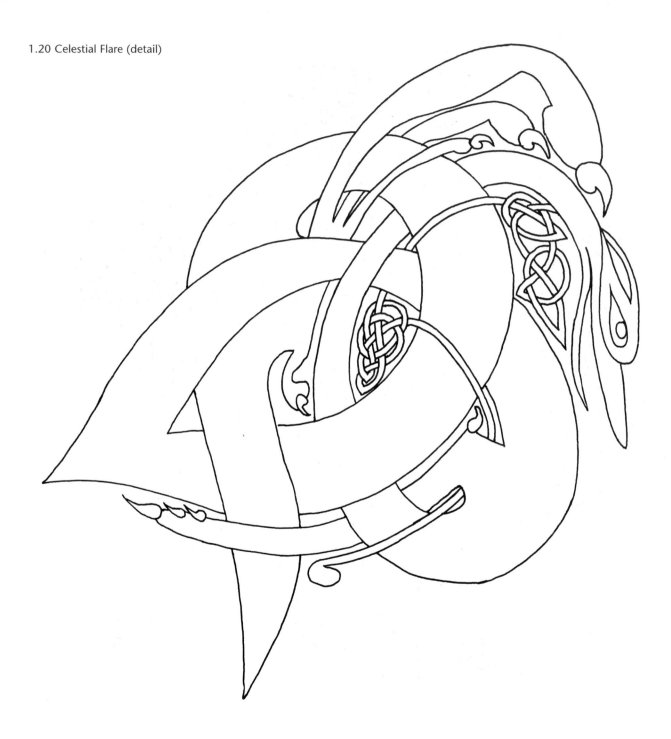

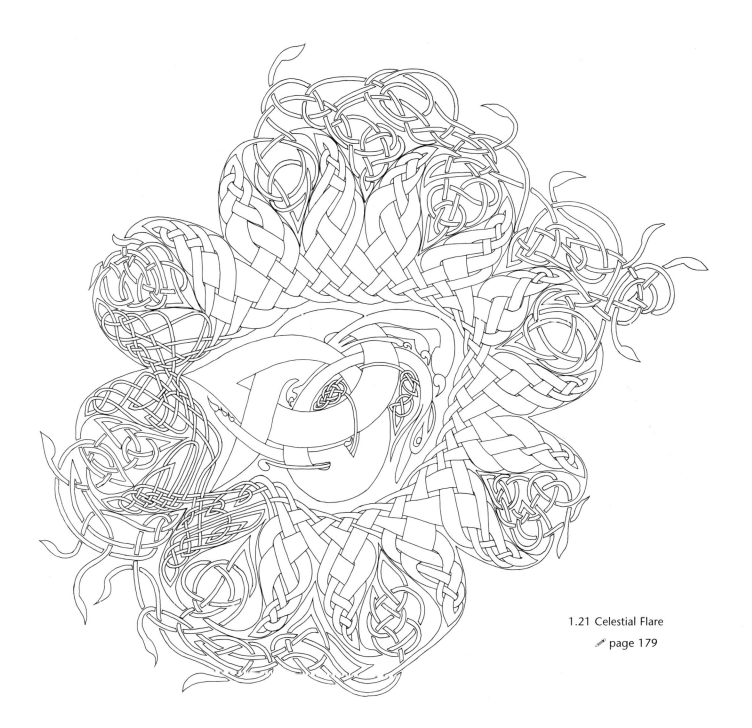

1.21 Celestial Flare

✐ page 179

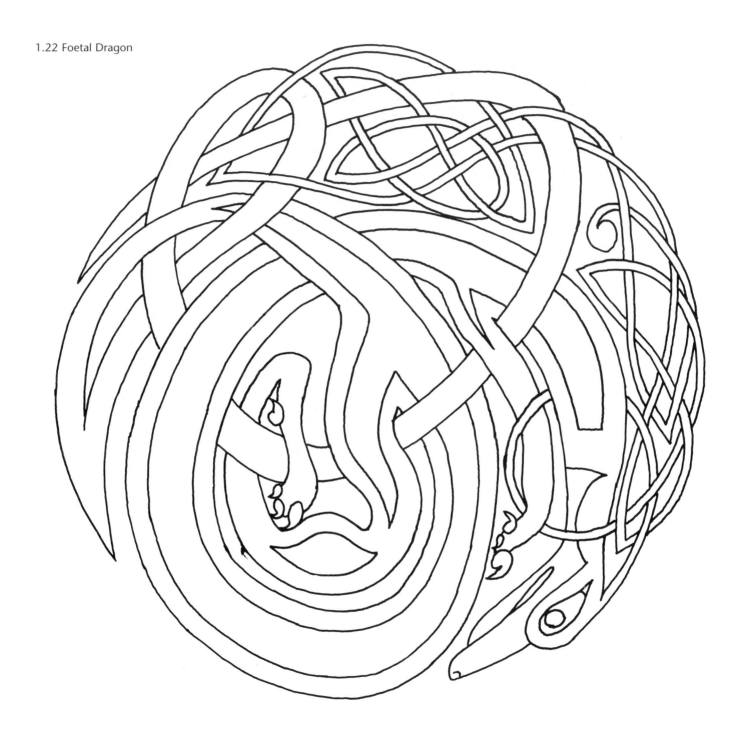

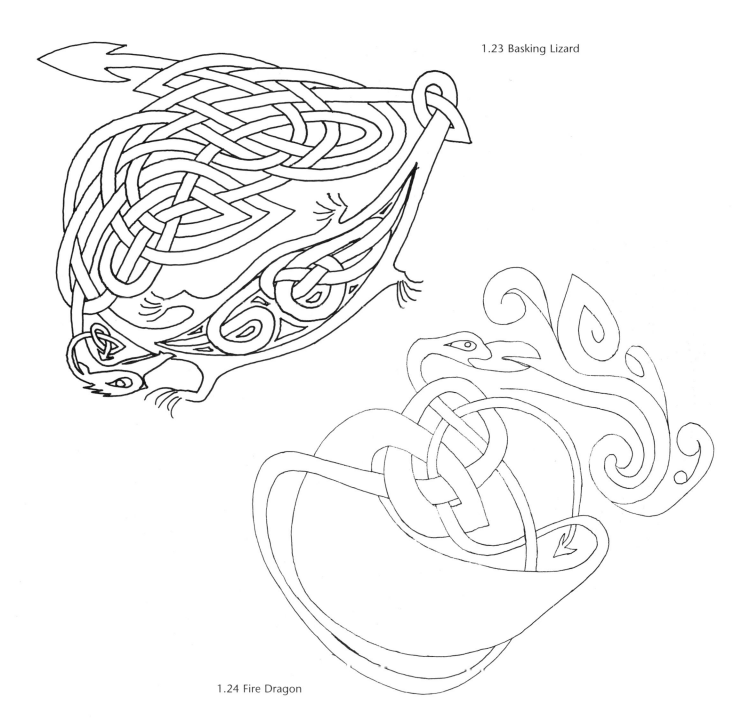

1.23 Basking Lizard

1.24 Fire Dragon

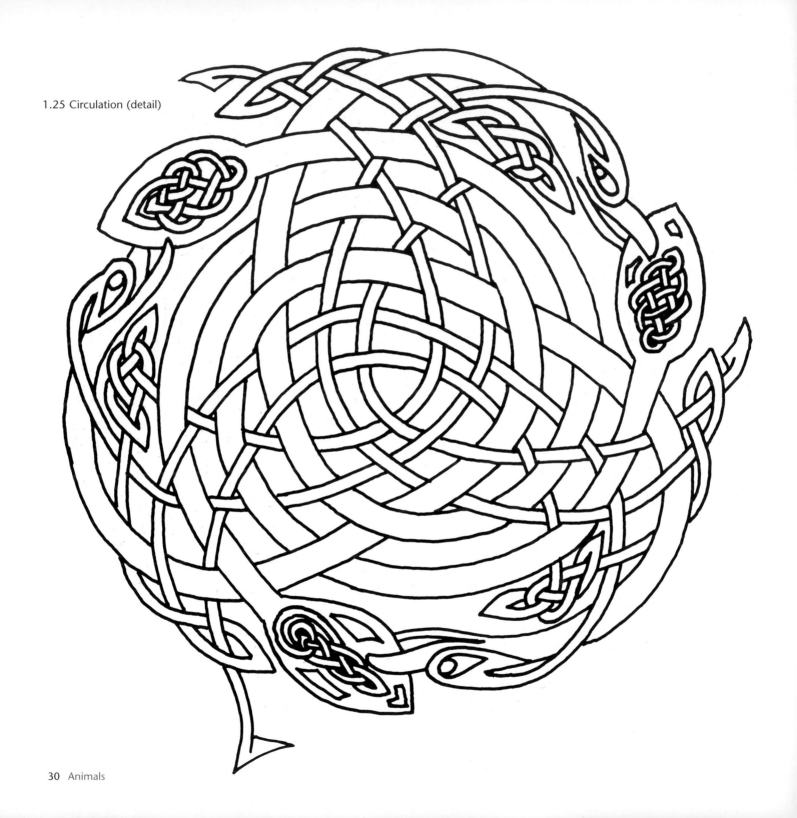

1.25 Circulation (detail)

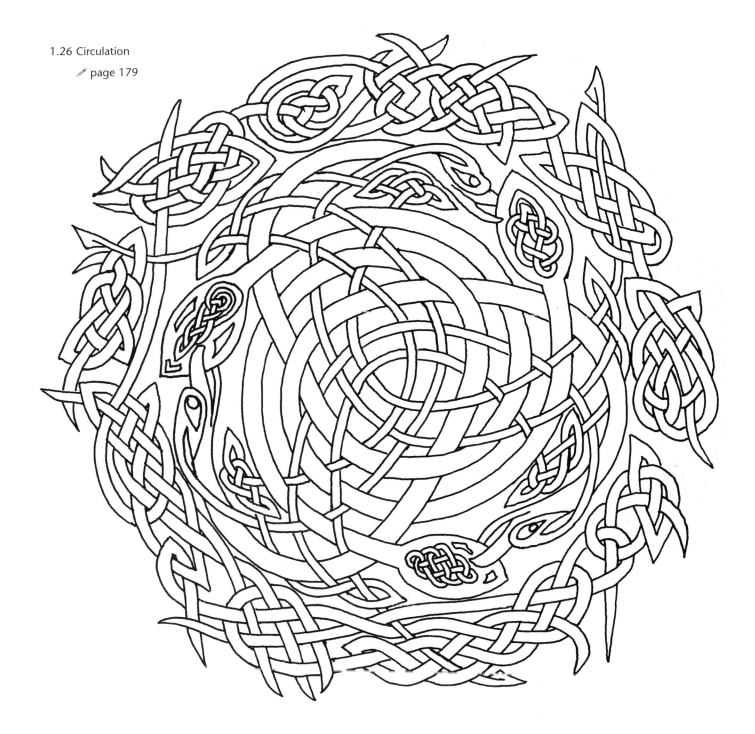

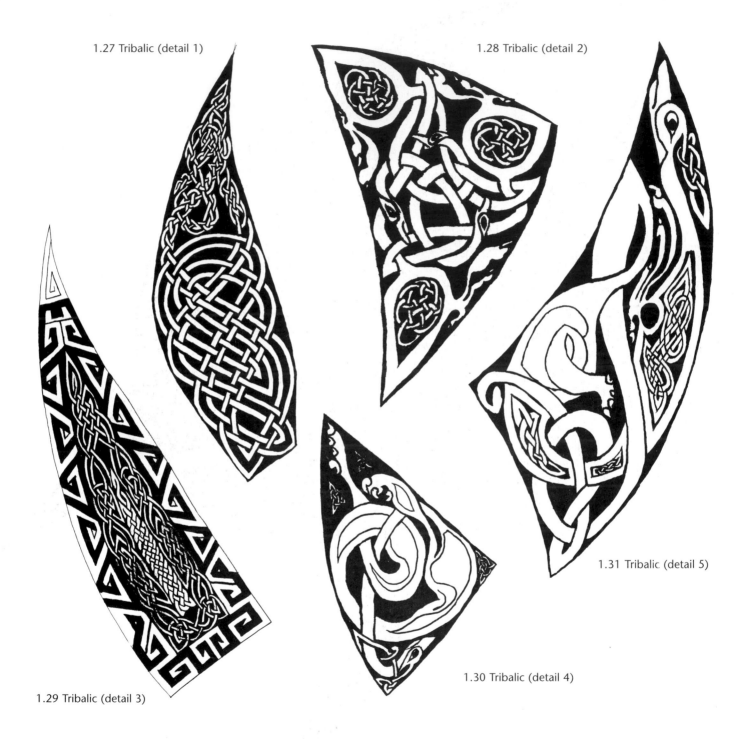

1.27 Tribalic (detail 1)

1.28 Tribalic (detail 2)

1.29 Tribalic (detail 3)

1.30 Tribalic (detail 4)

1.31 Tribalic (detail 5)

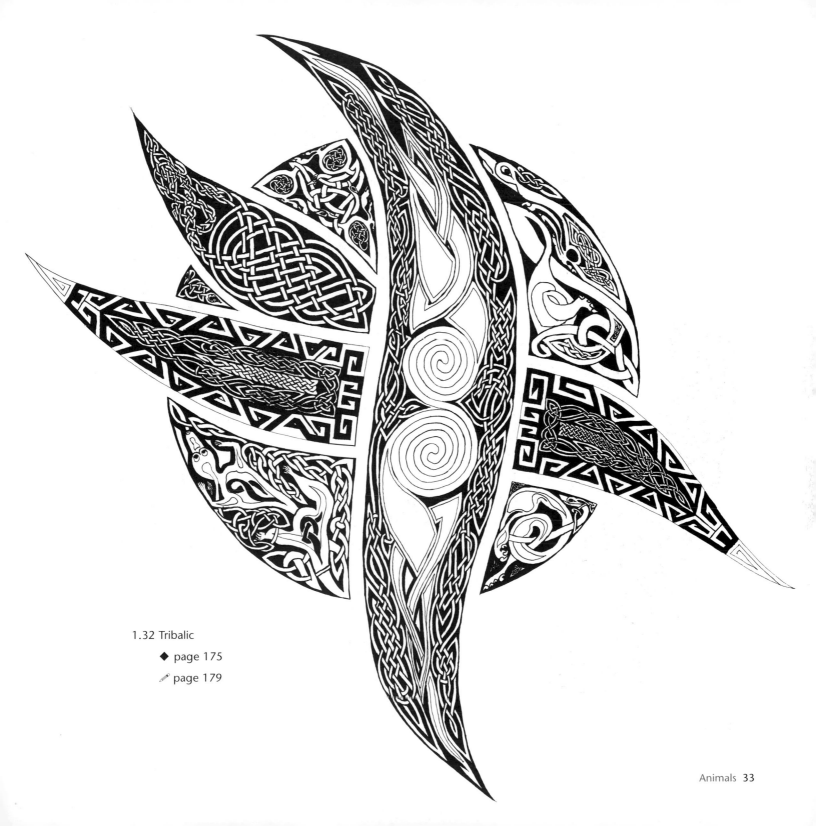

1.32 Tribalic

◆ page 175

✎ page 179

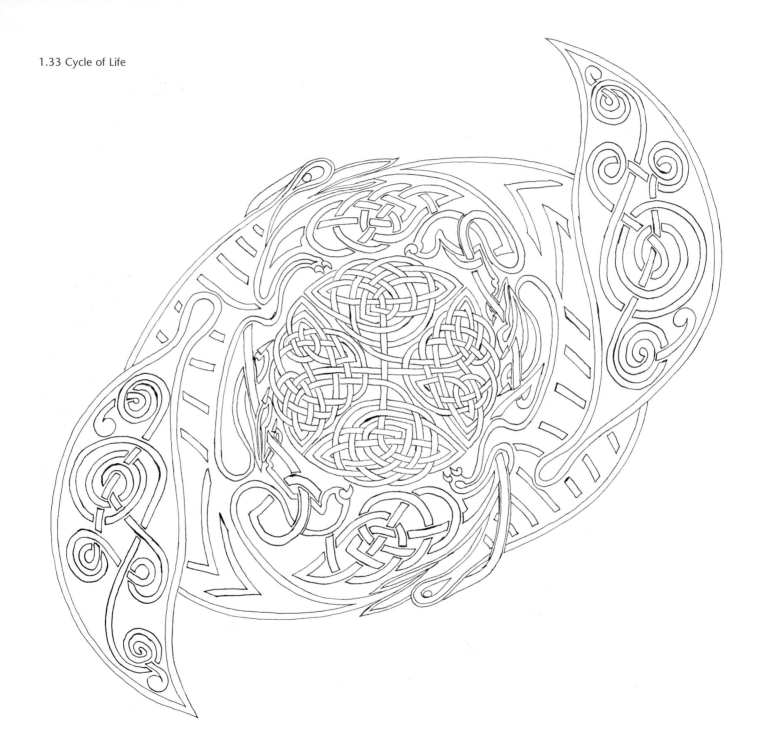

1.34 Cycle of Life (detail 1)

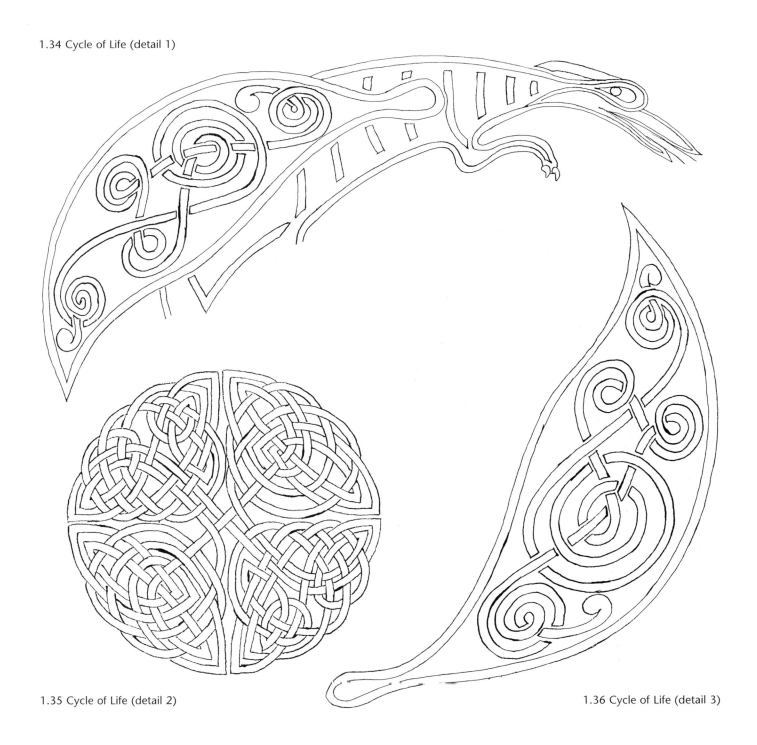

1.35 Cycle of Life (detail 2)

1.36 Cycle of Life (detail 3)

Animals 35

CIRCLES

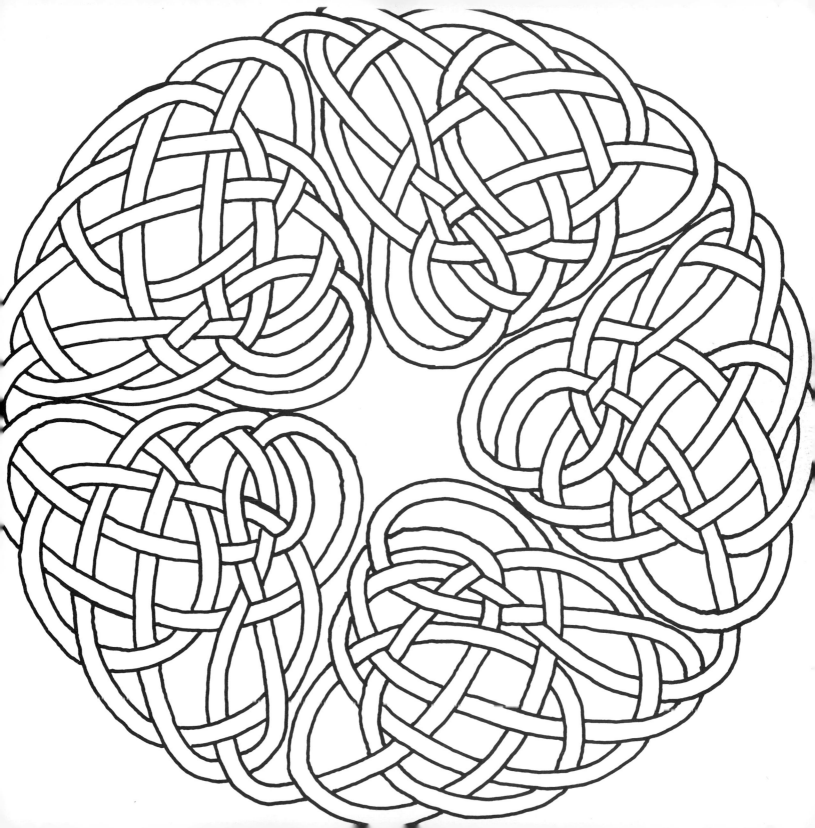

CIRCLES

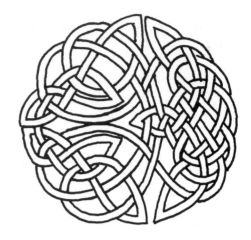

Circles are pleasing shapes to work with – perhaps the most pleasing. The options for filling a circle are limitless, and the selection shown here vary greatly, from very intricate designs in a very small circle drawn using a pen with a thick nib, to more simple motifs in a much larger circle, which gives a broader width to the central line.

Broadly speaking, circle designs fall into two categories. One style is symmetrical and rhythmic (eg 'Rosette' on page 64), repeating sections within a circle. These are easy enough to design using a compass and a ruler to separate a circle into equal sections, and repeating one section throughout.

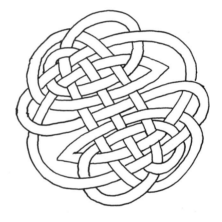

The other style is slightly more abstract (eg 'Settling' on page 72), because it is not necessarily symmetrical. Knotwork, animal work or some tessellation fills the circle, to make a small or freehand motif.

Circles naturally lend themselves to a flowing style, helping the designer to achieve a pleasing end point. With some of the more freehand designs, it is interesting to alter the feel of a circle, using square lines or lines that jar against the flowing nature of a circle.

In some of the larger motifs, it is possible to insert a number of different circles. However, it is always important to remember that

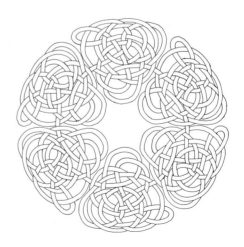

elements of a larger motif should be symbiotic rather than jarring. In one or two of the large designs, the circles inserted were not necessarily the originals, but seemed on hindsight to work best within the composite design.

The larger, single-line knotwork circles are very intricate (eg 'Woven Shield' on page 138), but again can be simplified by breaking down the circle into different compartments or cells to be filled, using a compass and ruler to experiment with the different shapes. I have noted the specific motifs where I used this approach.

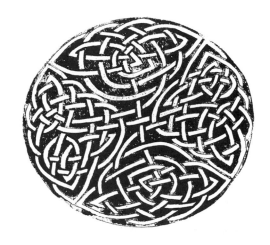

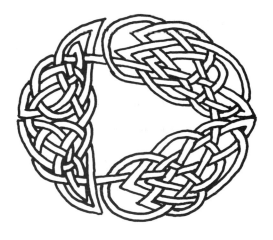

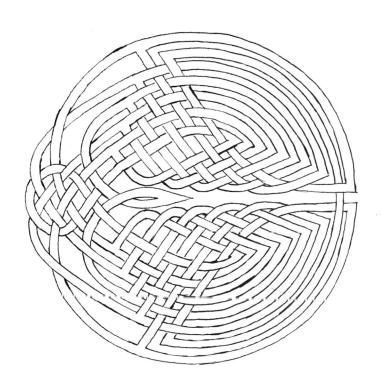

2.1 Bird Trellis

✎ page 180

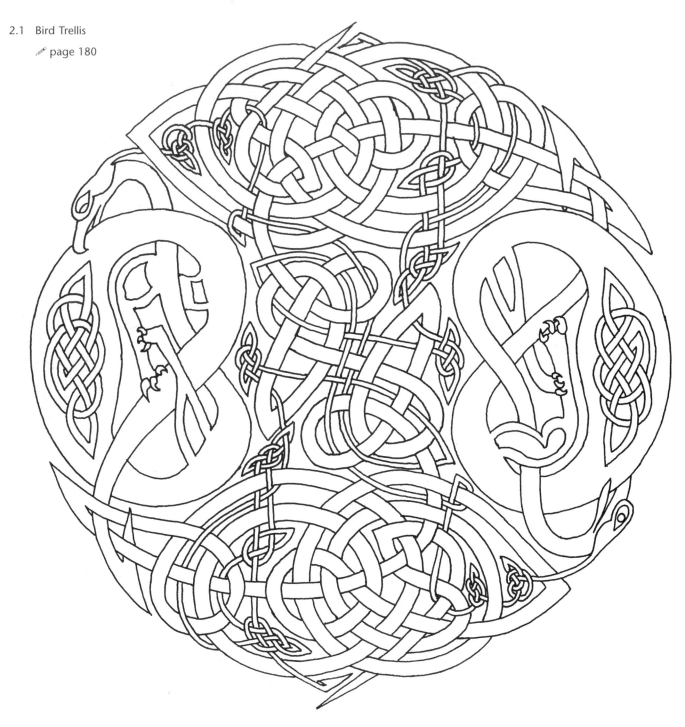

2.2 Bird Trellis in Reverse

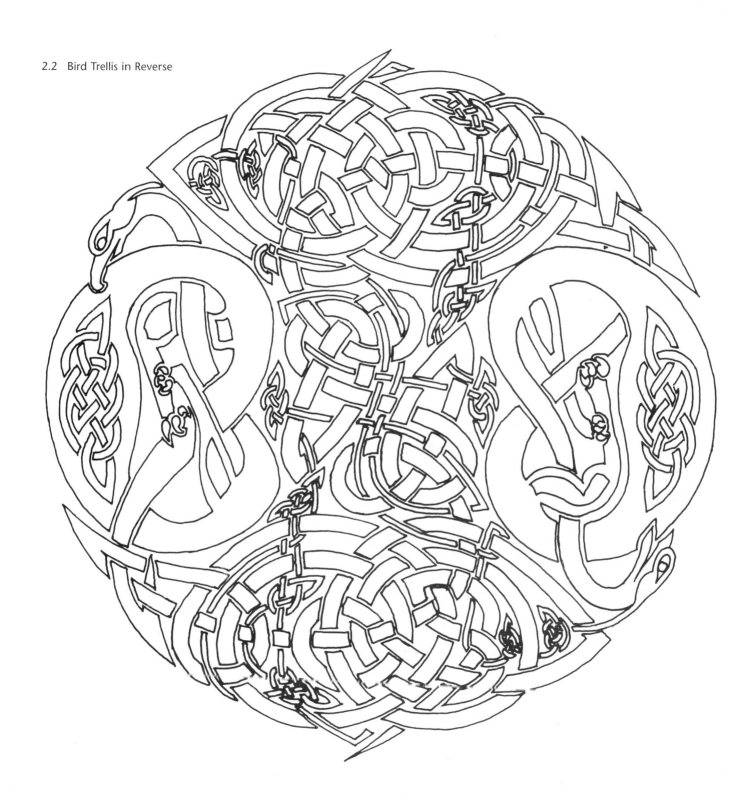

2.3 Compass

◆ page 166

✎ page 180

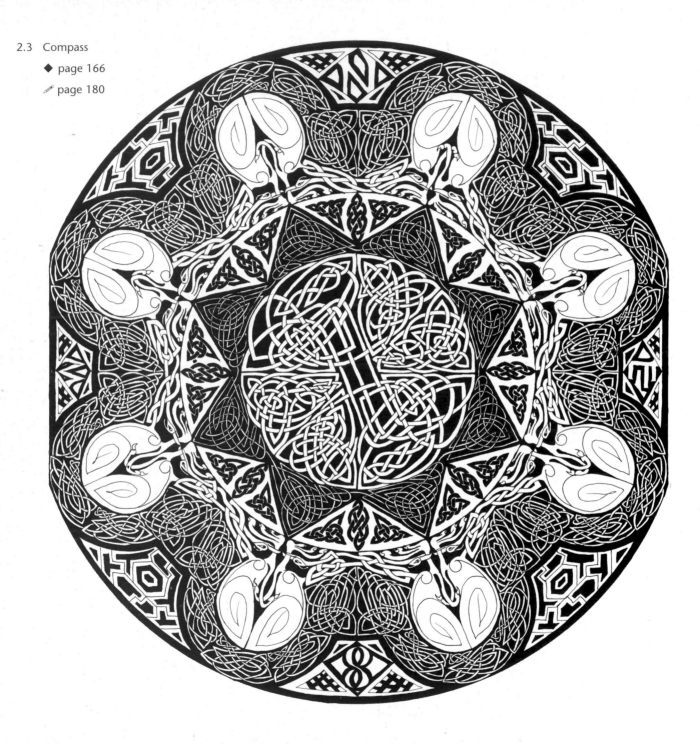

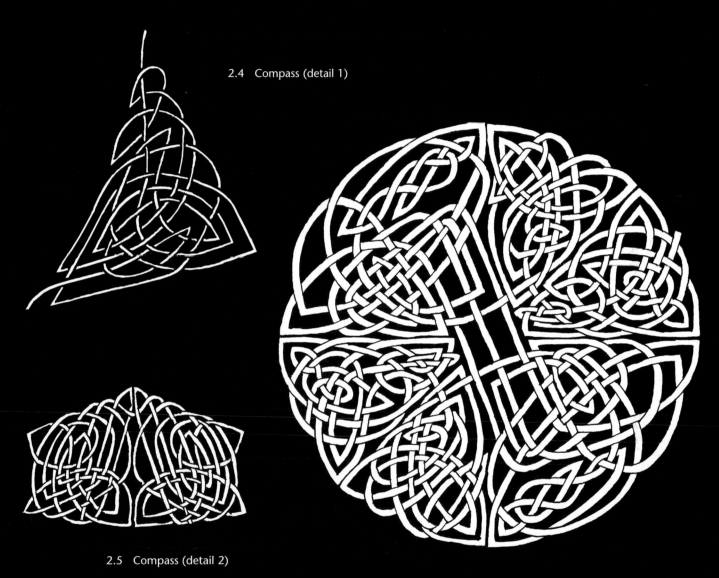

2.4 Compass (detail 1)

2.5 Compass (detail 2)

2.6 Compass (detail 3)

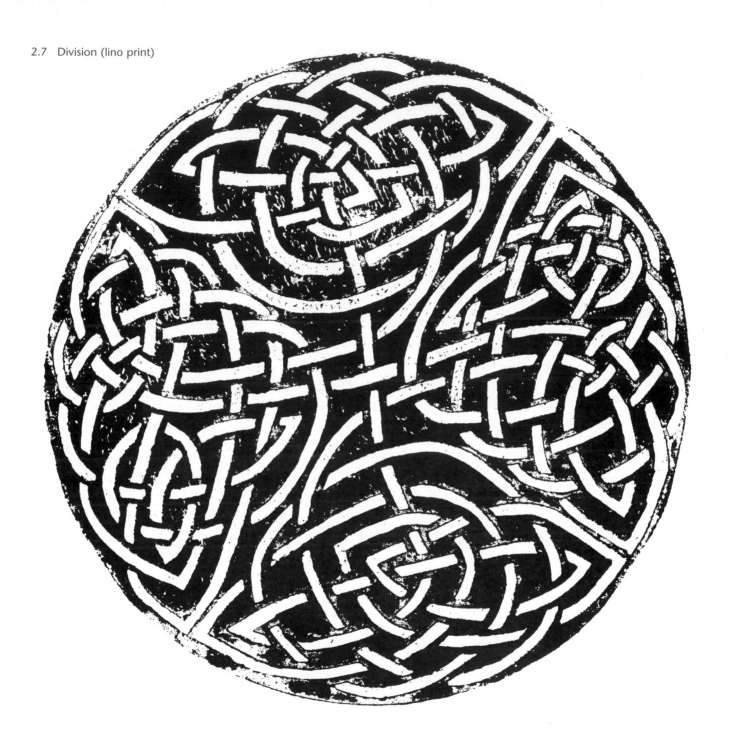

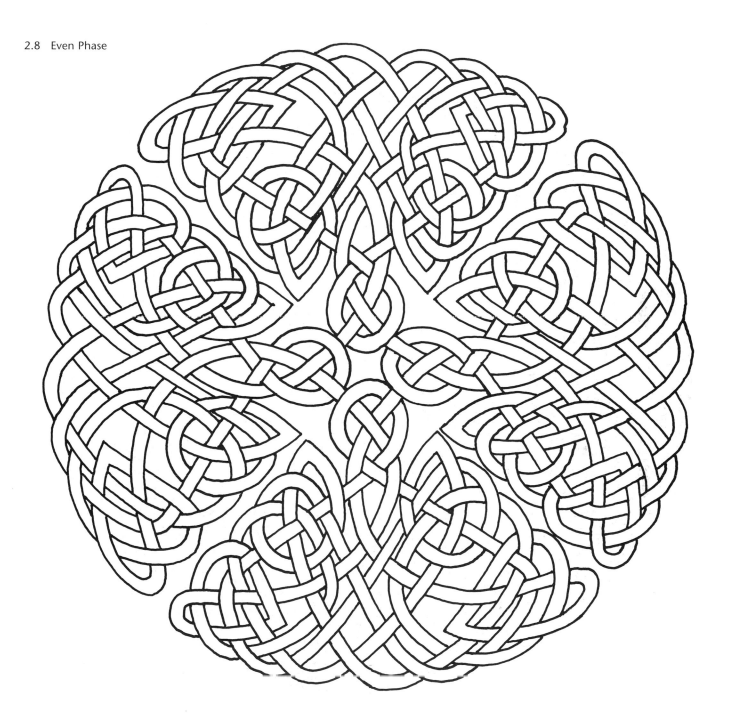

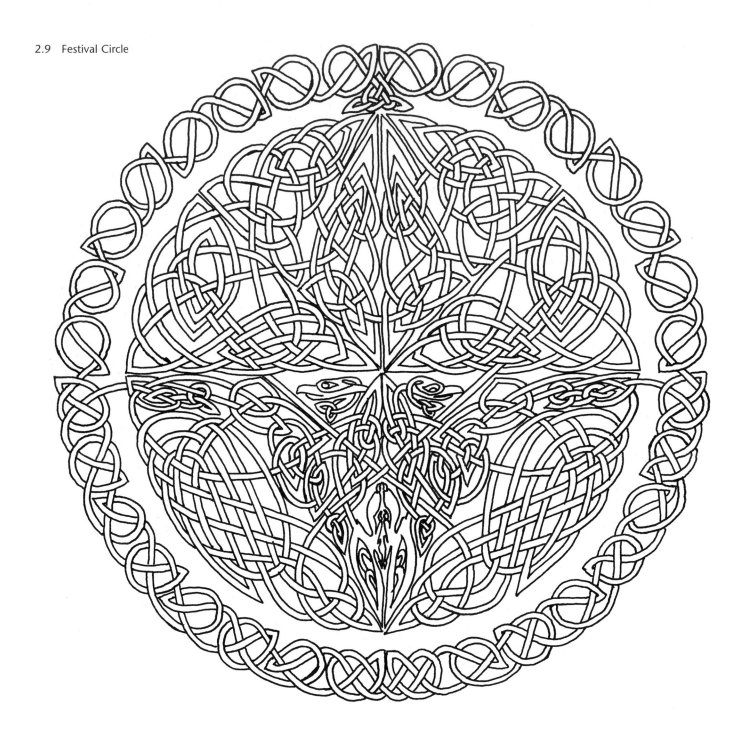

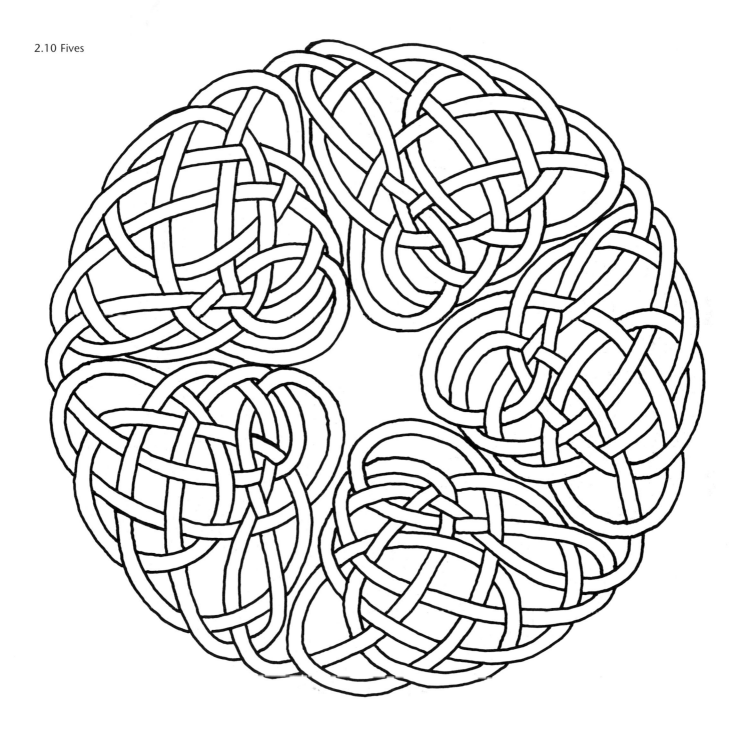

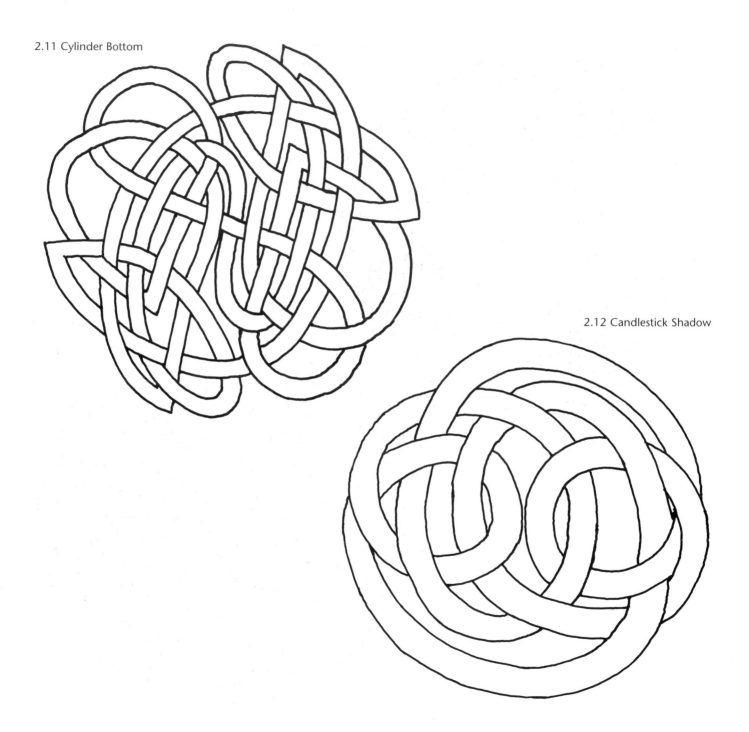

2.11 Cylinder Bottom

2.12 Candlestick Shadow

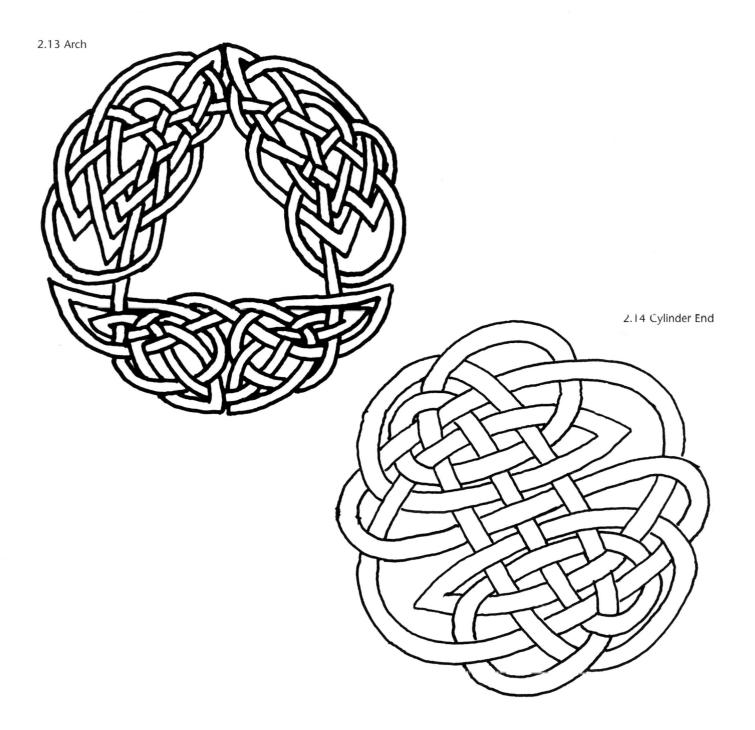

2.13 Arch

2.14 Cylinder End

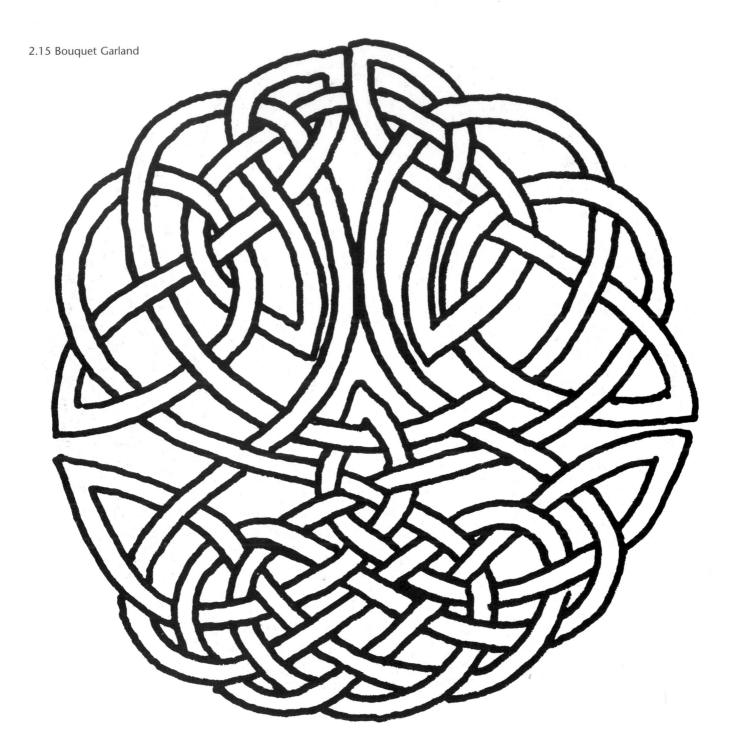

2.16 Lobster Pot

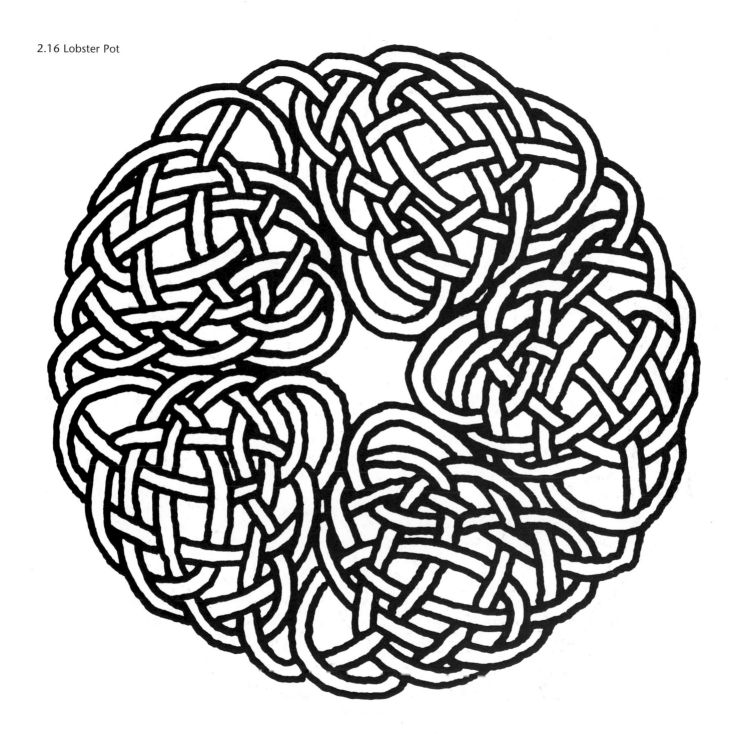

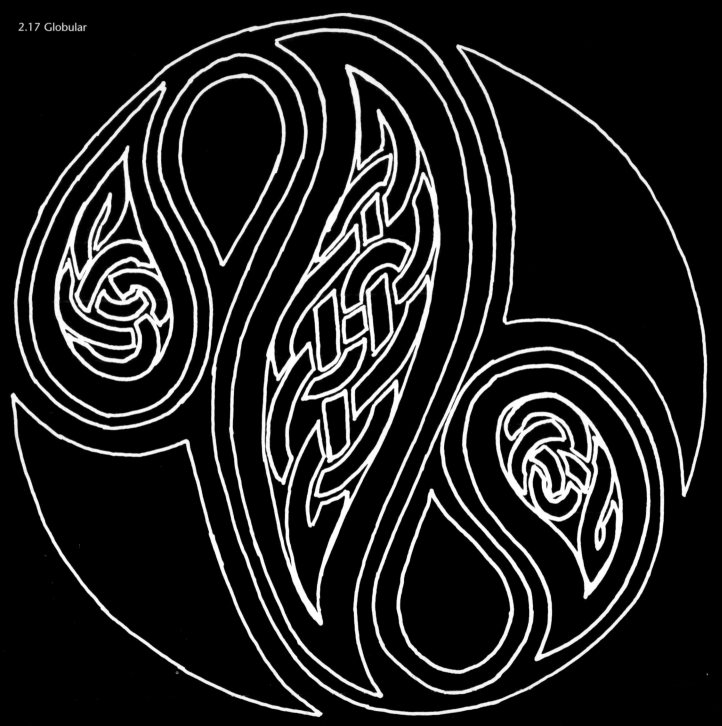

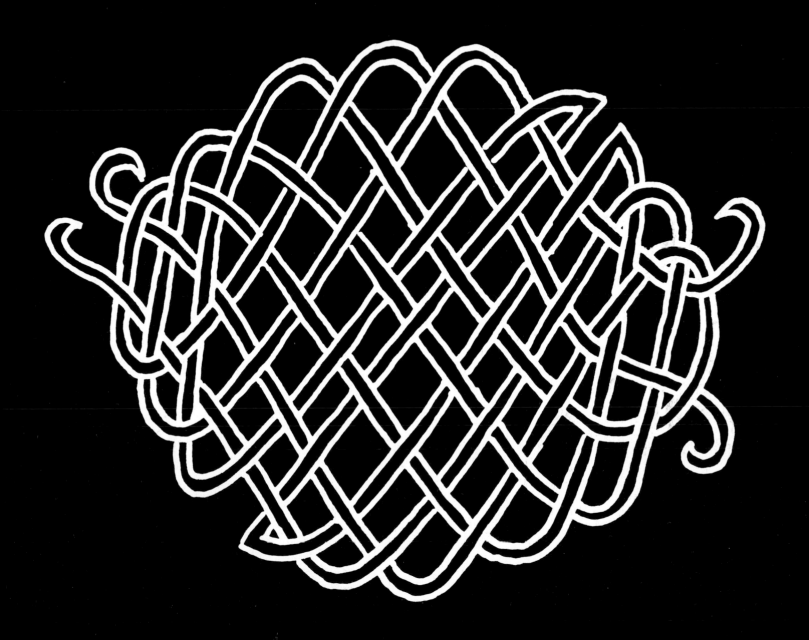

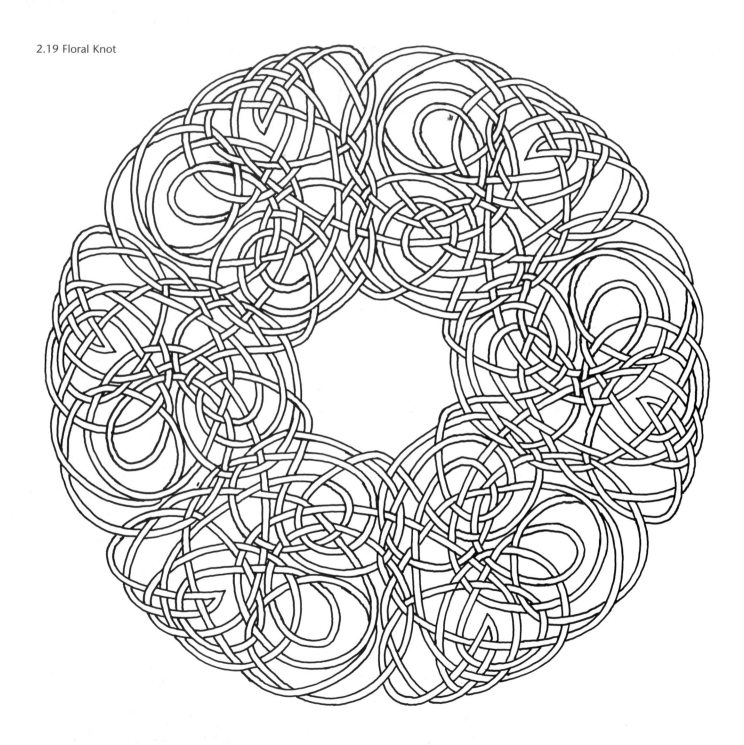

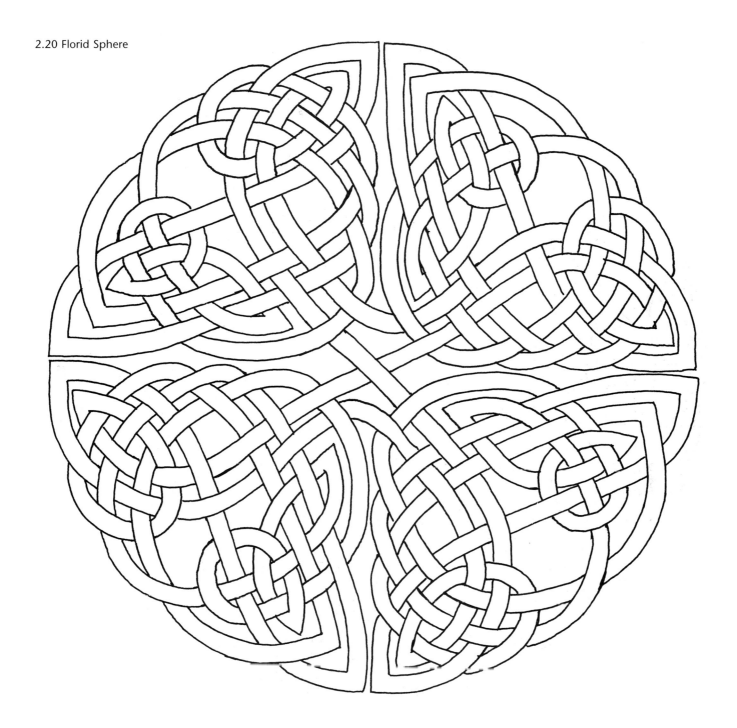

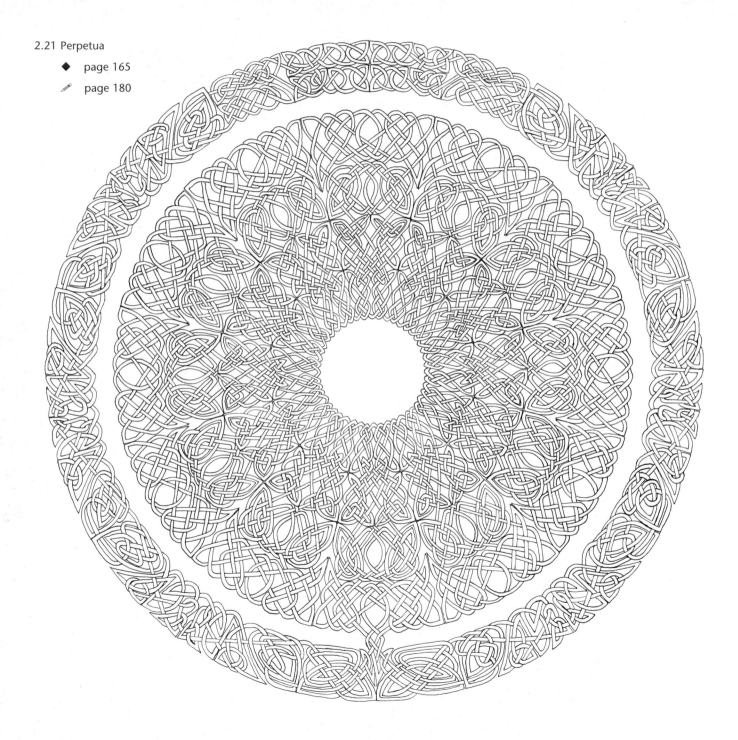

2.21 Perpetua

◆ page 165

✎ page 180

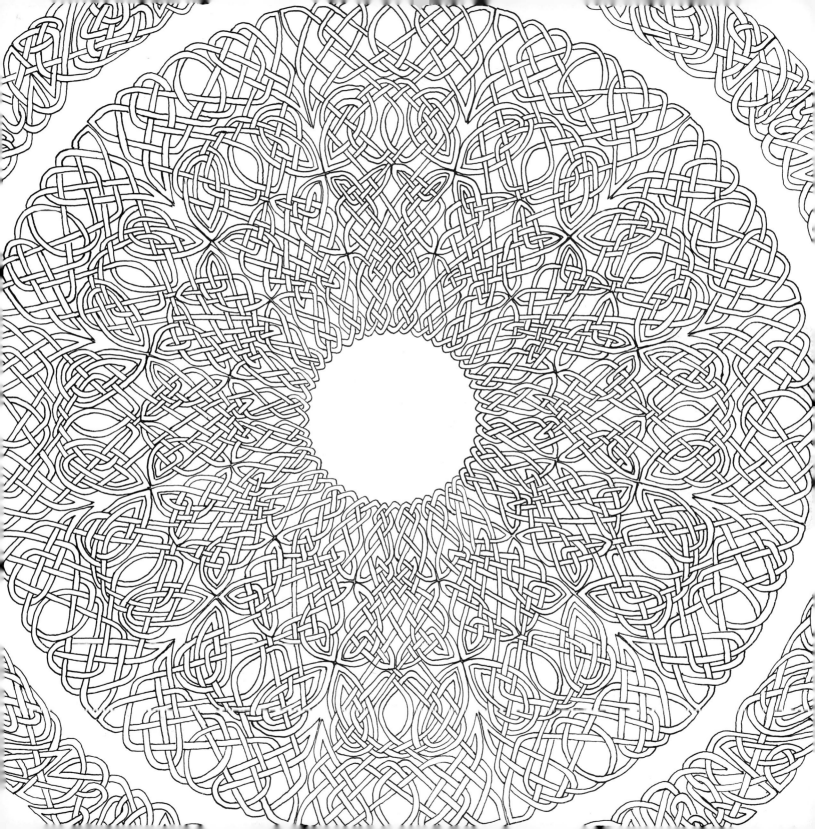

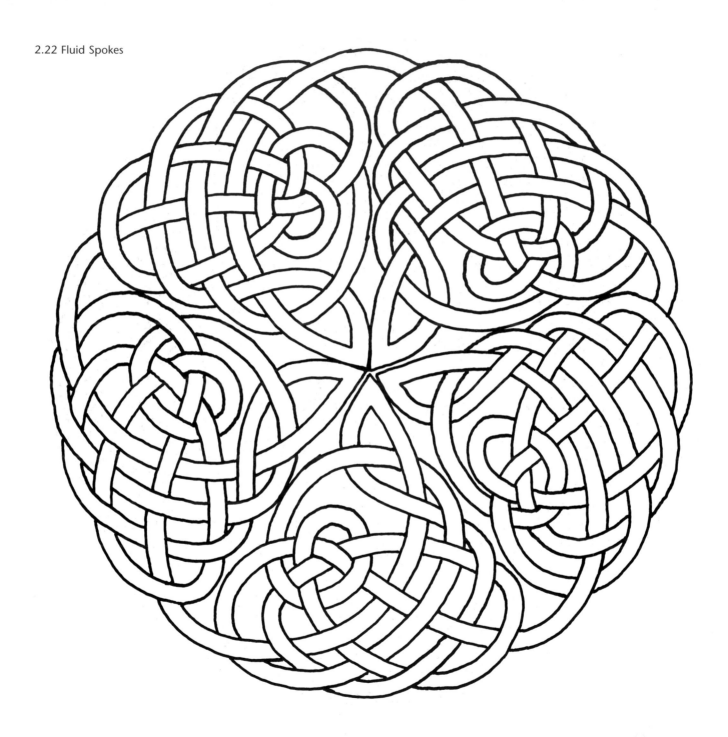

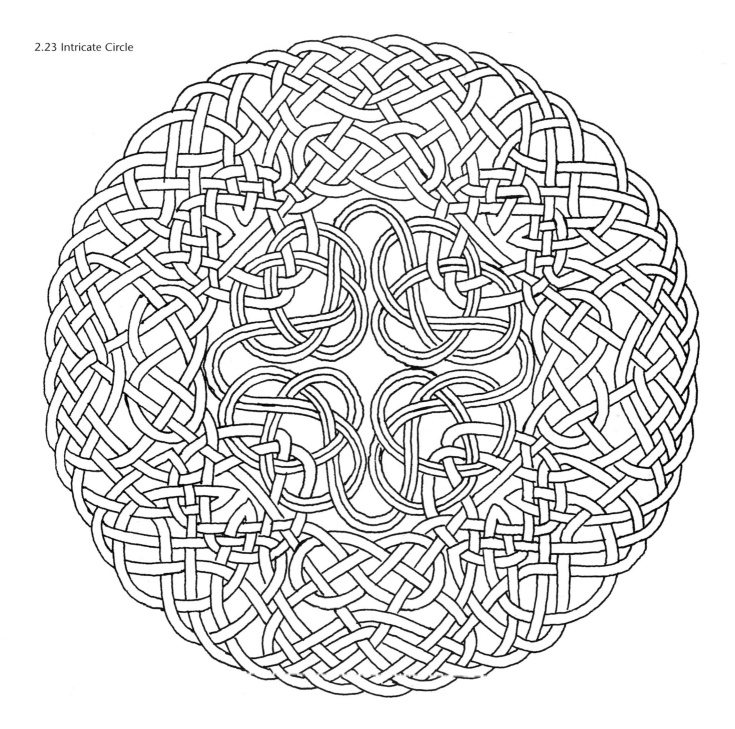

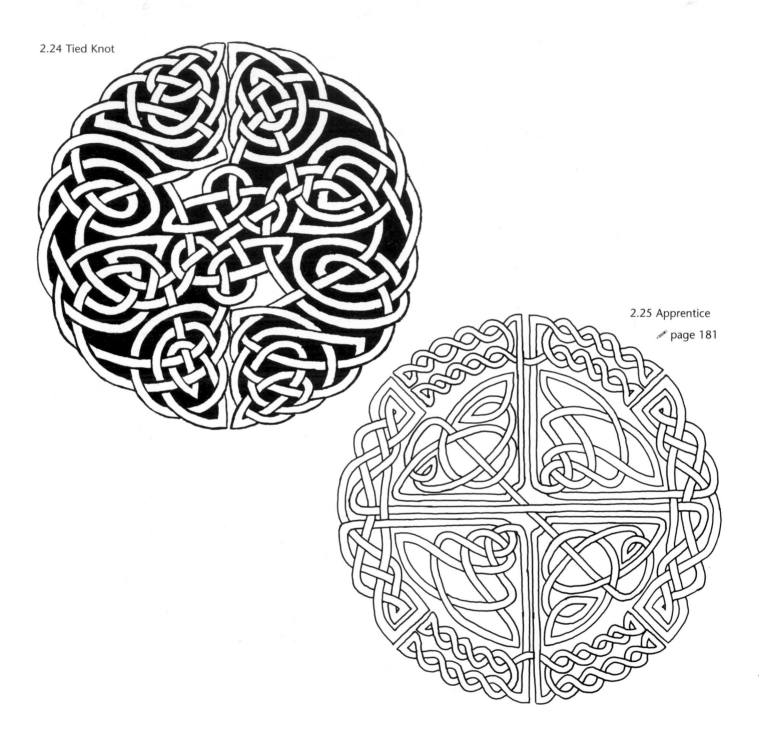

2.24 Tied Knot

2.25 Apprentice

✎ page 181

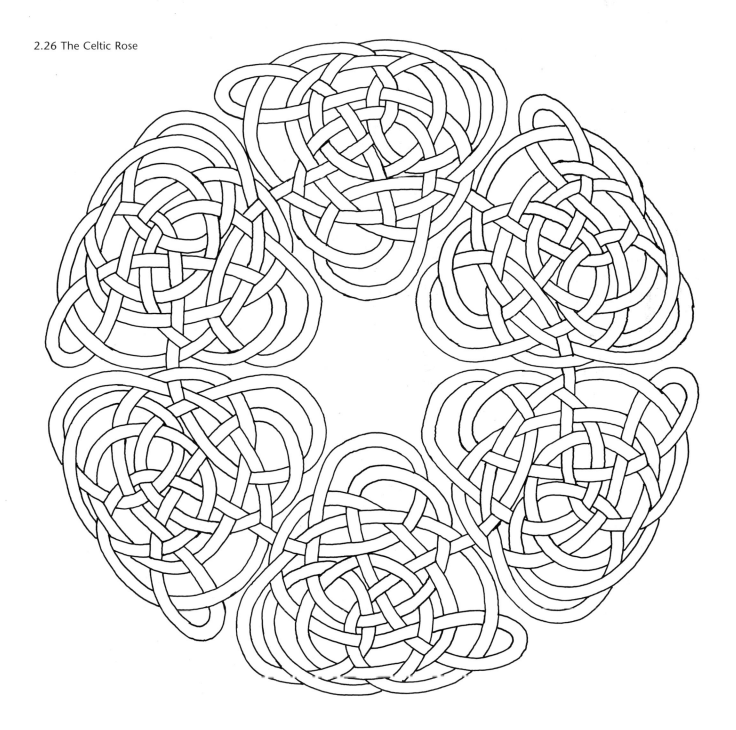

2.27 Ripples

🖉 page 181

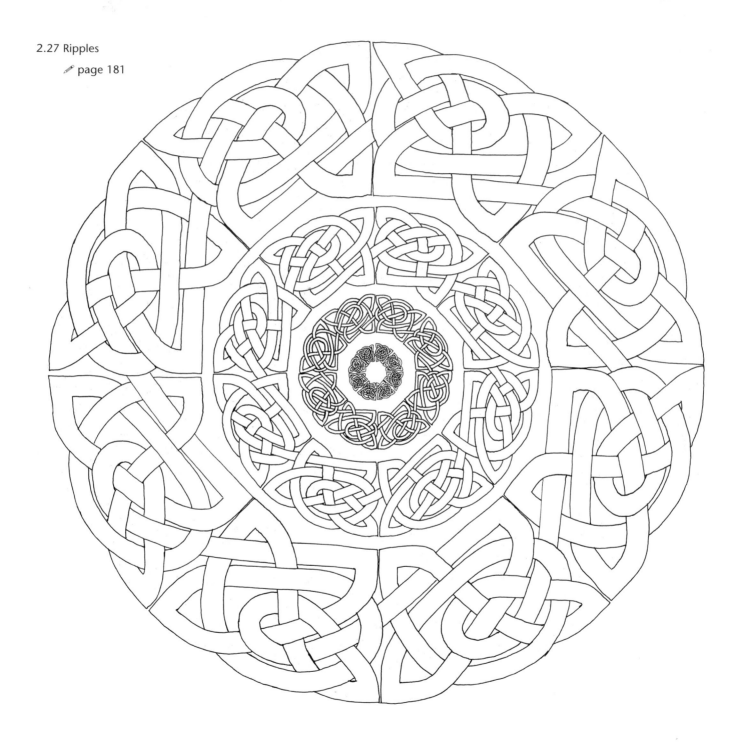

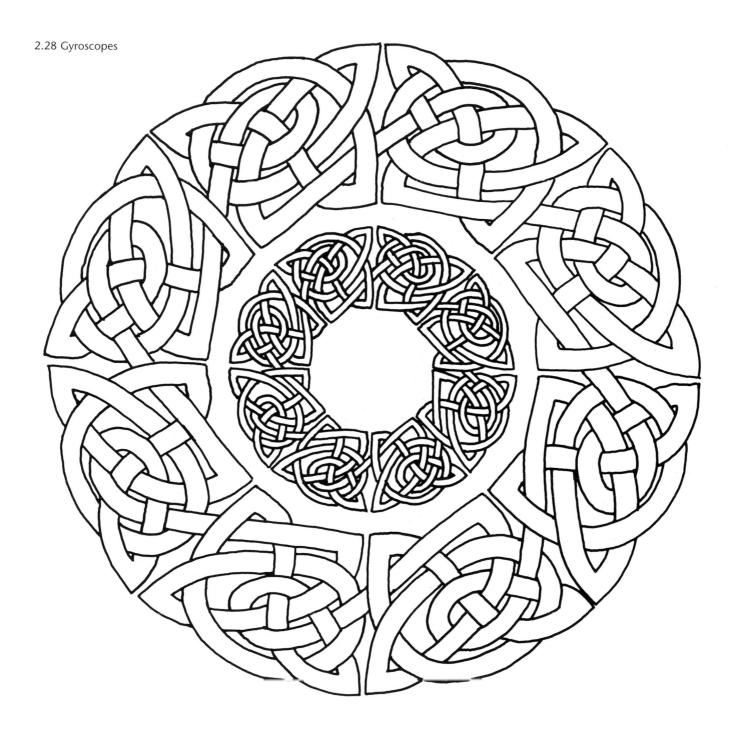

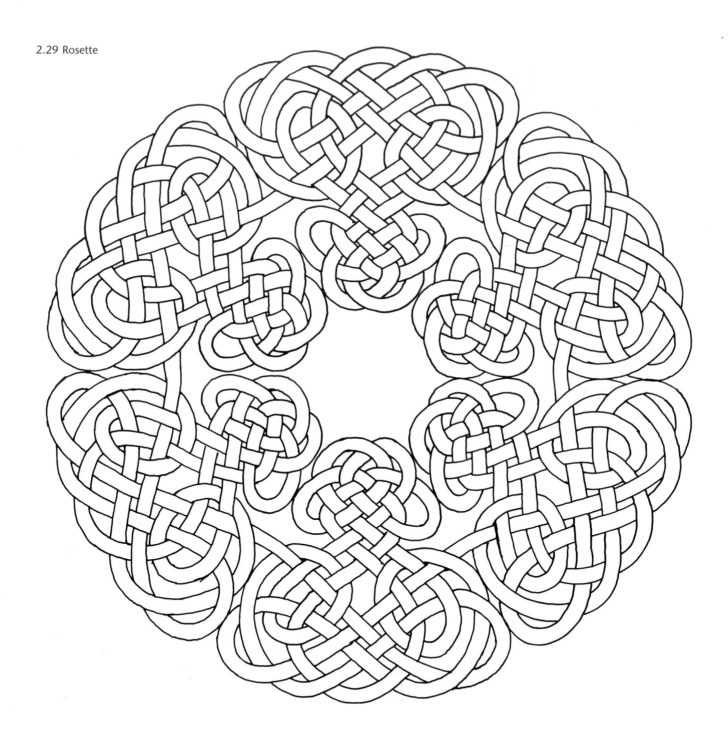

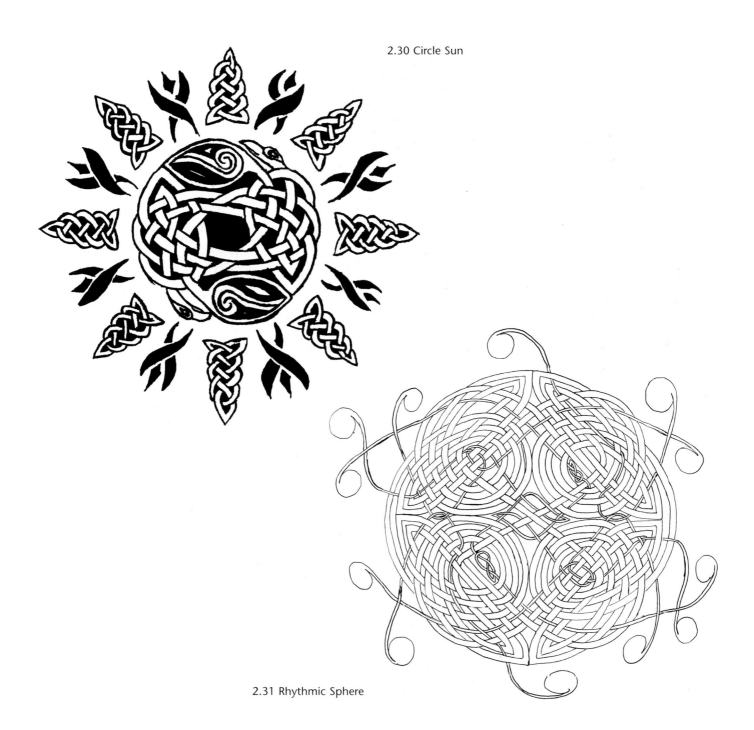

2.30 Circle Sun

2.31 Rhythmic Sphere

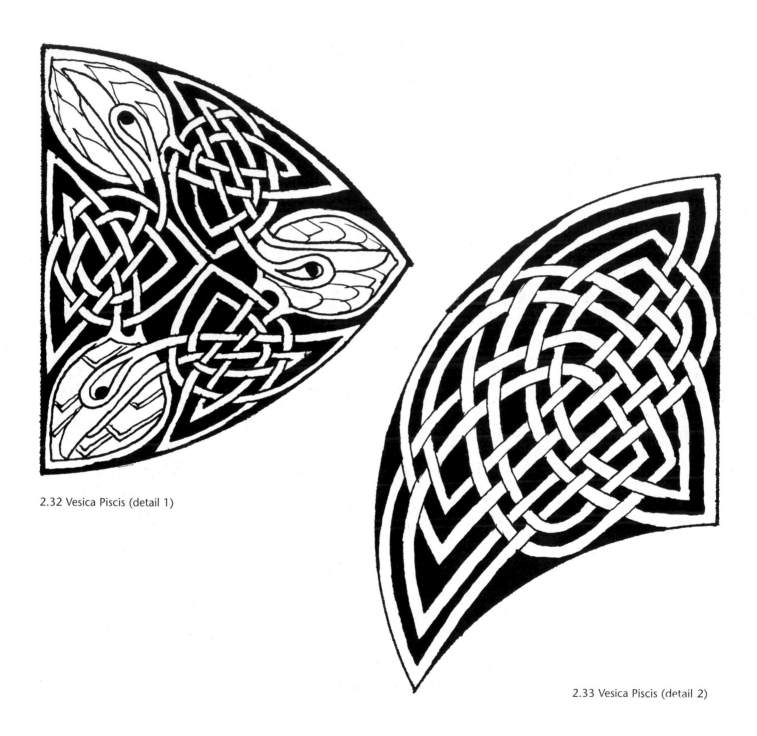

2.32 Vesica Piscis (detail 1)

2.33 Vesica Piscis (detail 2)

2.34 Vesica Piscis
◆ page 176
✎ page 181

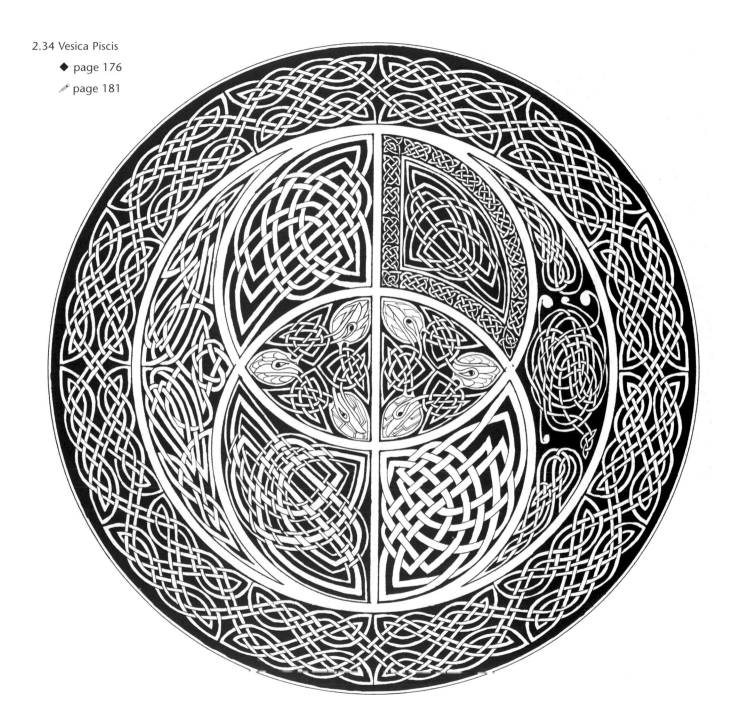

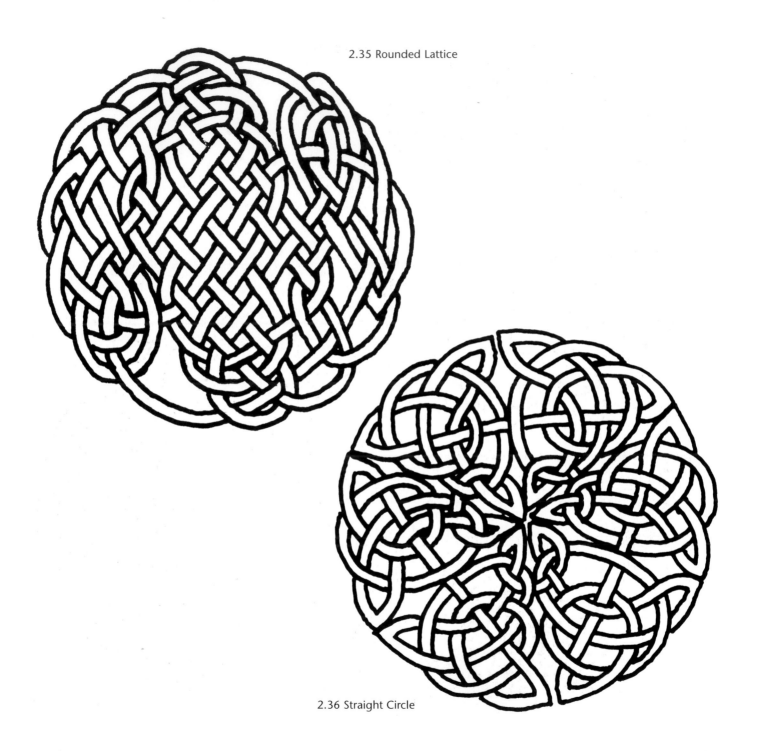

2.35 Rounded Lattice

2.36 Straight Circle

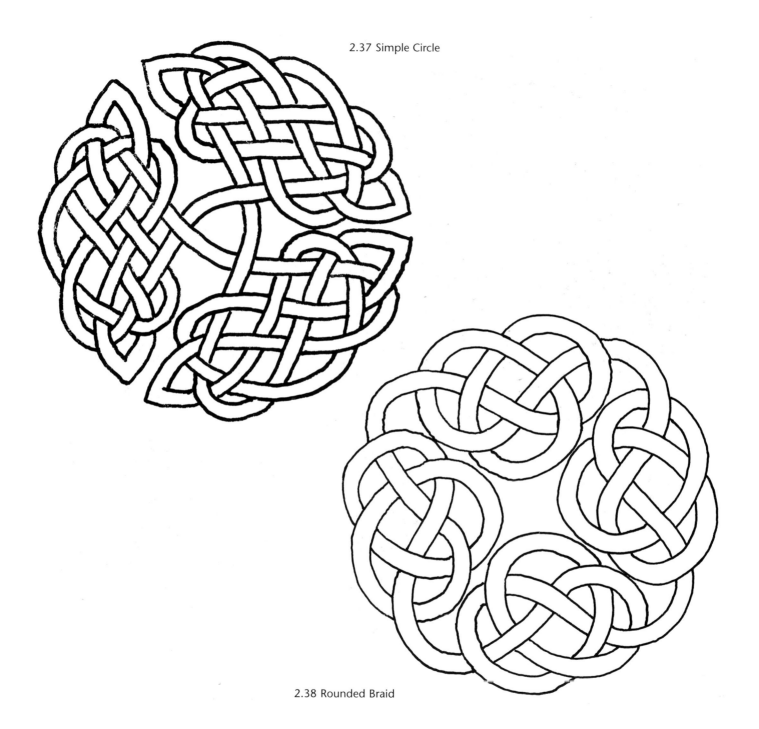

2.37 Simple Circle

2.38 Rounded Braid

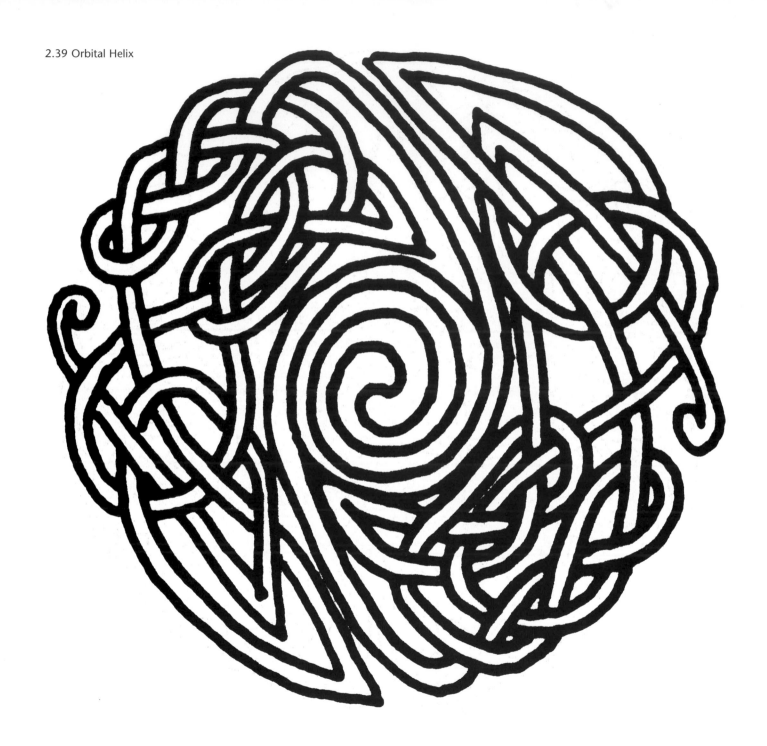

2.40 Unity

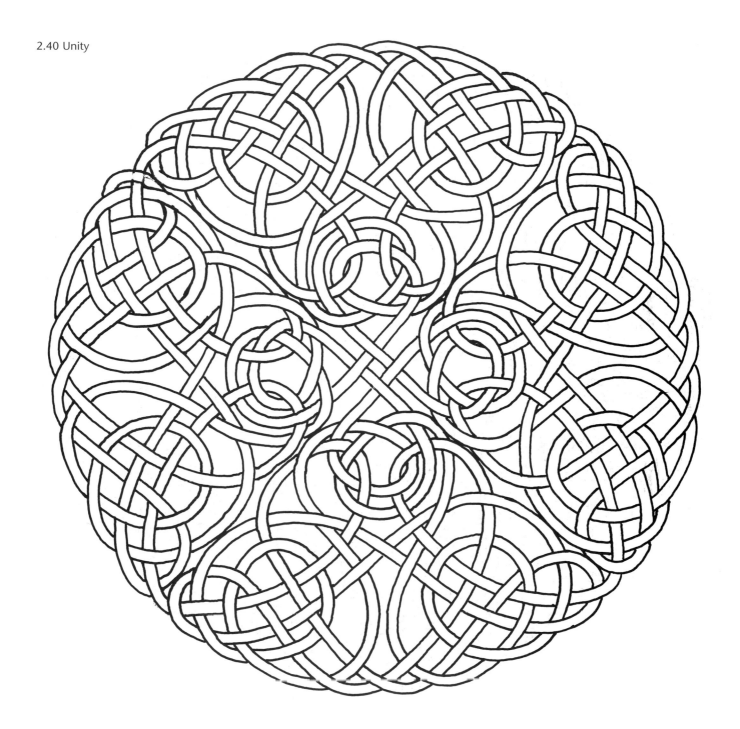

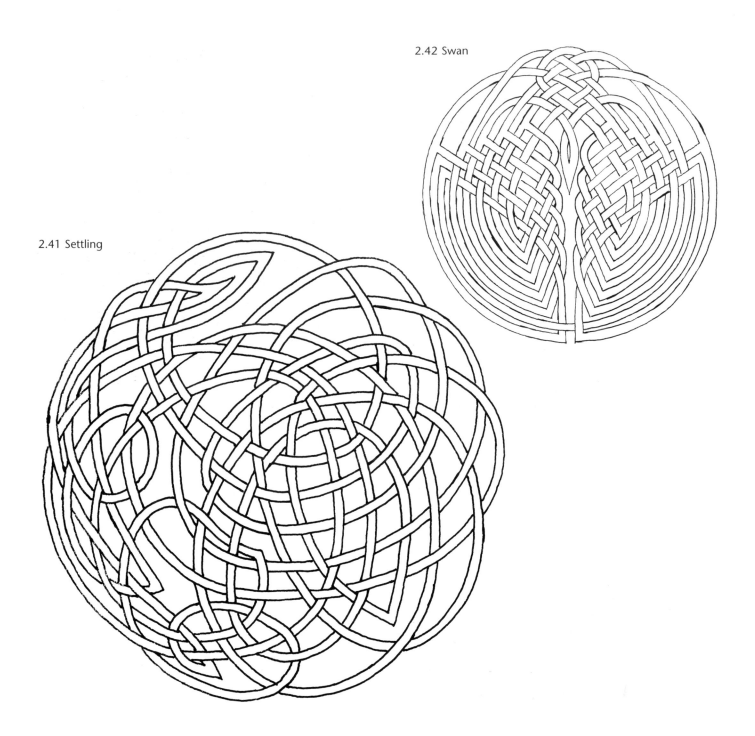

2.42 Swan

2.41 Settling

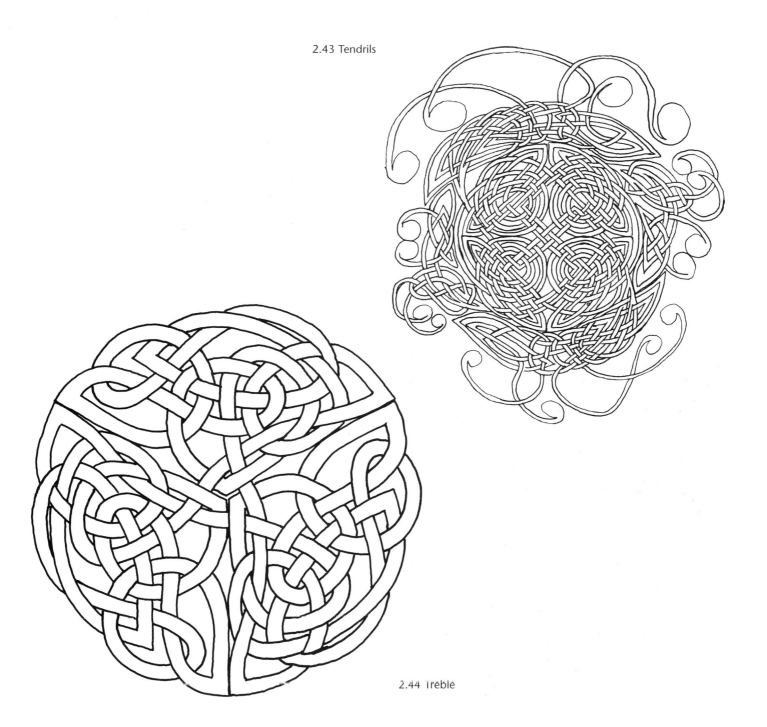

2.43 Tendrils

2.44 Treble

SMALLER-SCALE
PICTURE MOTIFS

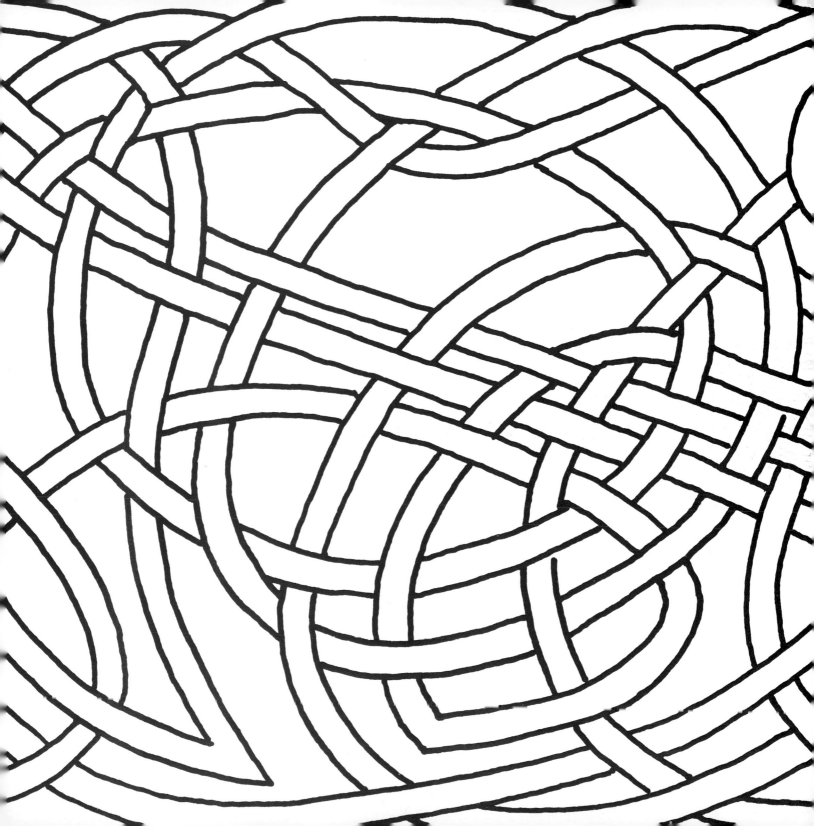

SMALLER-SCALE PICTURE MOTIFS

Larger designs contain numerous different elements, and show great intricacy, particularly when brought down to the size of this book. The small-scale motifs in this section are somewhat less intricate, but stand alone, creating a picture. Some feature a number of different elements, others contain just one design, which stands at its best on its own. In some ways, these are more pleasing to draw from start to finish than the larger designs because they can usually be started and finished in one day.

As mentioned in the introduction, I started out on some of these smaller-scale motifs with the intention of turning them into larger designs. These larger designs either never happened because I was happy with the motif as it developed, or I found I wanted to retain it on a smaller scale without adding more layers. This design process can be seen in 'Emblem' (page 82) – it consists of the central two circles of the classical Vesica Piscis symbol (also featured on page 67) and although it could have been expanded, I realised along the way that it worked best on its own.

Other motifs in this chapter started life as sections of much larger designs that I was not happy with in their entirety, but individual parts were worth salvaging. In some cases, different parts of different

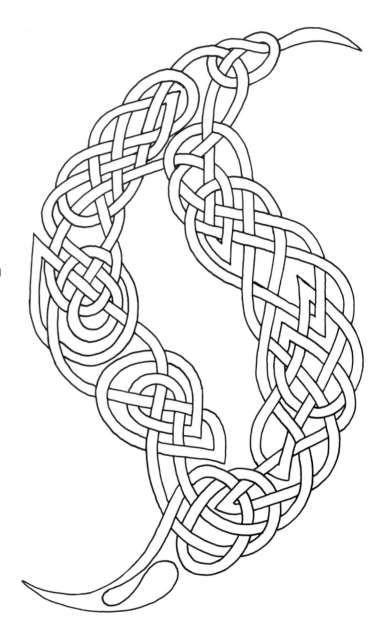

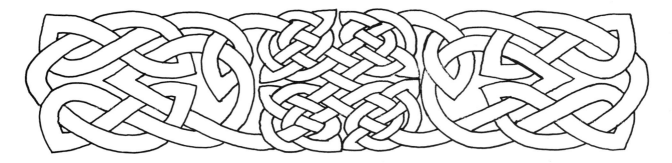

pieces were put together. An example is 'Amalgamation' (page 78), the name of which describes its origin – an amalgamation of four elements that were part of a never-completed larger design. The four elements, however, work well together due to their shared flowing nature.

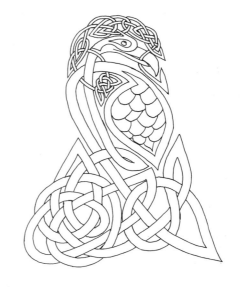

The final type of design in this category are those that are specific pictures in their own right, drawn as complete motifs. Many of them are designed to be used on T-shirts or postcards. I tend also to limit this type of image to the size and shape of the piece of paper I have available. An example of this would be 'Tribal' (page 88), which was intentionally drawn and limited by the dimensions of the A4-sized piece of paper I was using. The central S-shaped piece was the basic part and the circles at each end fit naturally within the curvature. The two wedding invitations (page 85) are an example of how a smaller-scale picture can be used for specific purposes. Both of these were hand-printed onto card using acrylic paint.

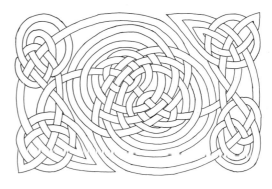

3.1 Amalgamation

✎ page 182

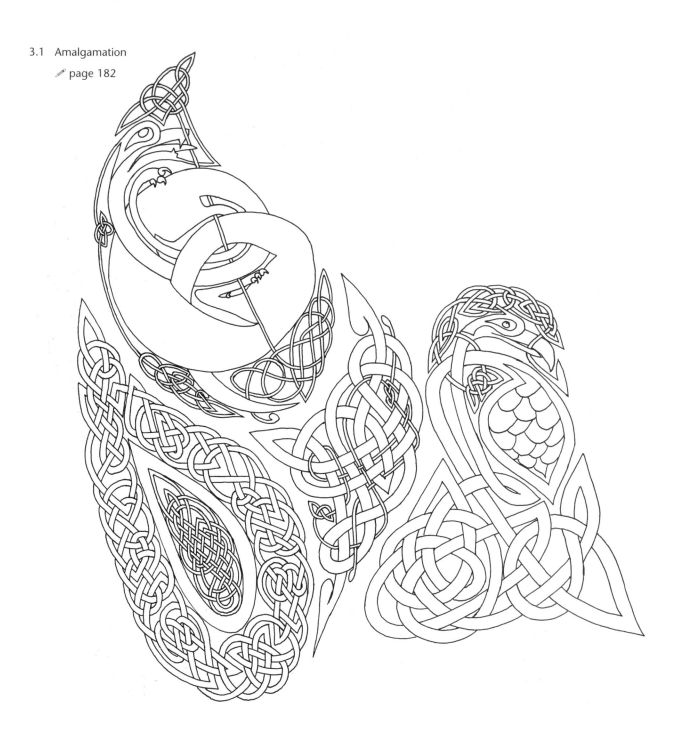

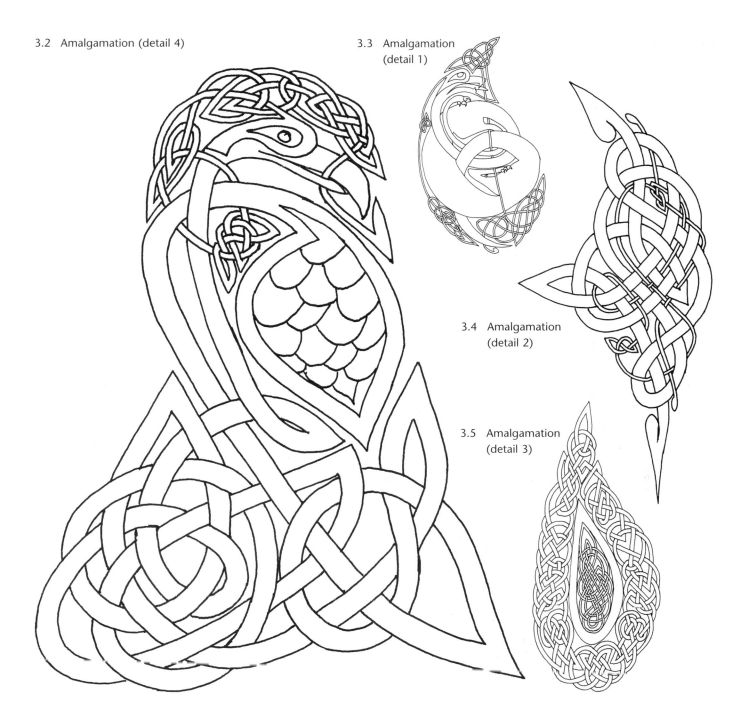

3.2 Amalgamation (detail 4)

3.3 Amalgamation
(detail 1)

3.4 Amalgamation
(detail 2)

3.5 Amalgamation
(detail 3)

3.6 Mark's Tattoo 1

✎ page 182

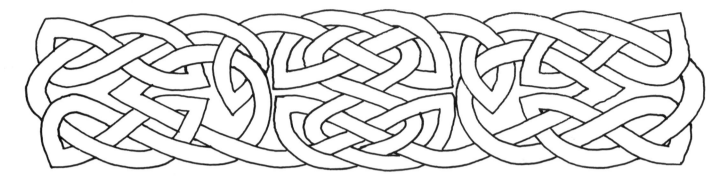

3.7 Mark's Tattoo 2

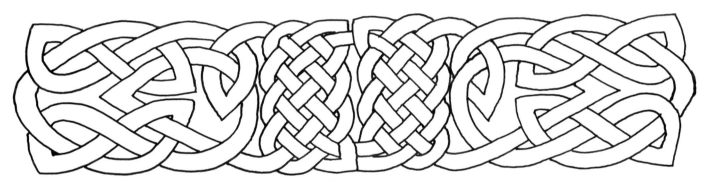

3.8 Mark's Tattoo 3

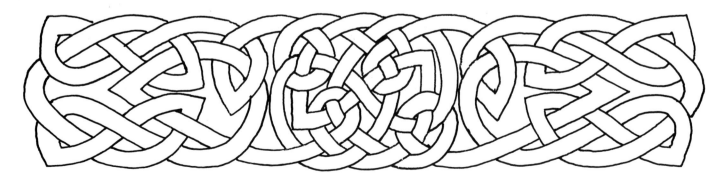

3.9 River Parrett Trail Logo

3.10 Mark's Tattoo 4

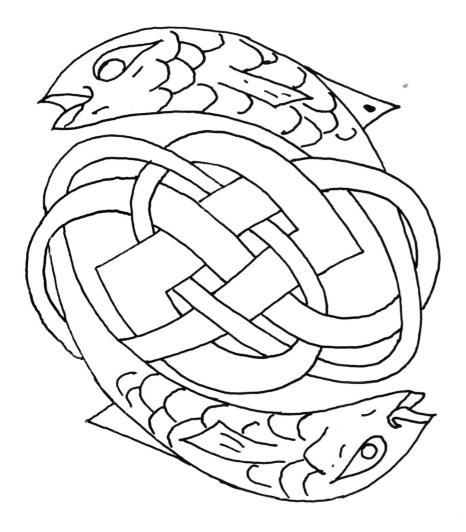

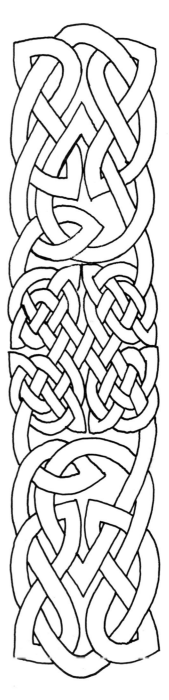

3.11 Emblem

page 182

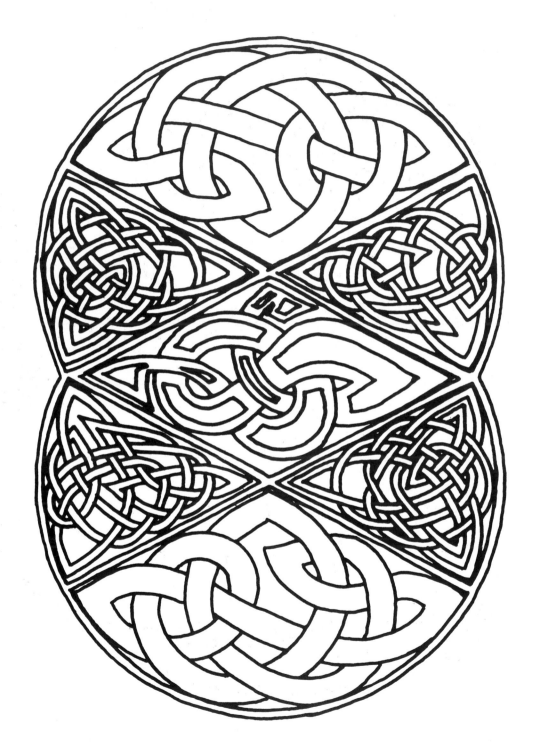

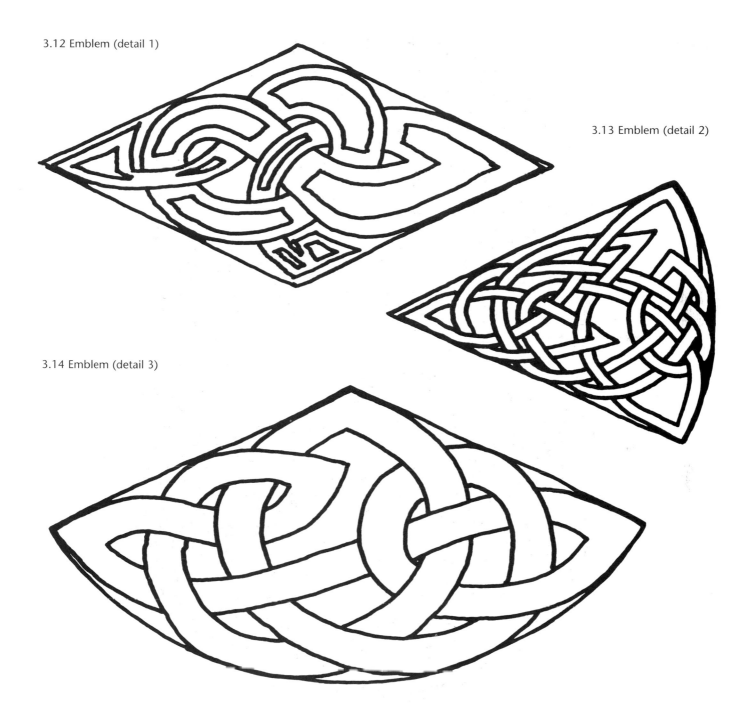

3.12 Emblem (detail 1)

3.13 Emblem (detail 2)

3.14 Emblem (detail 3)

3.15 Table Top

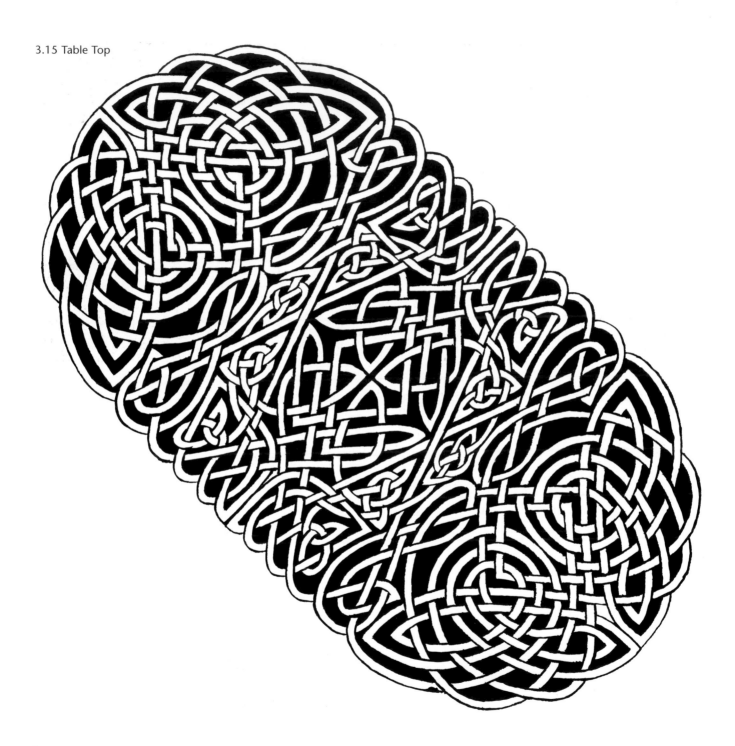

84 Smaller-Scale Picture Motifs

3.16 Wedding Invitation 1

3.17 Wedding Invitation 2

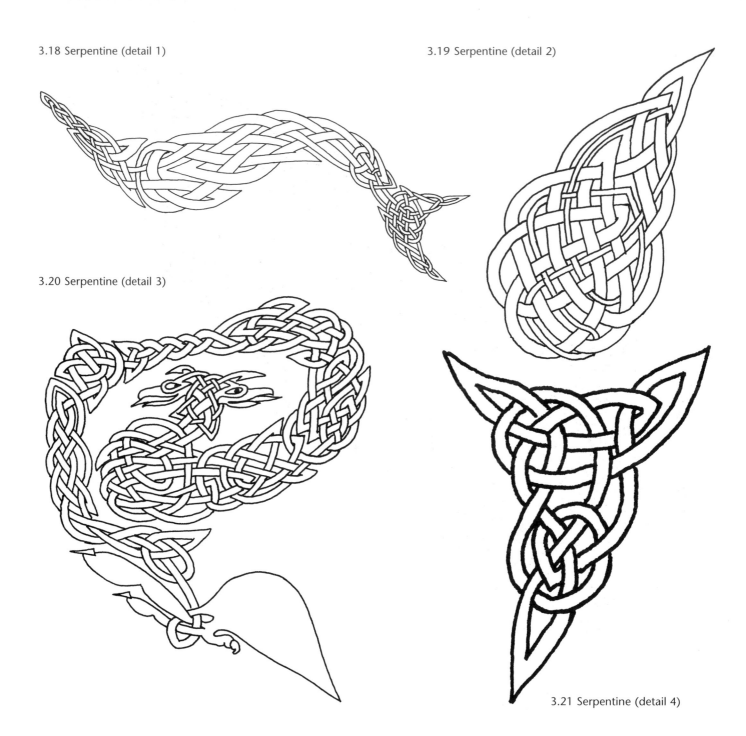

3.18 Serpentine (detail 1)

3.19 Serpentine (detail 2)

3.20 Serpentine (detail 3)

3.21 Serpentine (detail 4)

3.22 Serpentine

✏ page 182

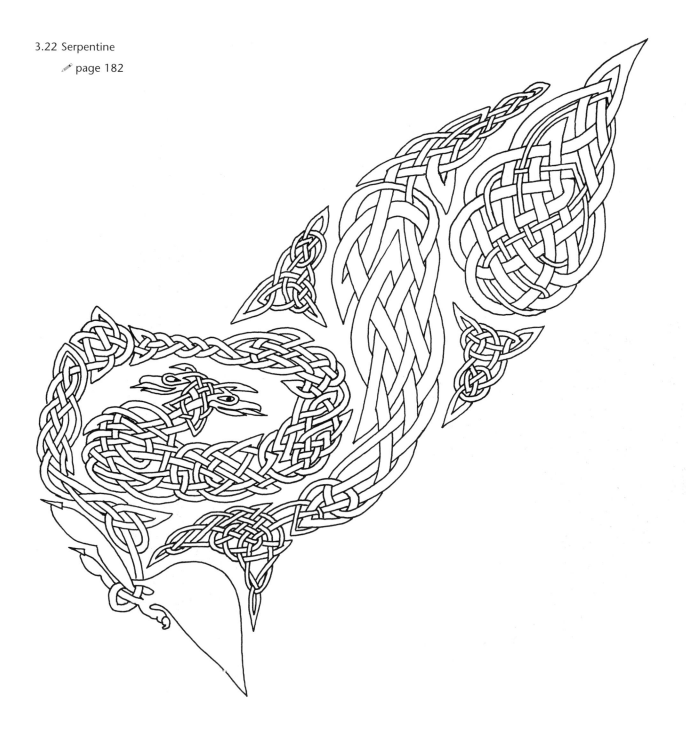

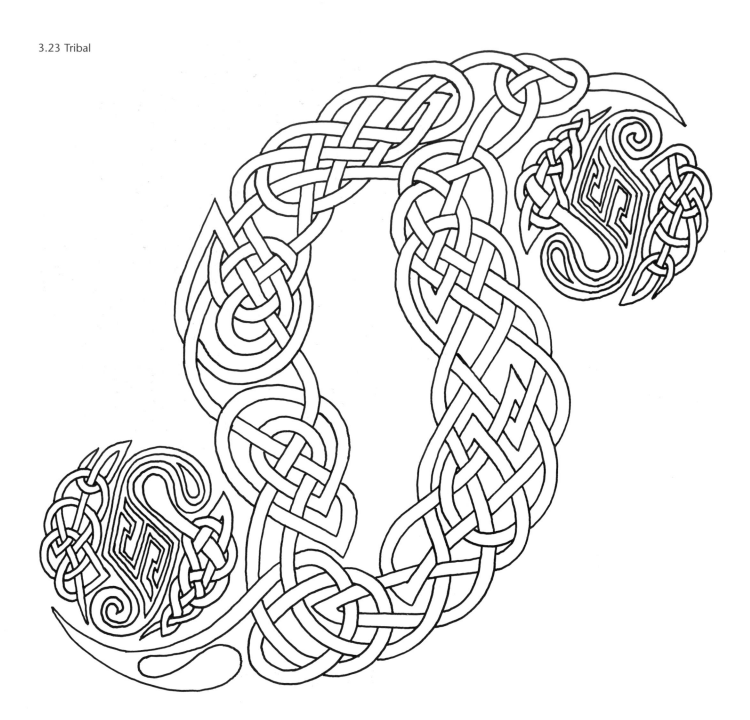

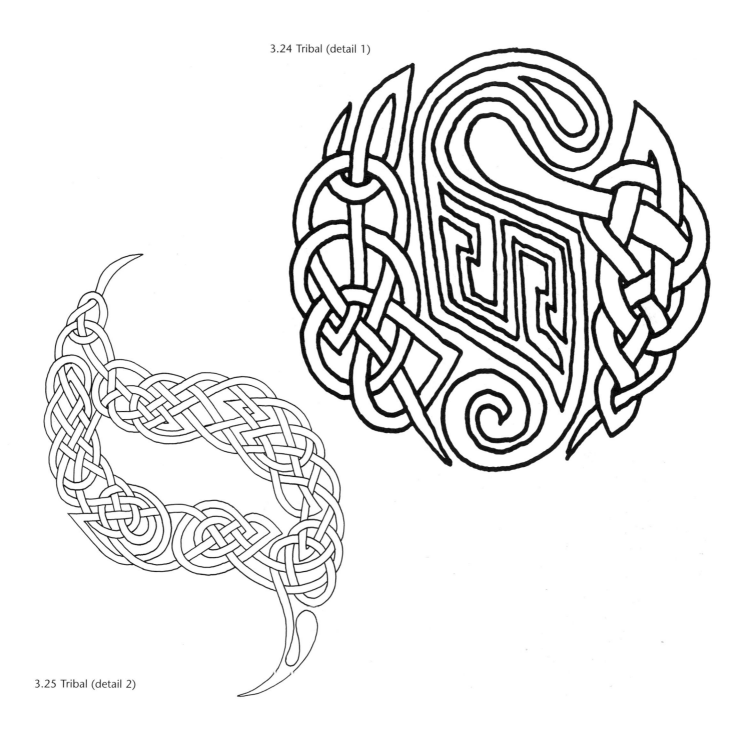

3.24 Tribal (detail 1)

3.25 Tribal (detail 2)

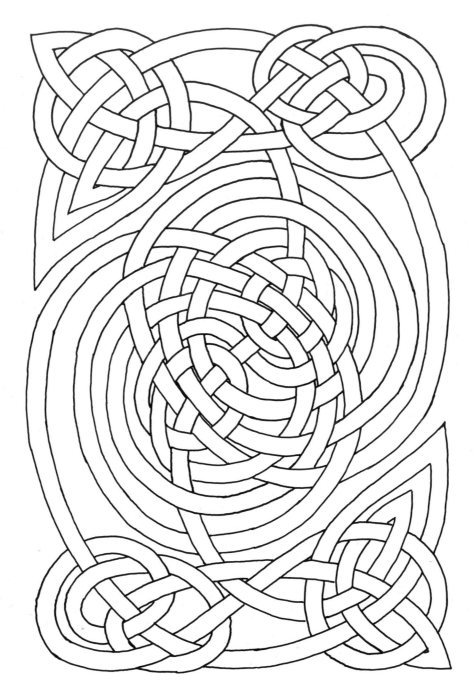

3.27 Nouveau Twist

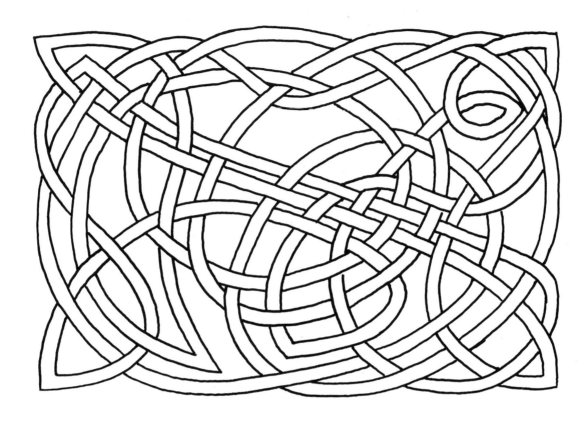

3.28 Double Blade

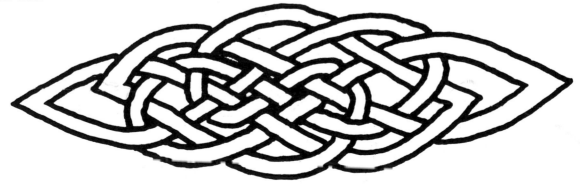

3.29 Tribal Crown (detail 1)

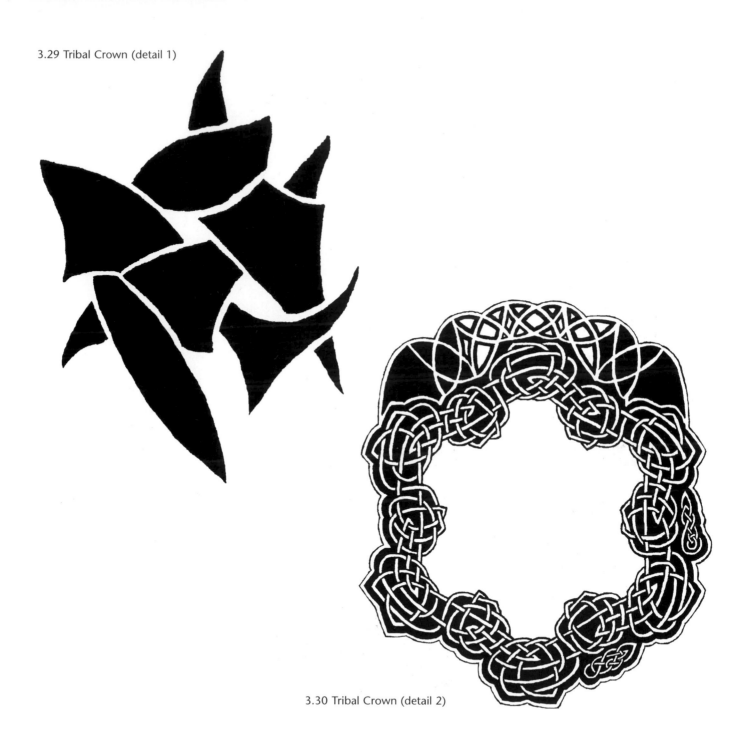

3.30 Tribal Crown (detail 2)

3.31 Tribal Crown

🖊 page 182

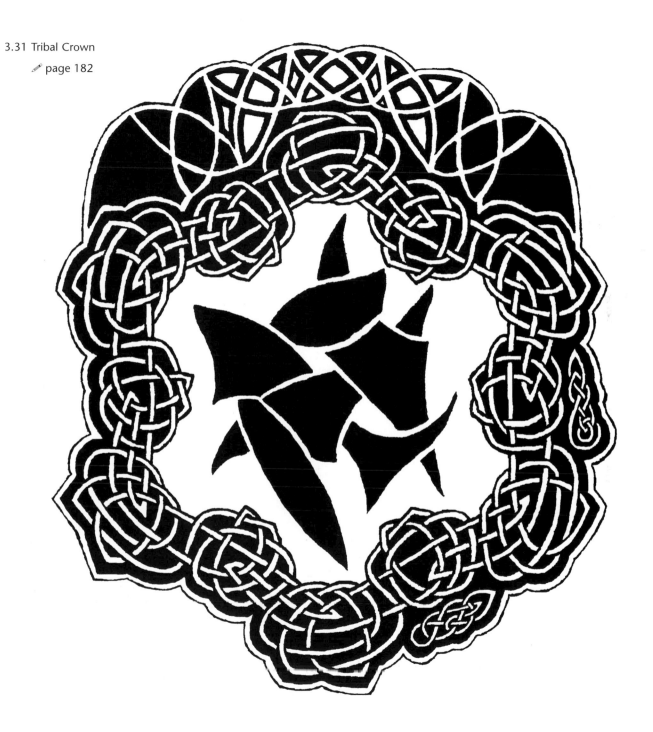

URBAN STYLE

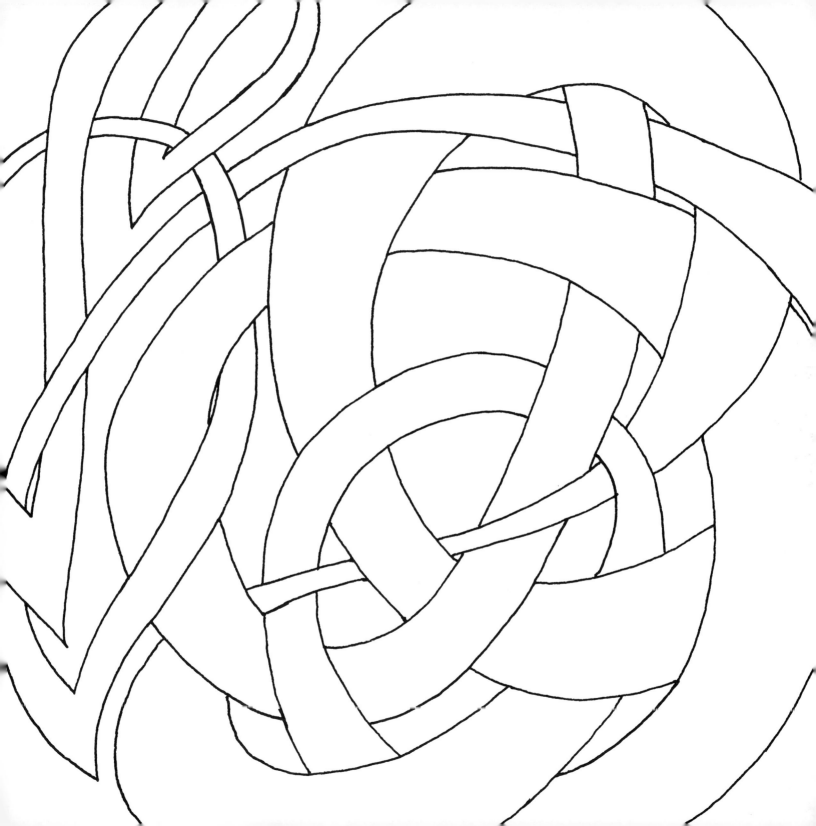

URBAN STYLE

This is the most recent style I have been experimenting with, and I was not sure what to call it. Adopting what I call the variable line width, it mixes the style of drawing used for animals and knotwork – the constant line is not bounded by a specific width. This is an extremely fluid approach but also a very modern one, and in some ways it reminds me of graffiti, especially stencilled graffiti – hence the name I have given it.

The urban style lends itself well to abstract freehand shapes. Although it can be used with a high degree of symmetry, it does not require an intentionally symmetrical approach. The more bulbous areas of the line highlight and accentuate curves, adding strongly to the sense of curvature in the designs.

The finished designs look quite simple and easily constructed. This is, however, a deceptively in-depth process, because to provide the feel of bulbous and changeable widths of the central line, constant consideration must given to how those changes affect the overall look of the motif. In addition, not working to a pre-set outline with this process means that the designer must have an idea of the final shape and ensure that the motif retains its original Celtic feel and structure.

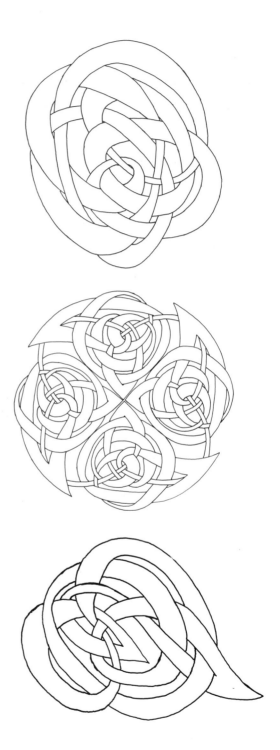

These designs are hugely enjoyable to draw, however, and the changeable width of the lines gives a very tactile, chunky feel to the resulting motif. Curves and circles are accentuated by thickening lines, a technique shown to its greatest effect in 'Eccentric Orbit' (page 103) and 'Rewind' (page 110), although it may be seen throughout this chapter.

The urban style is one I have recently been developing further and continue to experiment with. Although it does suit itself very well to freehand shapes, it can also be used very strikingly with symmetry, as can be seen in Katharine Wheel (page 105), in which the changing central width of the line adds a sense of movement to the entire motif.

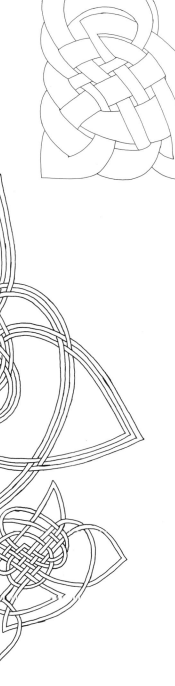

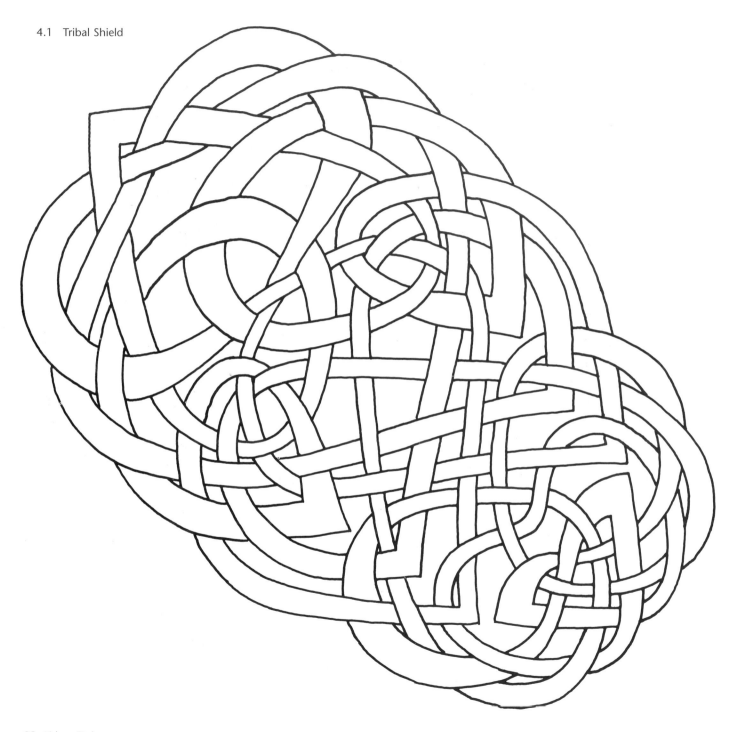

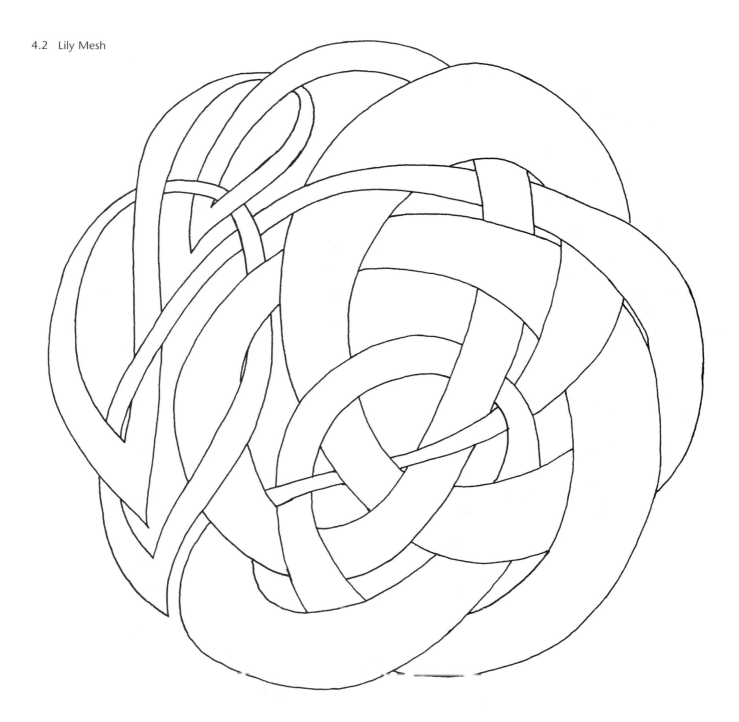

4.3 Reflection

✎ page 183

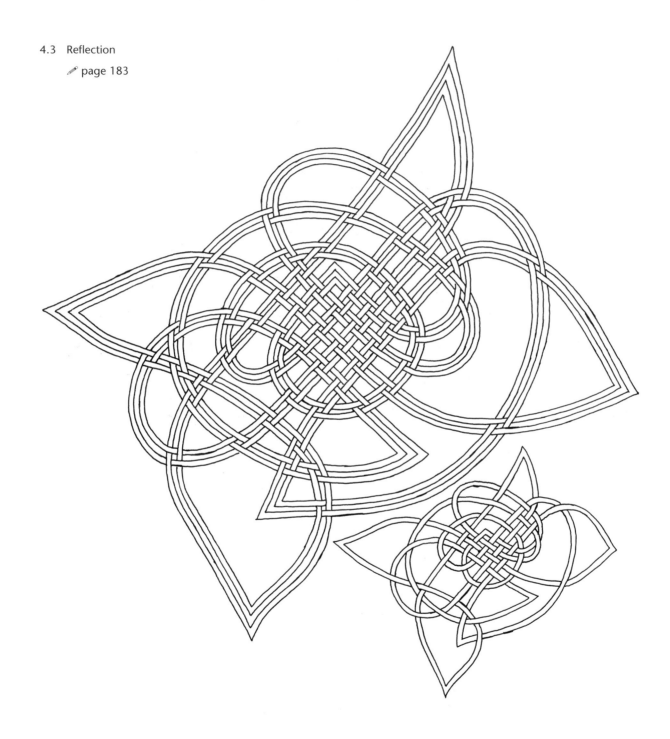

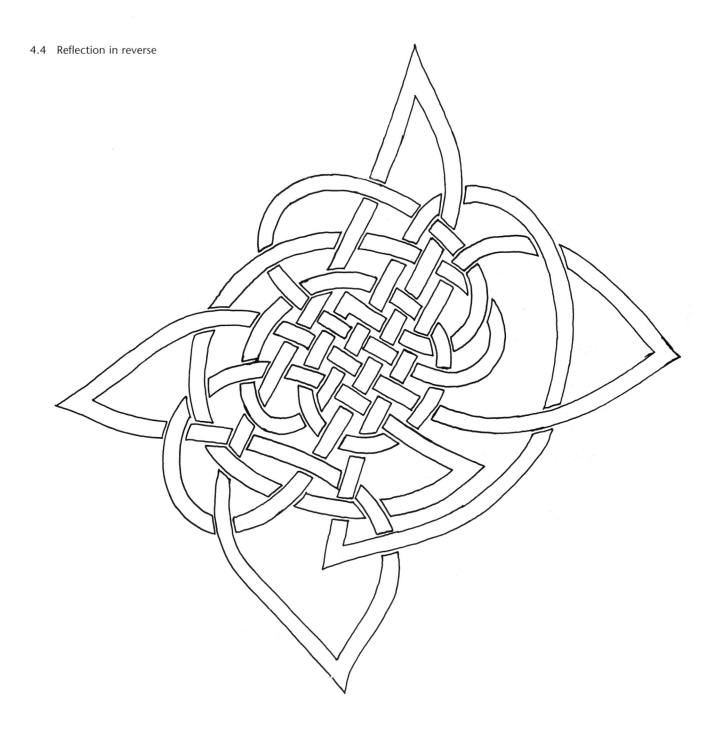

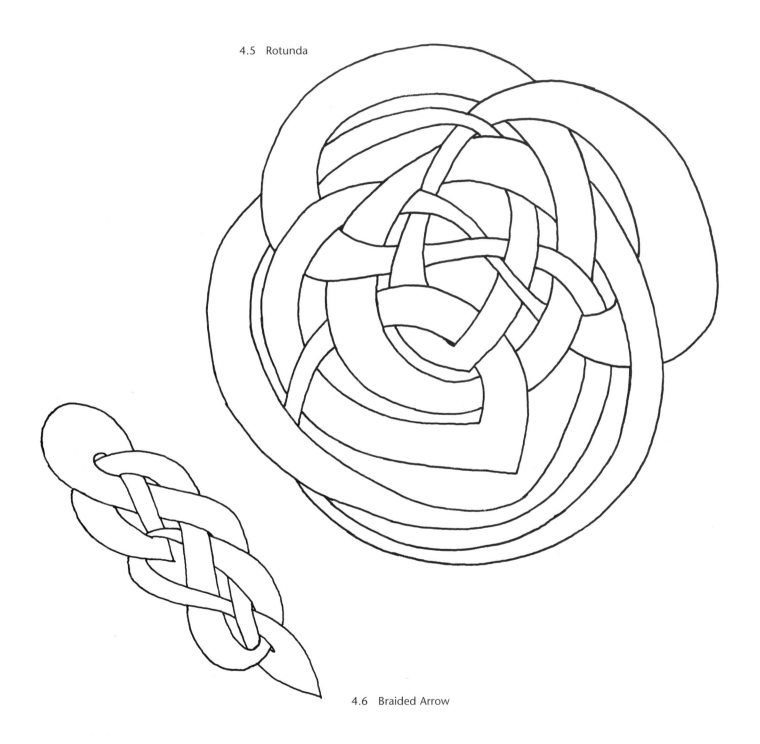

4.5 Rotunda

4.6 Braided Arrow

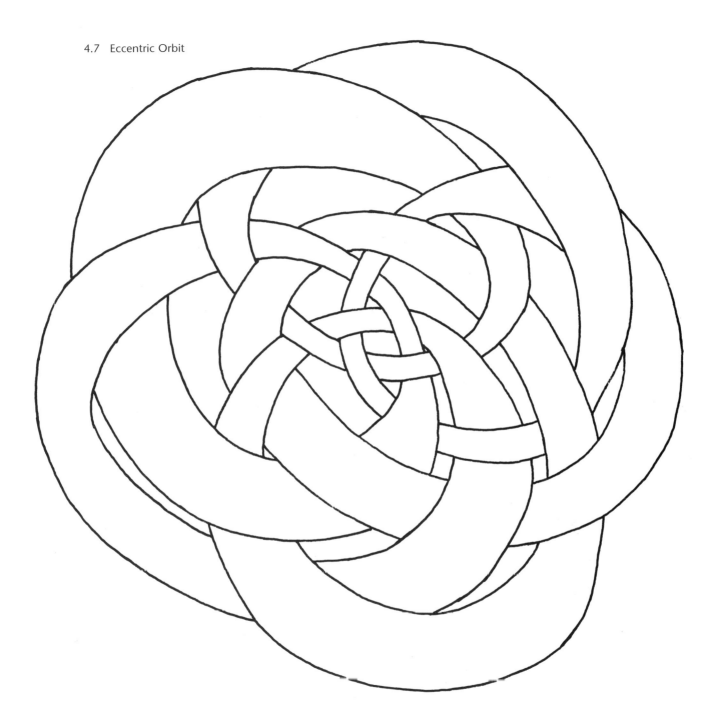

4.8 Bulbous Tangle

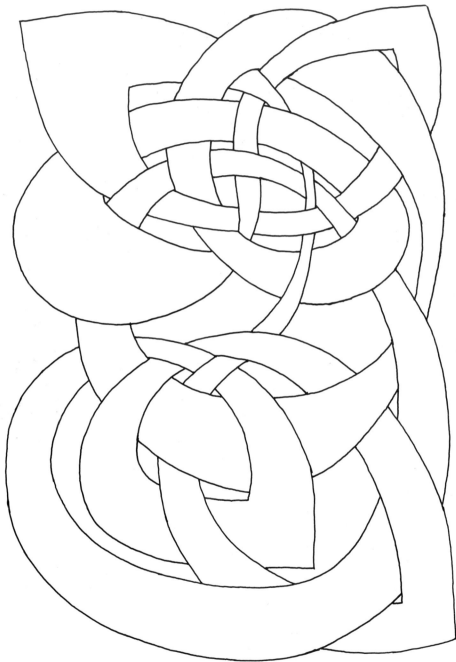

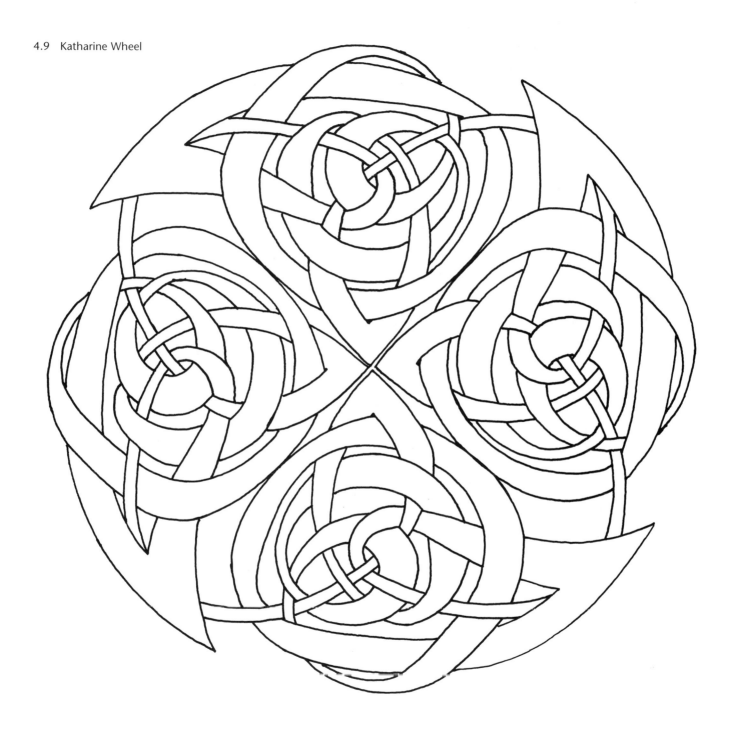

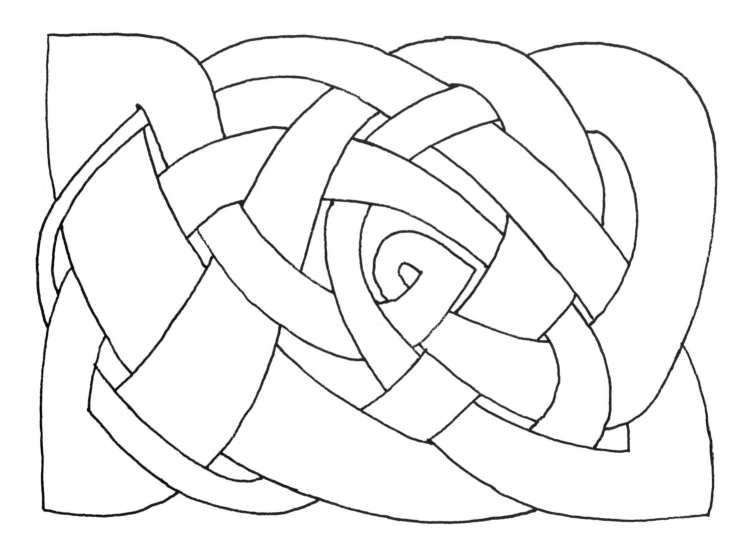

4.10 Celtic Postcard

4.11 Sound Waves

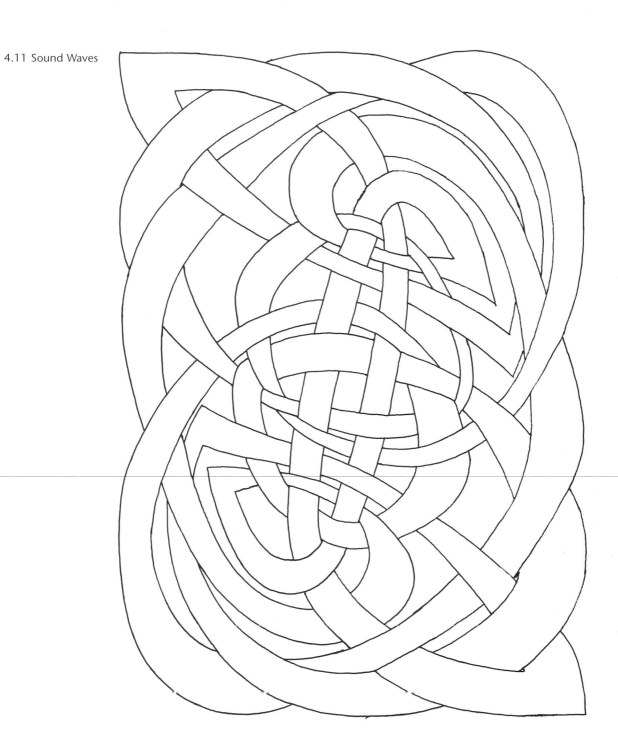

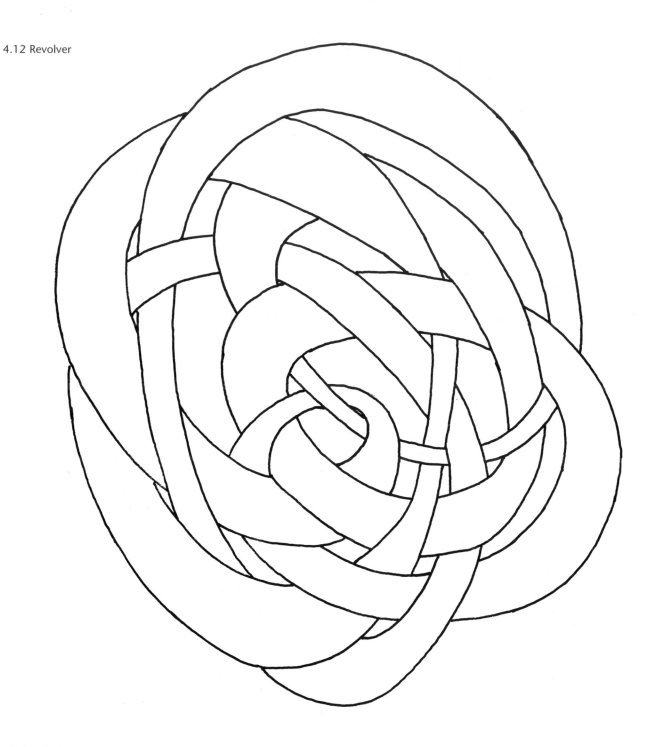

4.13 Writhe

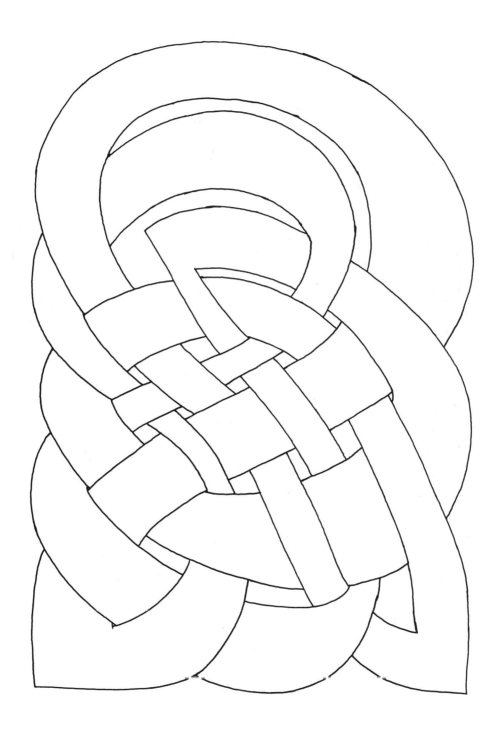

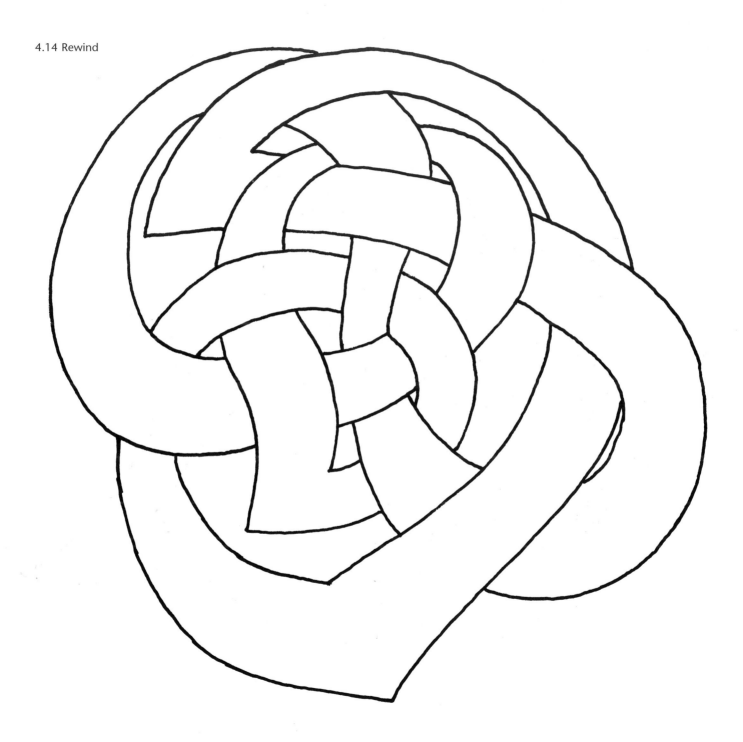

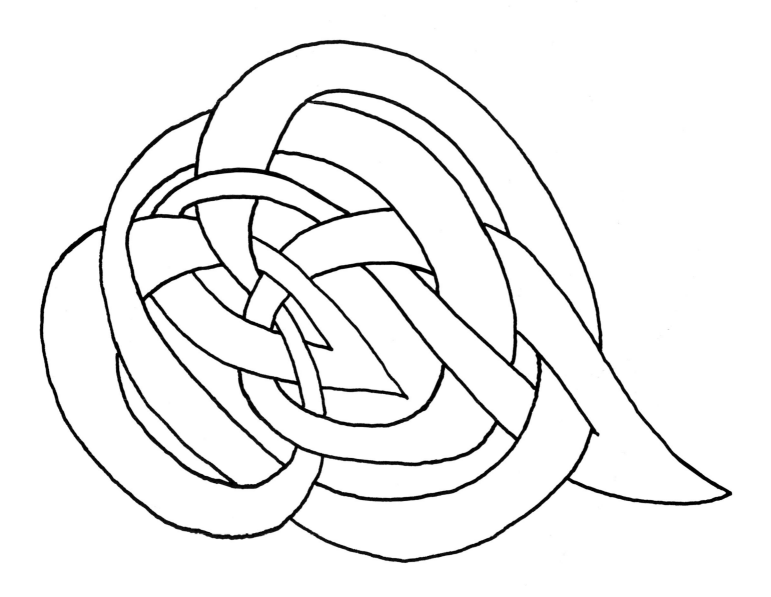

FREEHAND MOTIFS

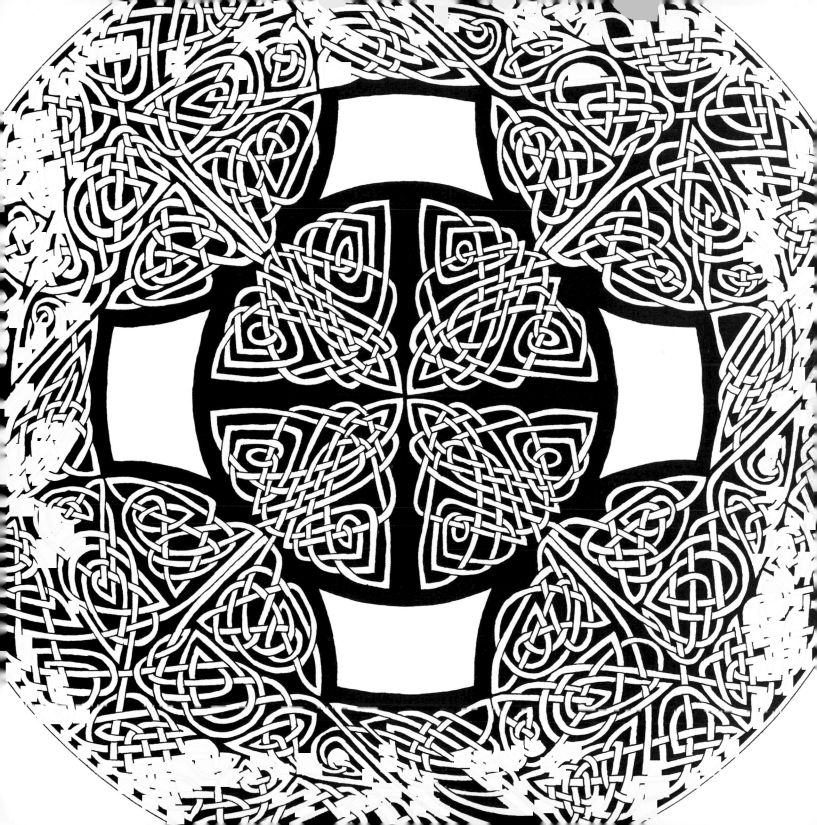

FREEHAND MOTIFS

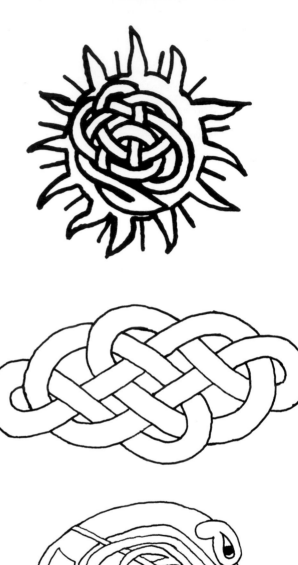

This is the largest section of the book and covers the broadest range of motif styles. It encompasses most of the larger motifs I have created – that is, large designs incorporating many different elements – as well as smaller stand-alone motifs that range from the simple to the more complex.

The smaller individual pieces vary in purpose and origin. Some were intended to be used as composite sections within larger motifs, but were either not used because the larger motifs were aborted or were experiments, eventually replaced by other pieces. Some smaller motifs were intended just to be a smaller decorative item. Many of the smaller knots were created for this purpose – individual motifs completed solely as single pieces.

Although many of the larger designs are symmetrical and the overall shape is not abstract, I have included them in this section. In part, this is because they contain many abstract elements. It is true that most of the larger, complete motifs were created with the help of a template, but once an outline has been established, it can, of course, be divided into smaller shapes to fill with linework tessellation or animal work. These smaller, individual shapes need not be pre-ordained or predictable.

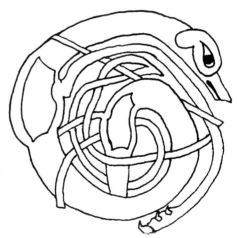

Abstract shapes obviously offer more variations than circles, though circles can be filled in a myriad of ways. Abstract shapes are even more liberating since their outlines are not fixed, meaning that designs can be carried across them. The abstract nature of this type of design also allows the opportunity for expression, and the outline that a designer uses enhances the interior design. The result is a broad range of designs and motifs, showing the full freedom of Celtic expression. It is, however, useful to remember that these designs need to remain Celtic in appearance.

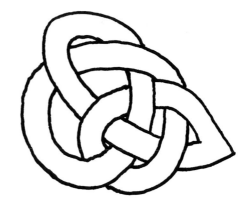

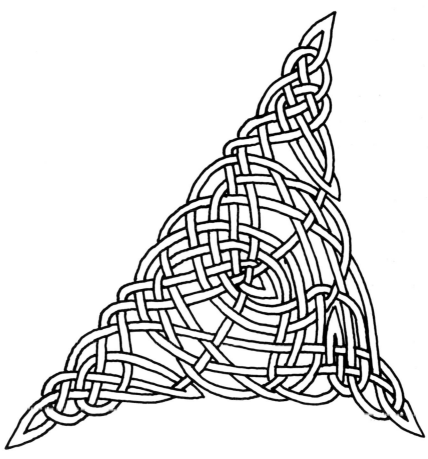

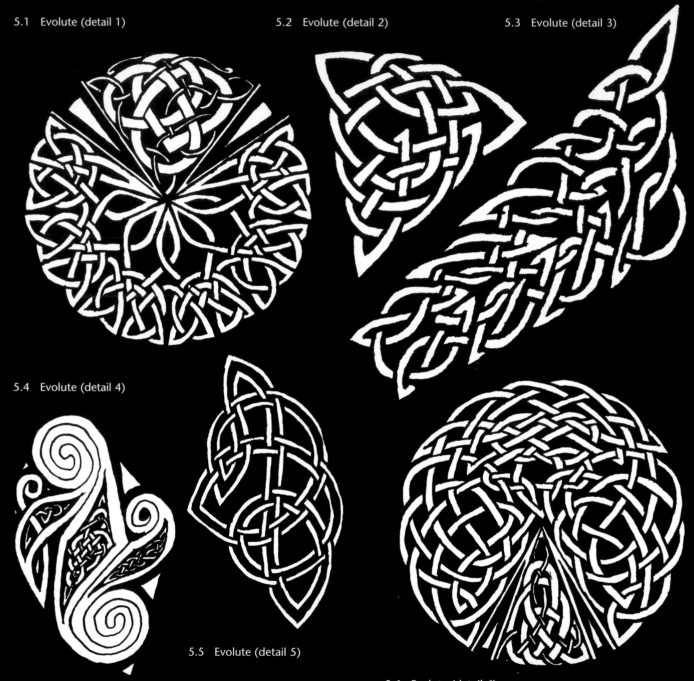

5.1 Evolute (detail 1)

5.2 Evolute (detail 2)

5.3 Evolute (detail 3)

5.4 Evolute (detail 4)

5.5 Evolute (detail 5)

5.6 Evolute (detail 6)

5.7 Evolute

◆ page 167

✎ page 184

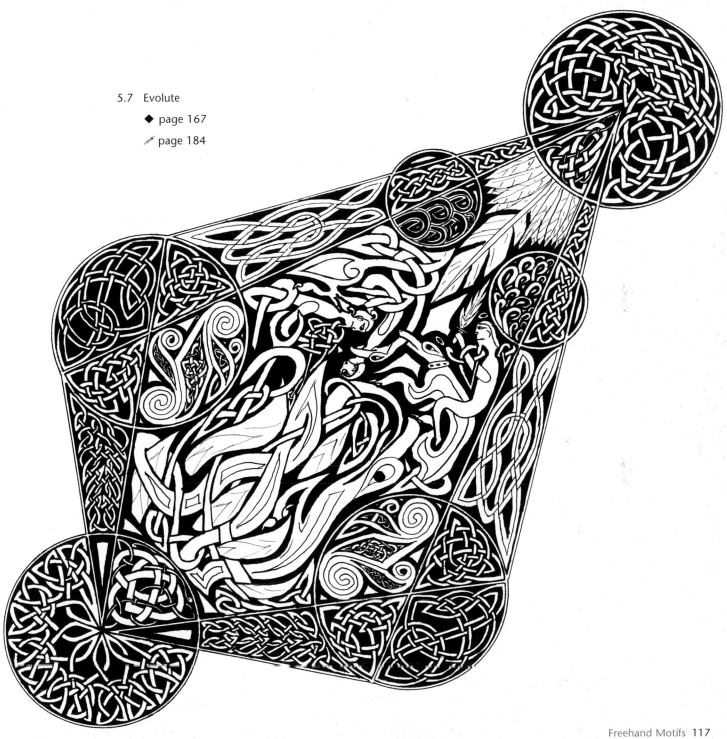

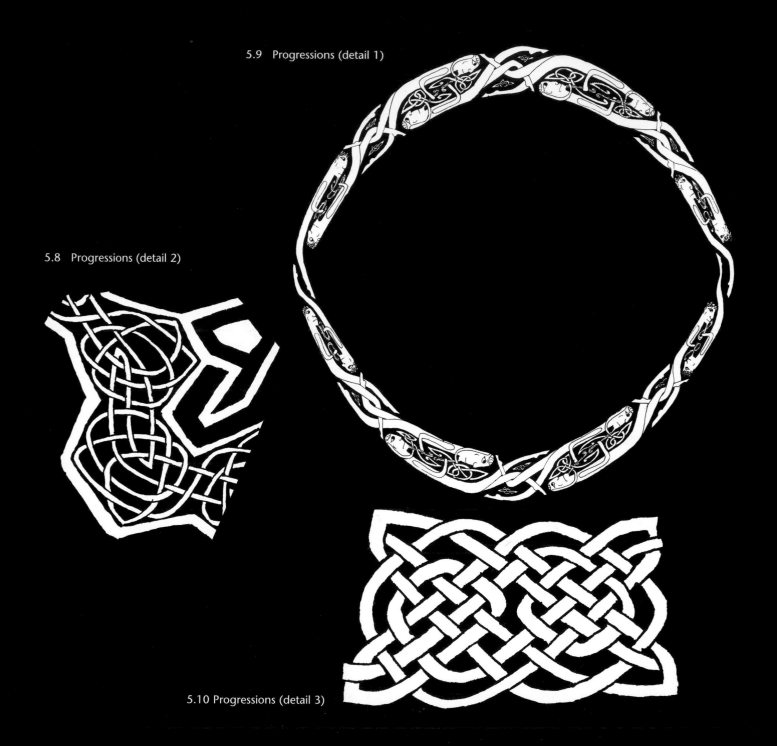

5.9 Progressions (detail 1)

5.8 Progressions (detail 2)

5.10 Progressions (detail 3)

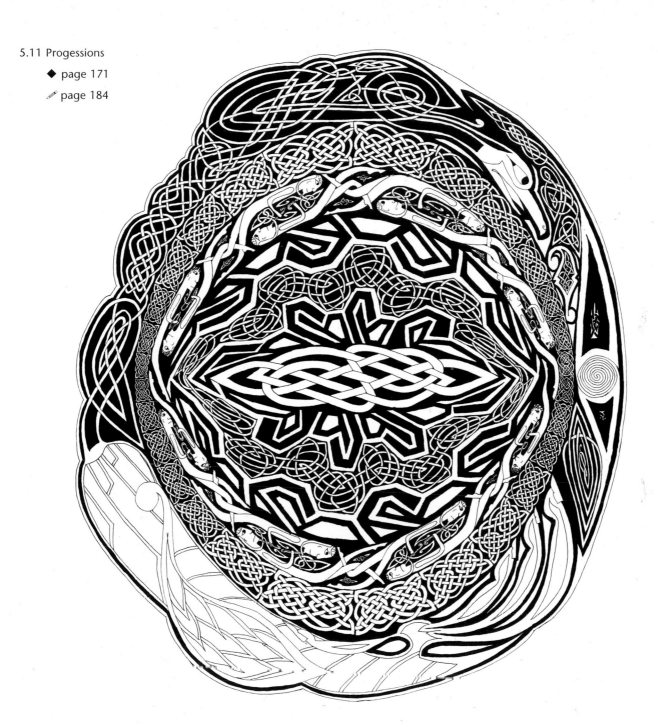

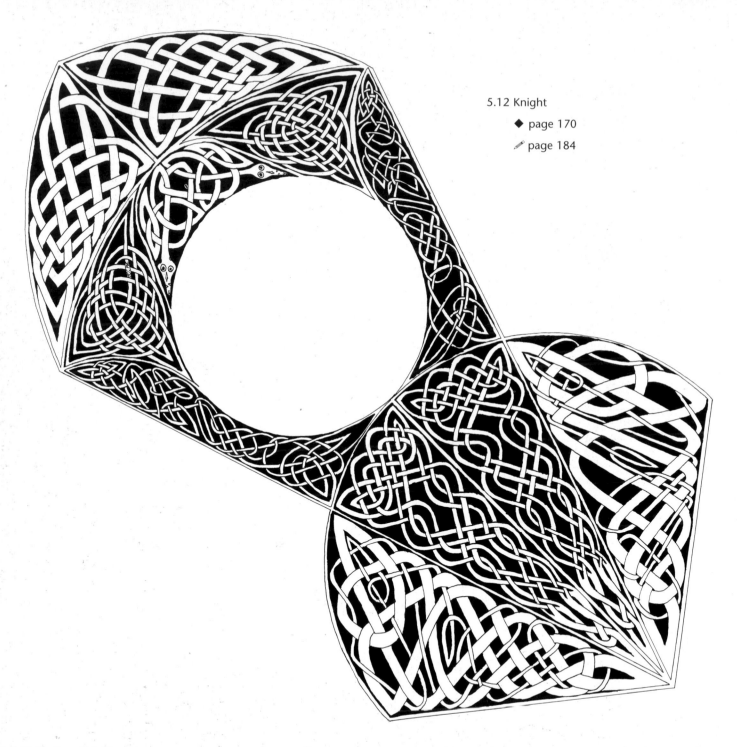

5.12 Knight

◆ page 170

✎ page 184

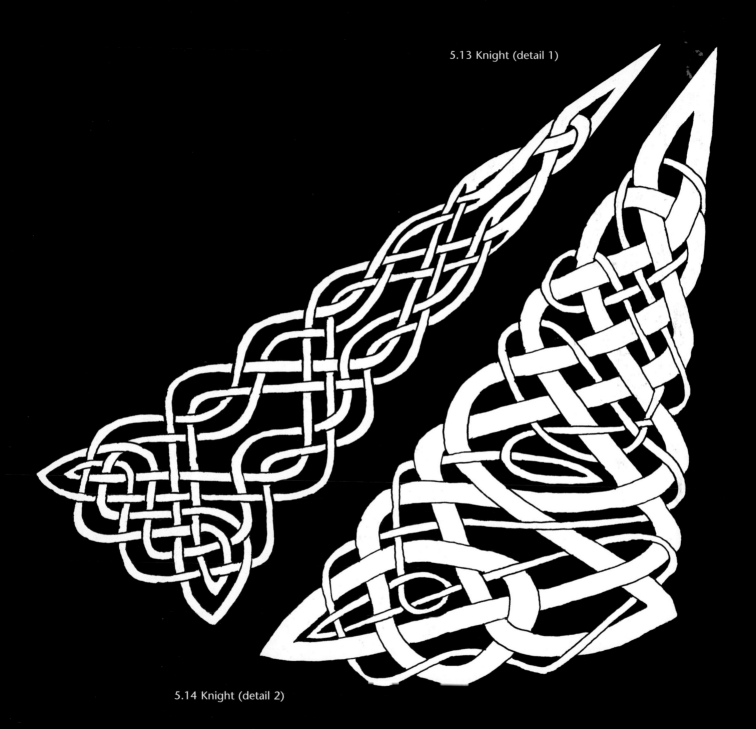

5.13 Knight (detail 1)

5.14 Knight (detail 2)

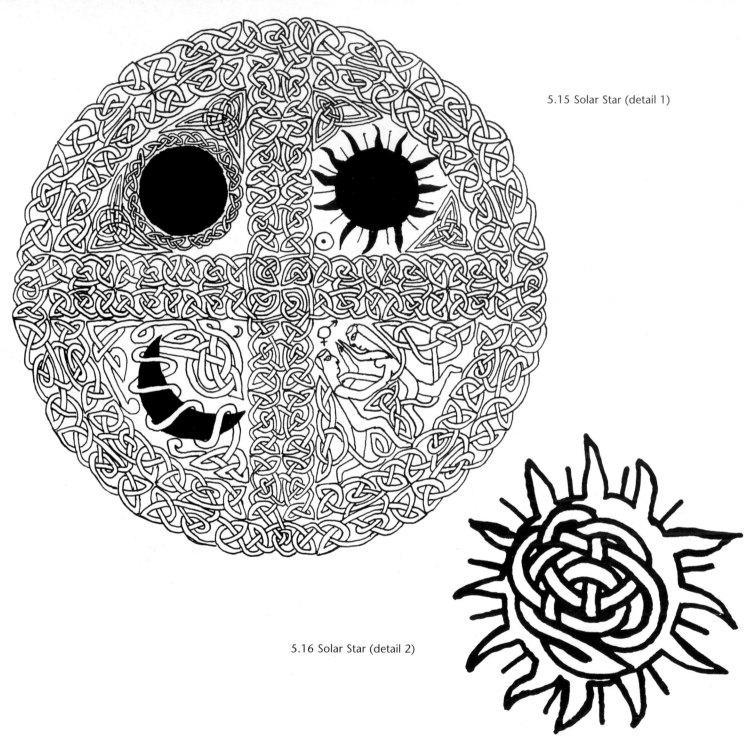

5.15 Solar Star (detail 1)

5.16 Solar Star (detail 2)

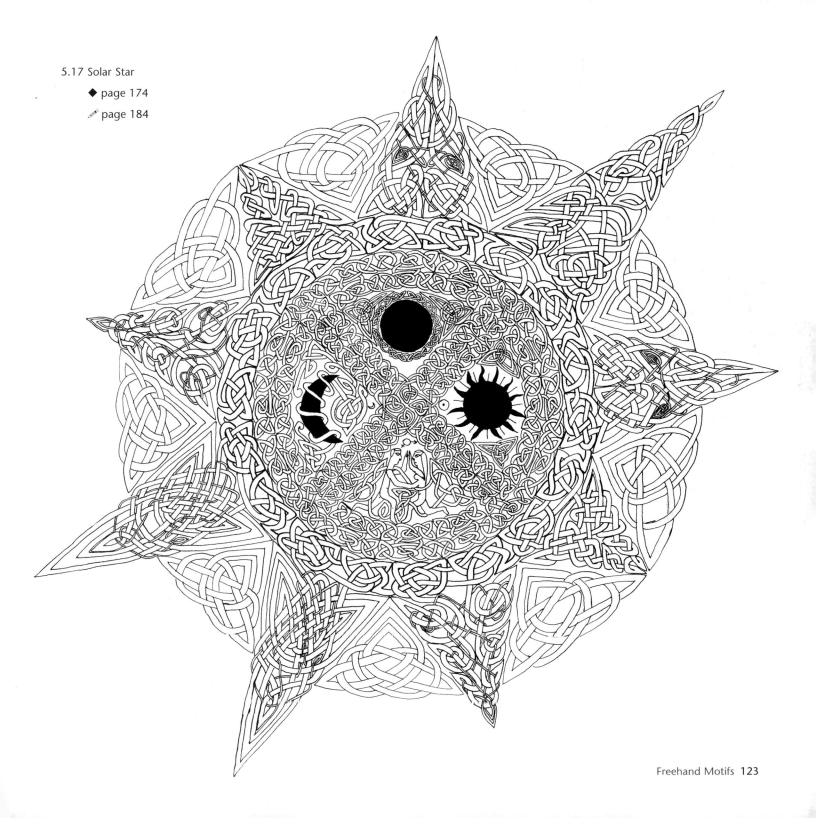

5.17 Solar Star

◆ page 174

🖊 page 184

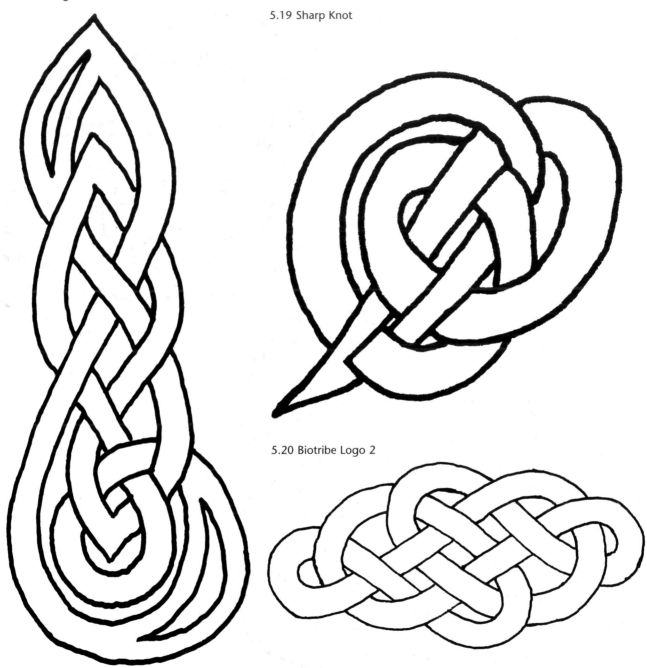

5.18 Biotribe Logo 1

5.19 Sharp Knot

5.20 Biotribe Logo 2

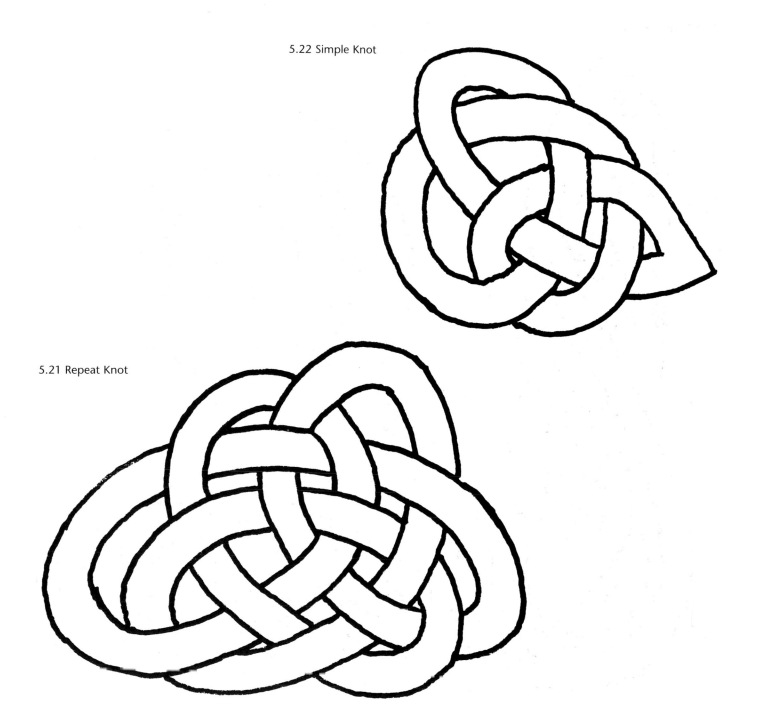

5.22 Simple Knot

5.21 Repeat Knot

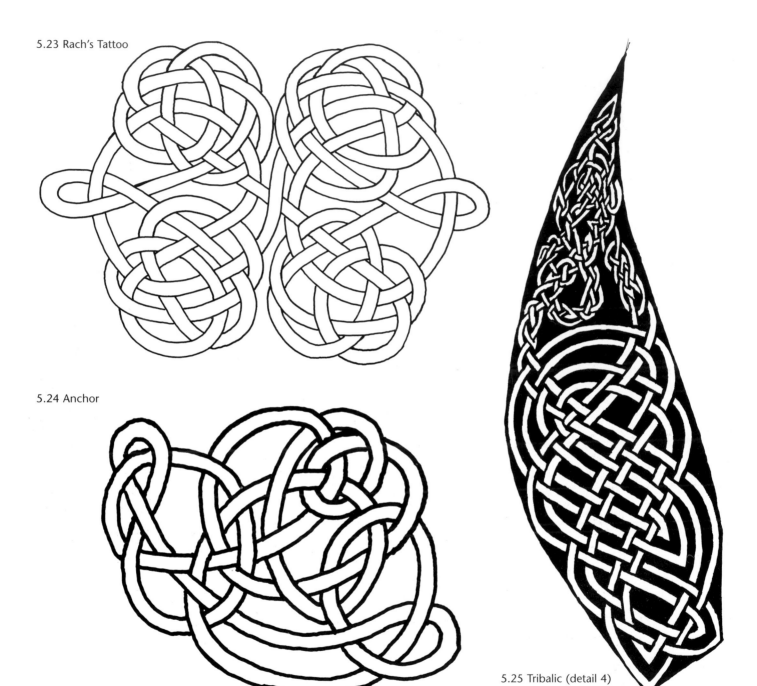

5.23 Rach's Tattoo

5.24 Anchor

5.25 Tribalic (detail 4)

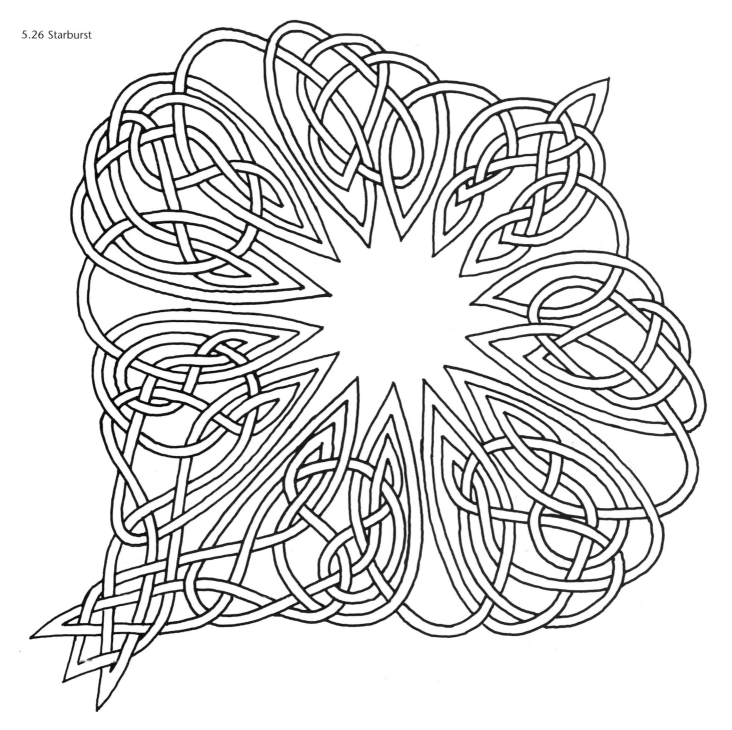

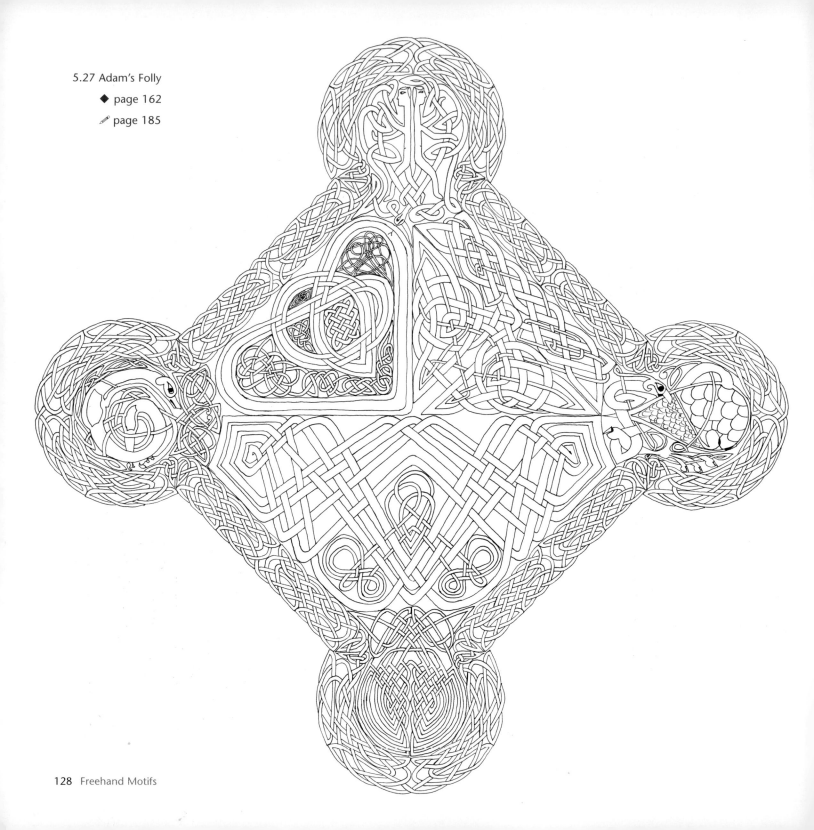

5.27 Adam's Folly

◆ page 162

✎ page 185

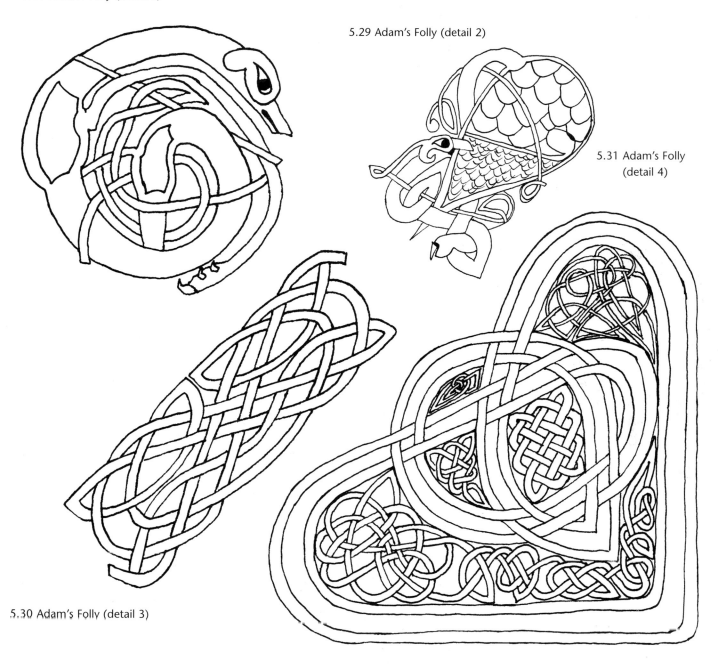

5.28 Adam's Folly (detail 1)

5.29 Adam's Folly (detail 2)

5.31 Adam's Folly (detail 4)

5.30 Adam's Folly (detail 3)

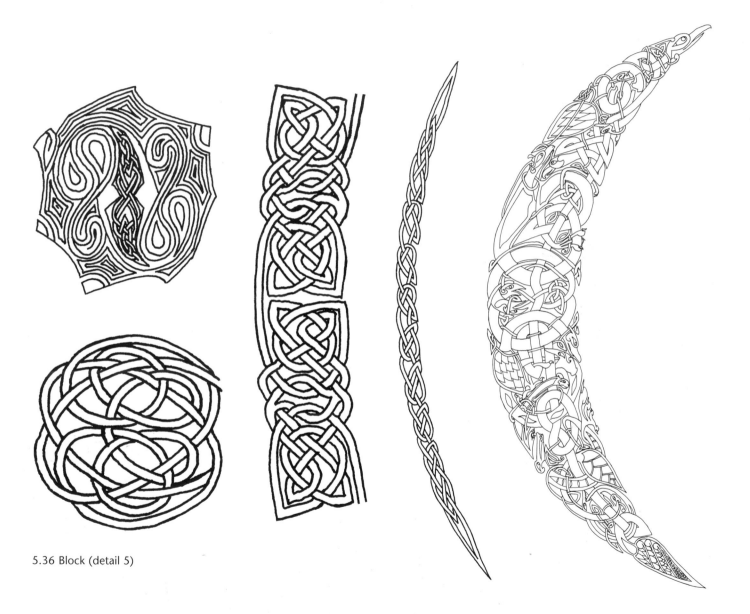

5.32 Block (detail 1) 5.33 Block (detail 2) 5.34 Block (detail 3) 5.35 Block (detail 4)

5.36 Block (detail 5)

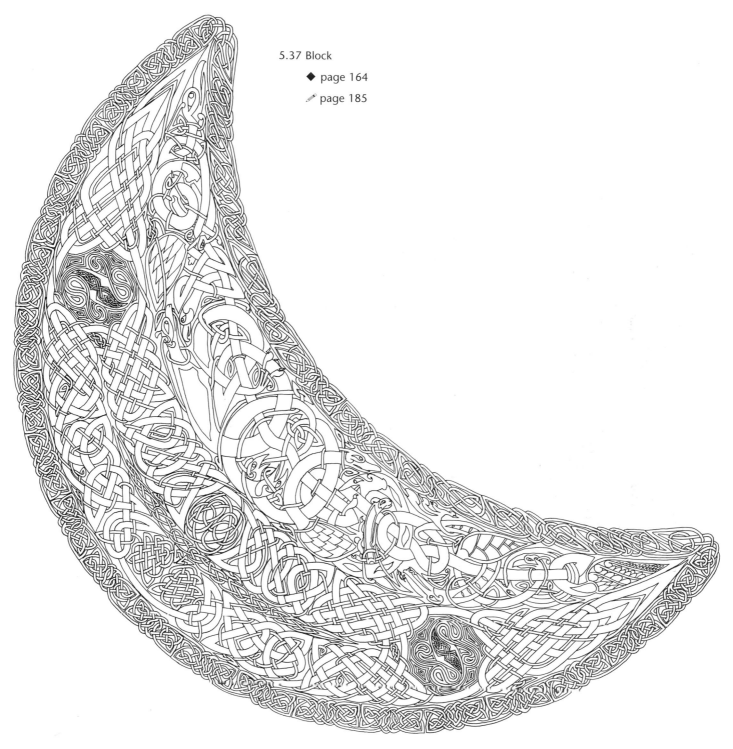

5.37 Block

◆ page 164

✎ page 185

5.38 Rise (detail 1)

5.39 Rise (detail 2)

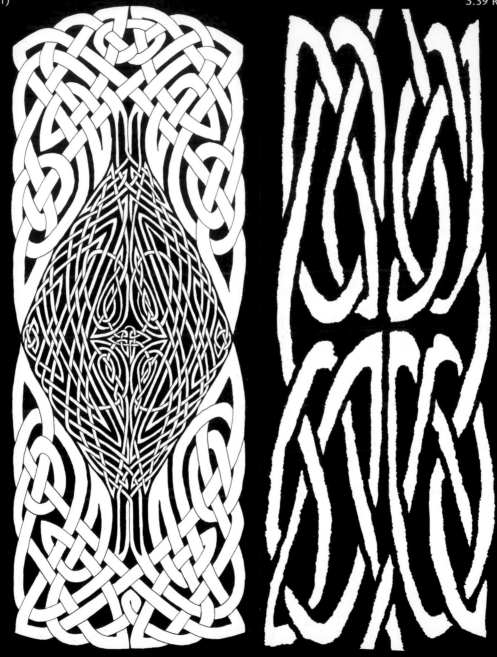

5.40 Rise

◆ page 173

✎ page 185

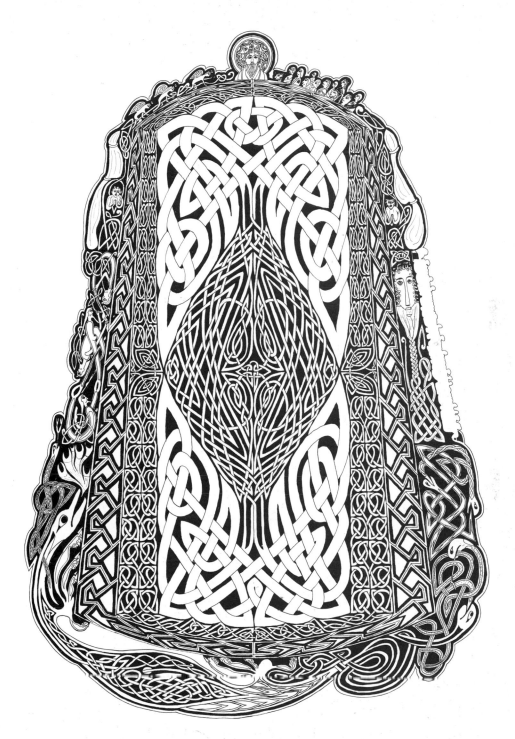

5.41 Believe

✏ page 186

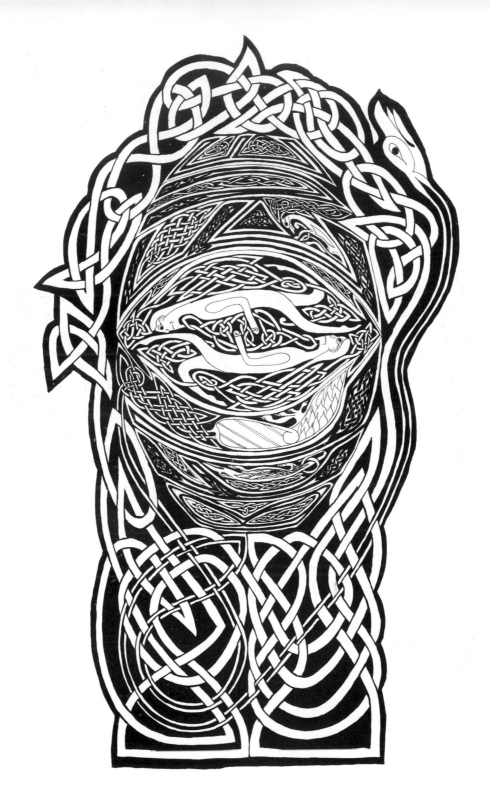

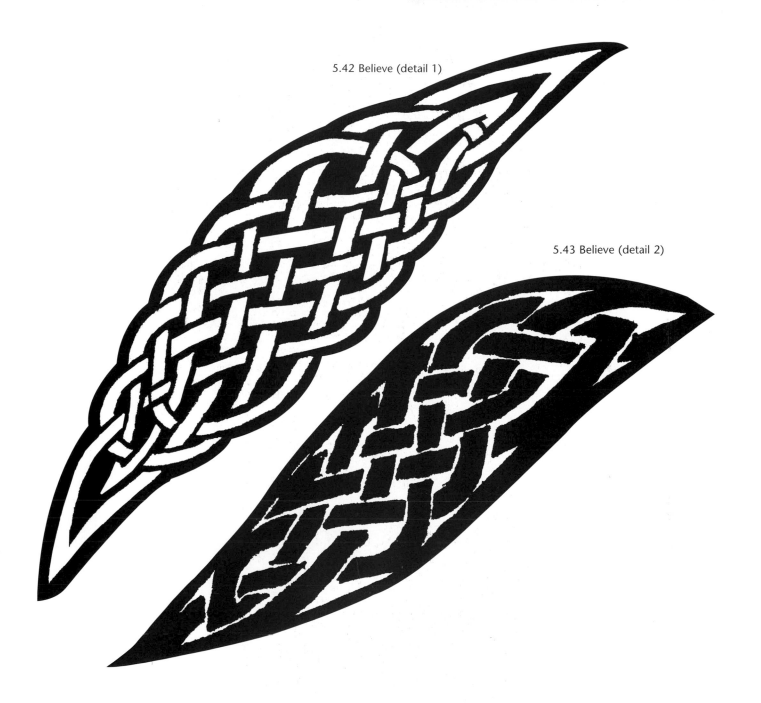

5.42 Believe (detail 1)

5.43 Believe (detail 2)

5.44 Rounded Triangle 1

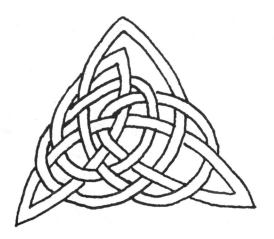

5.45 Rounded Triangle 2

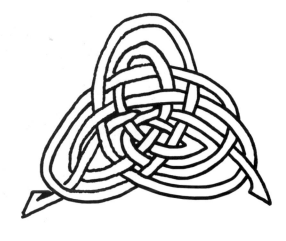

5.46 Rounded Triangle 3

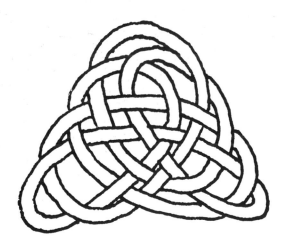

5.47 Rounded Triangle 4

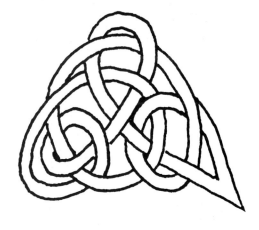

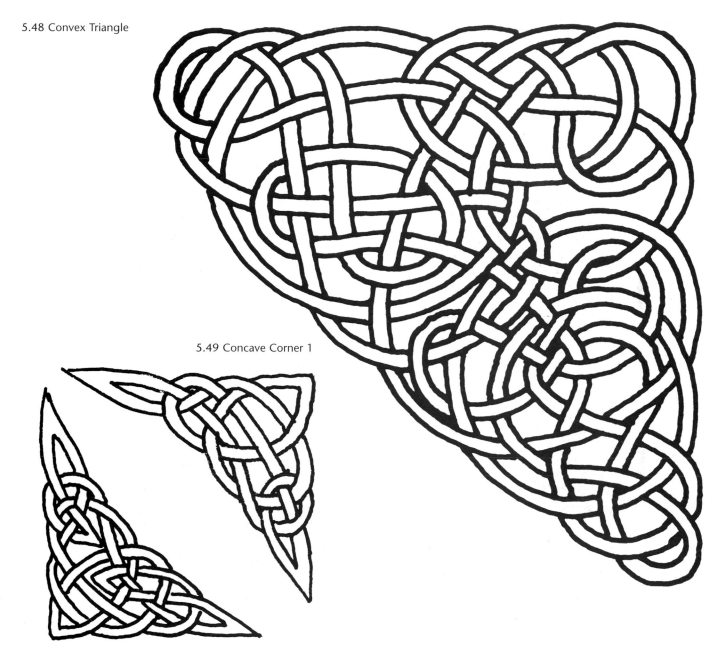

5.48 Convex Triangle

5.49 Concave Corner 1

5.50 Concave Corner 2

5.51 Woven Shield

◆ page 177

✎ page 186

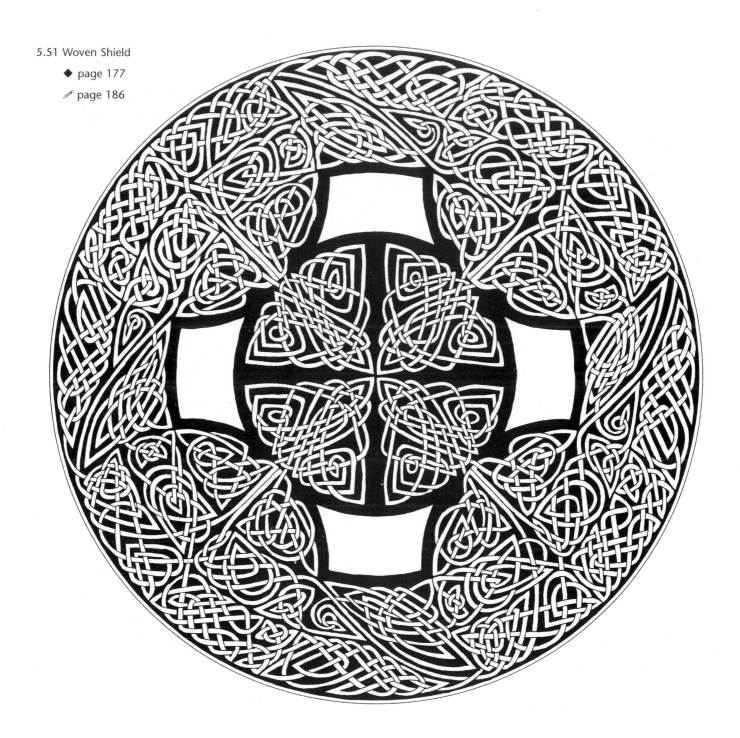

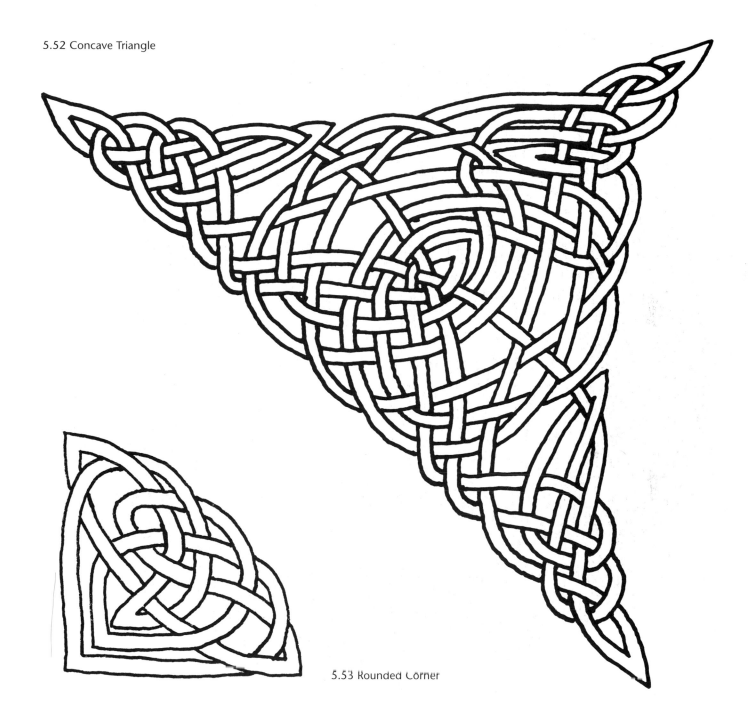

5.52 Concave Triangle

5.53 Rounded Corner

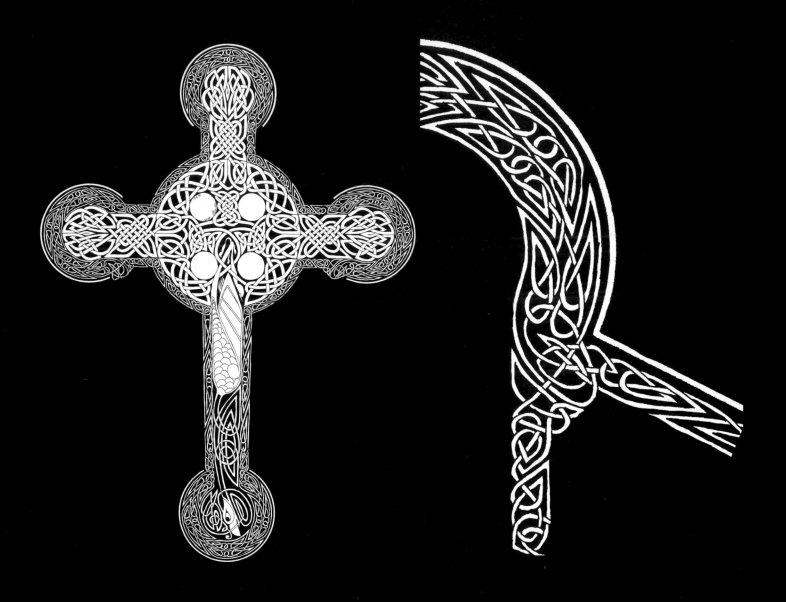

5.56 Grief

◆ page 168

✎ page 186

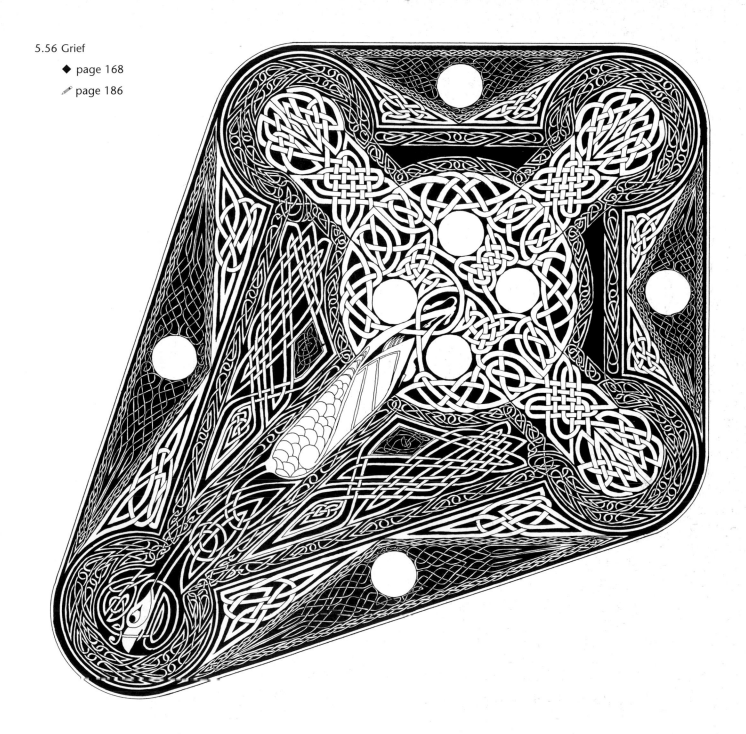

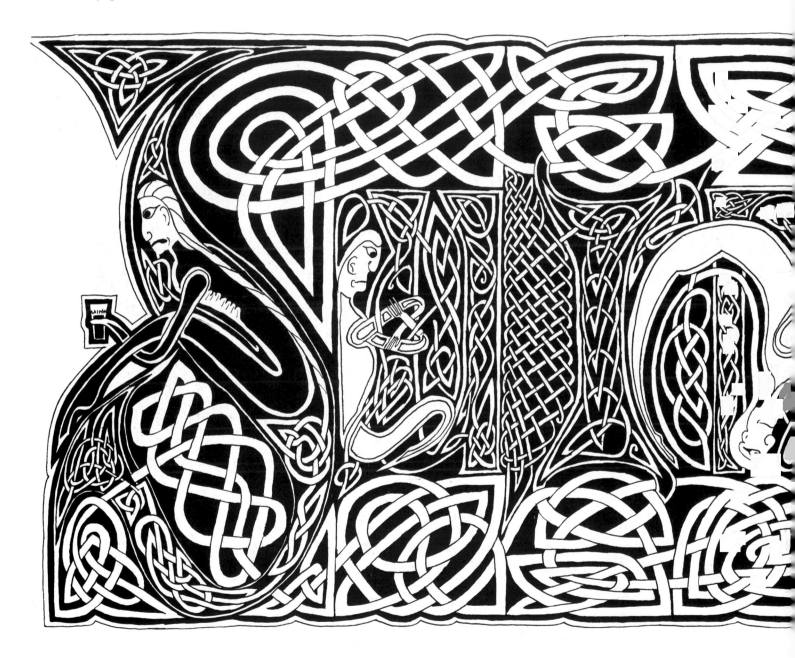

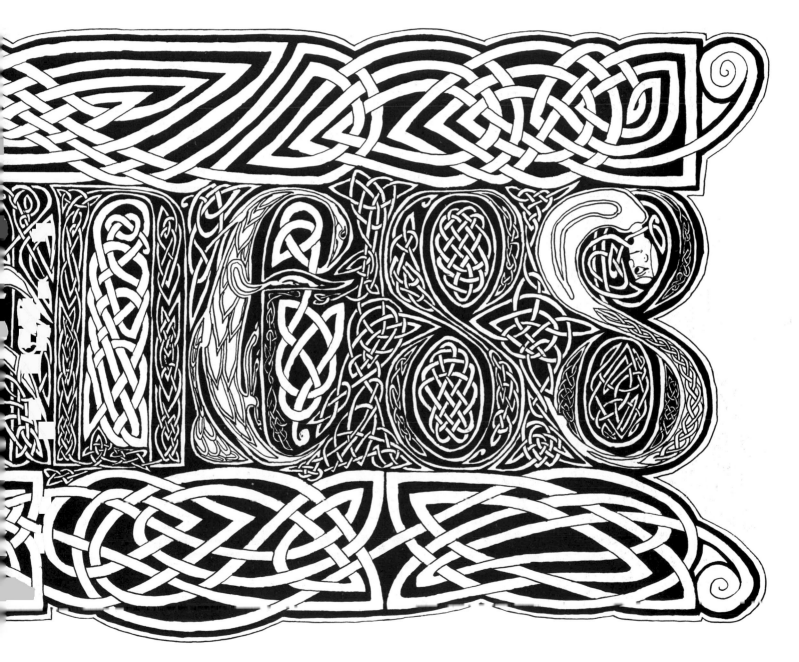

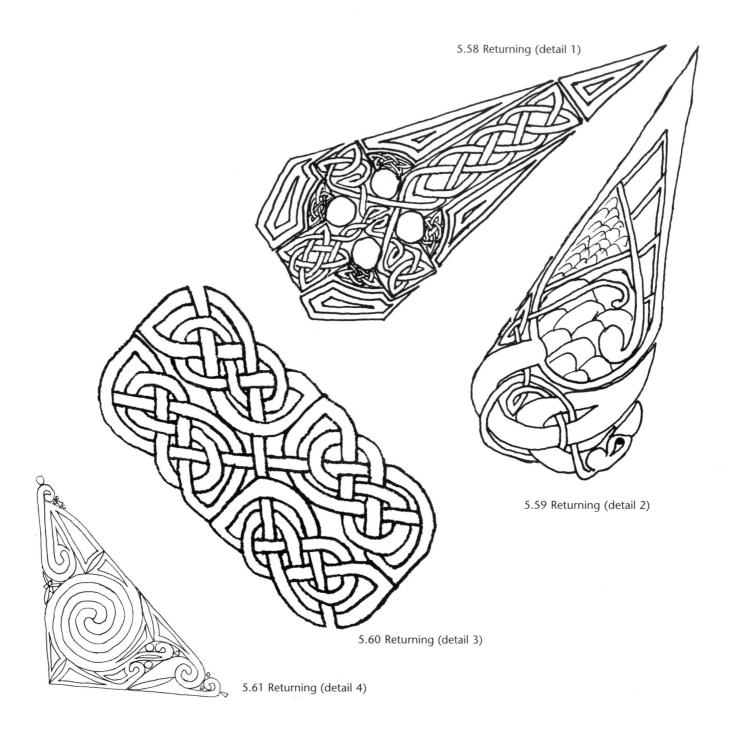

5.58 Returning (detail 1)

5.59 Returning (detail 2)

5.60 Returning (detail 3)

5.61 Returning (detail 4)

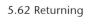

5.62 Returning

◆ page 172

✎ page 187

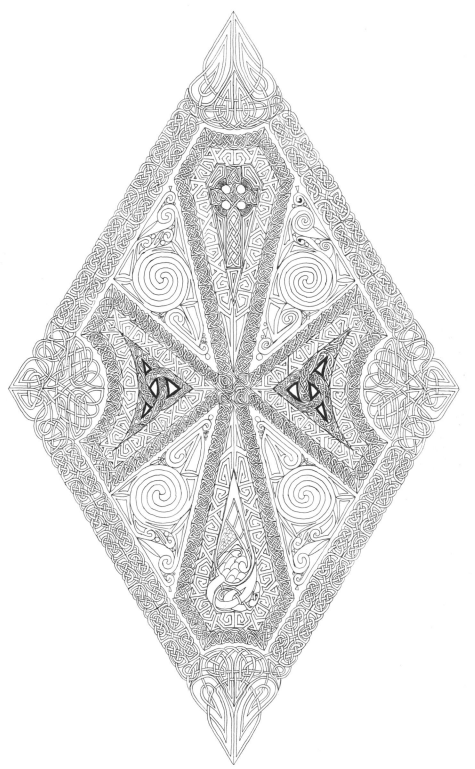

5.63 Flaming Cluster

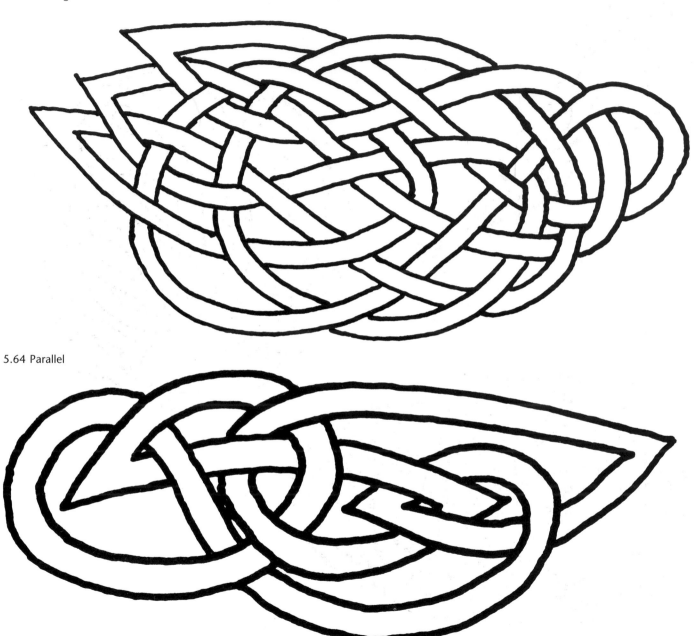

5.64 Parallel

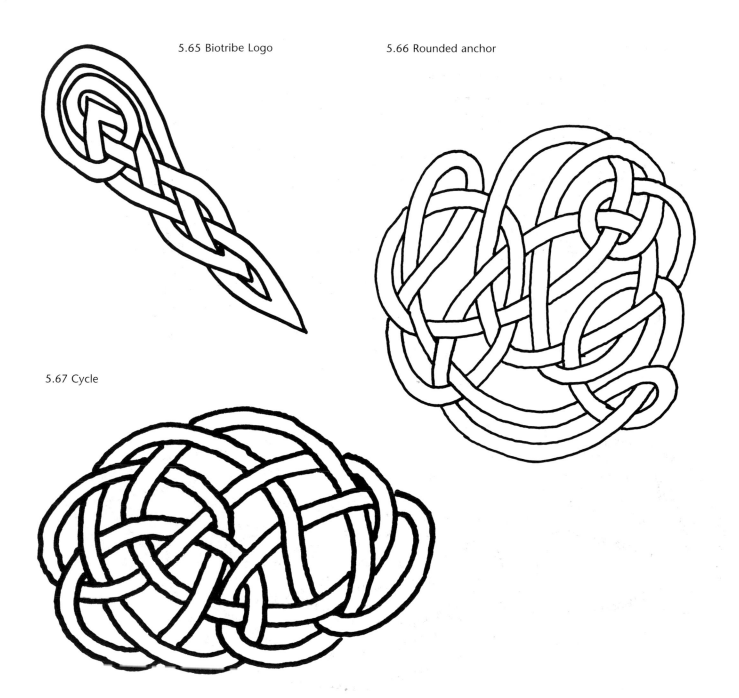

5.65 Biotribe Logo

5.66 Rounded anchor

5.67 Cycle

5.68 Portcullis

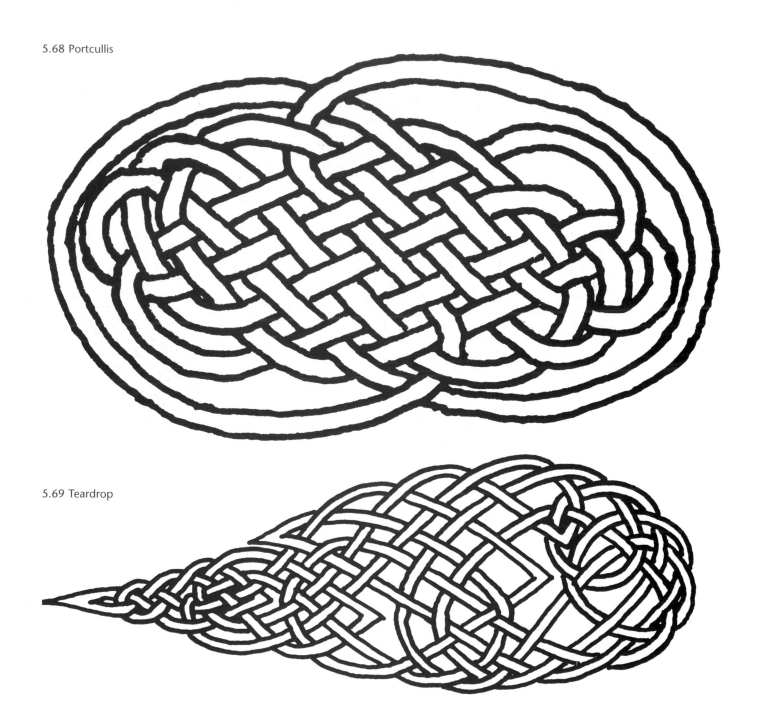

5.69 Teardrop

5.70 The Dreaming Tree

🖊 page 187

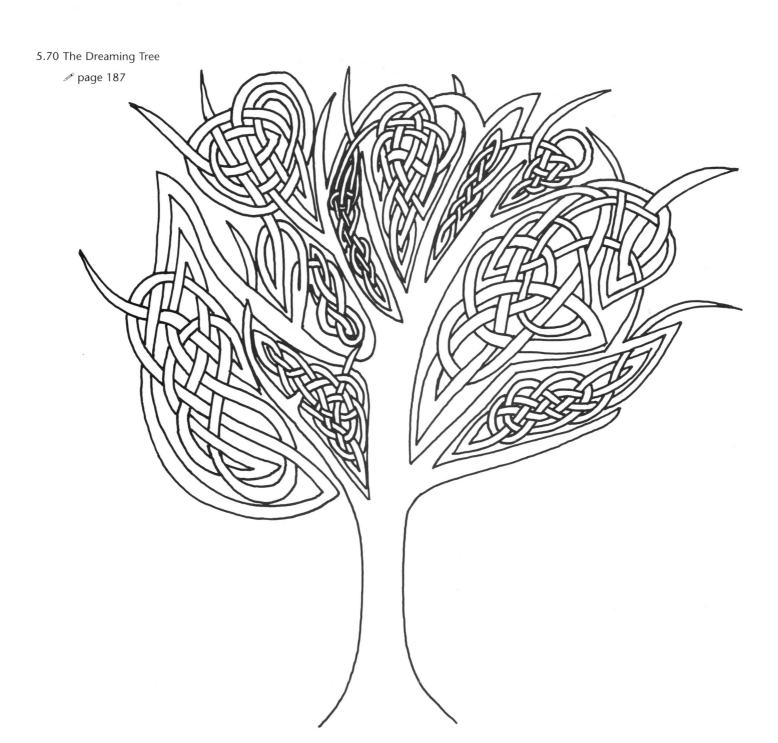

BORDERS

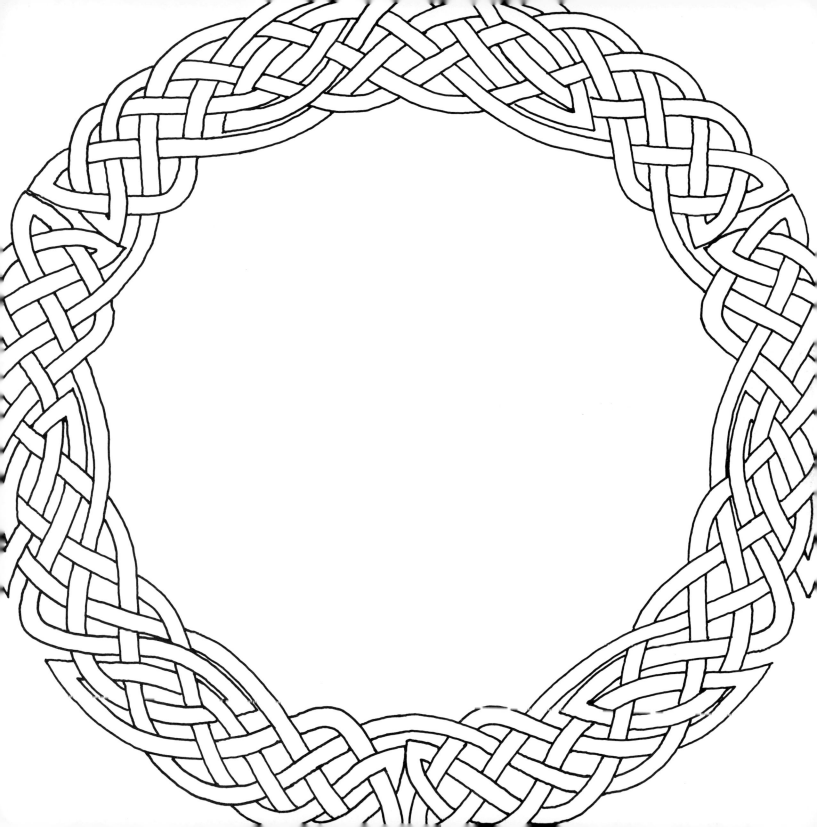

BORDERS

Borders can be enormously versatile. They are essential for composite motifs, as they outline a shape and can draw the viewer's eye towards the central focus. Alternatively, they can draw the eye away from the centre and attract attention themselves.

Almost any element of Celtic design – animal-work, tessellation, spiral work and knotwork, as well as variable line widths – can be used for a border. The advantage of the border area, which is visible in many of these motifs, is that when the size of an individual cell – a single, closed-off design element with a border – changes, the design can be manipulated accordingly to fit that shape. Repetition is also an important part of the design. A common approach is to lay out a single cell size and find the most effective way of filling it with knotwork, and then repeat this throughout the design.

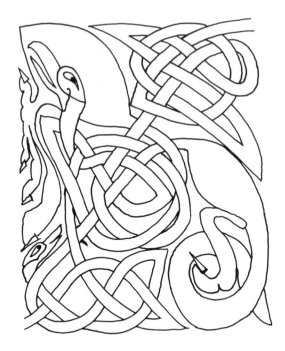

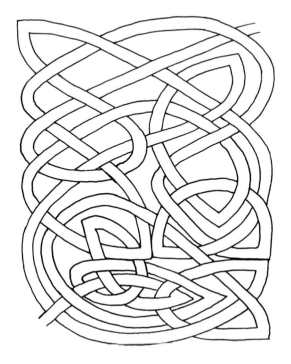

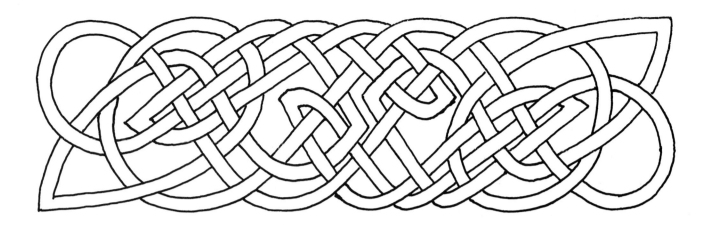

While many borders are linked to each other, it is also possible to have individual cells of unlinked work. Equally, individual cells of knotwork, spirals or tessellation can be left unlinked but made to interact with each other rather than stand alone.

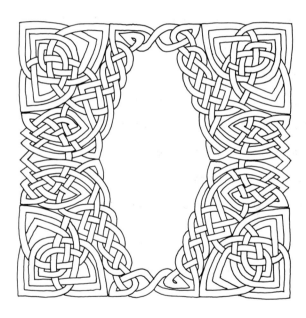

6.1 Circlet

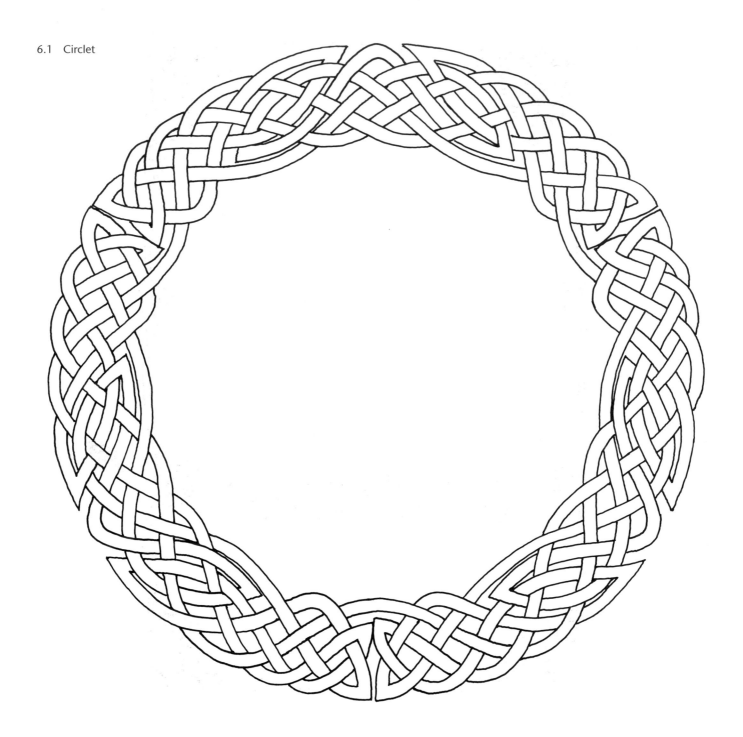

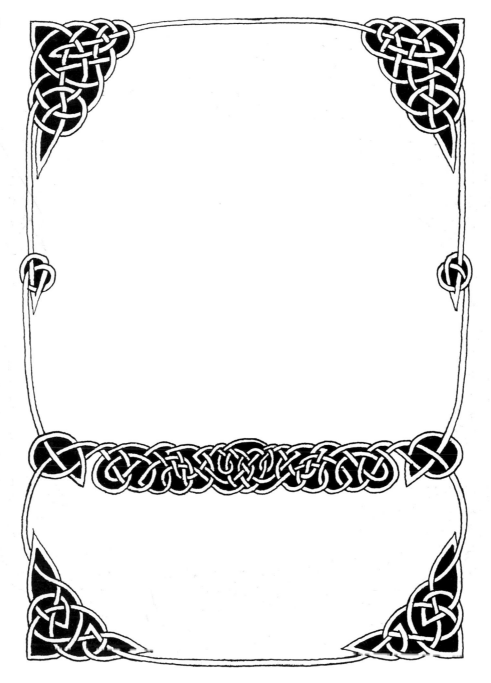

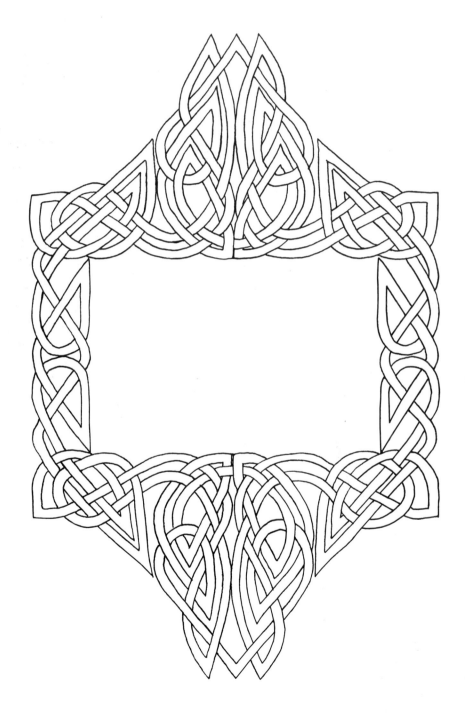

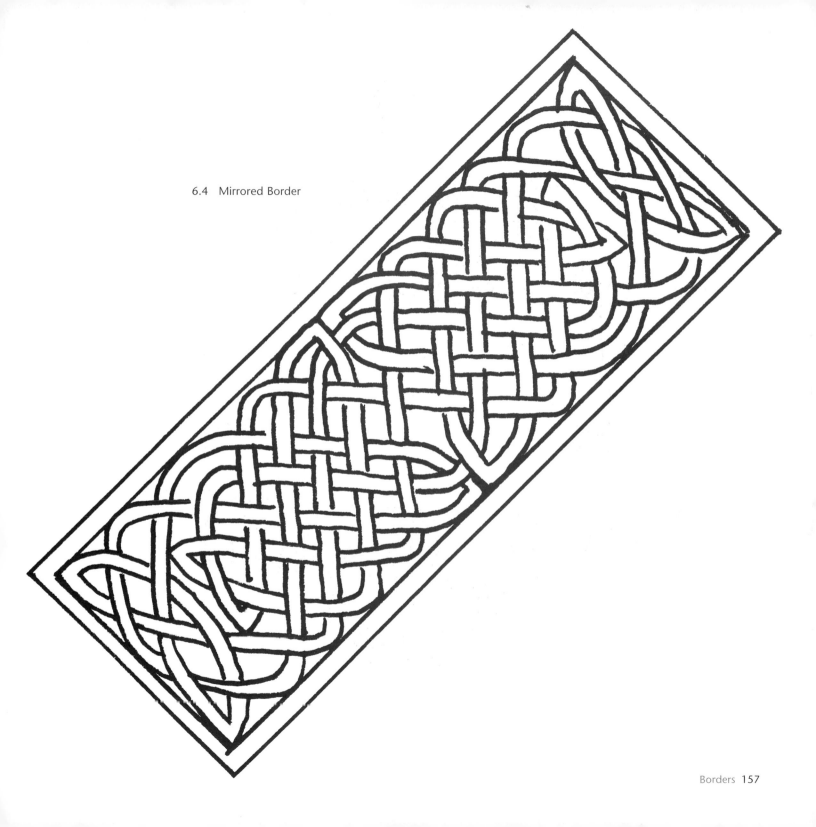

6.4 Mirrored Border

6.5 Bar

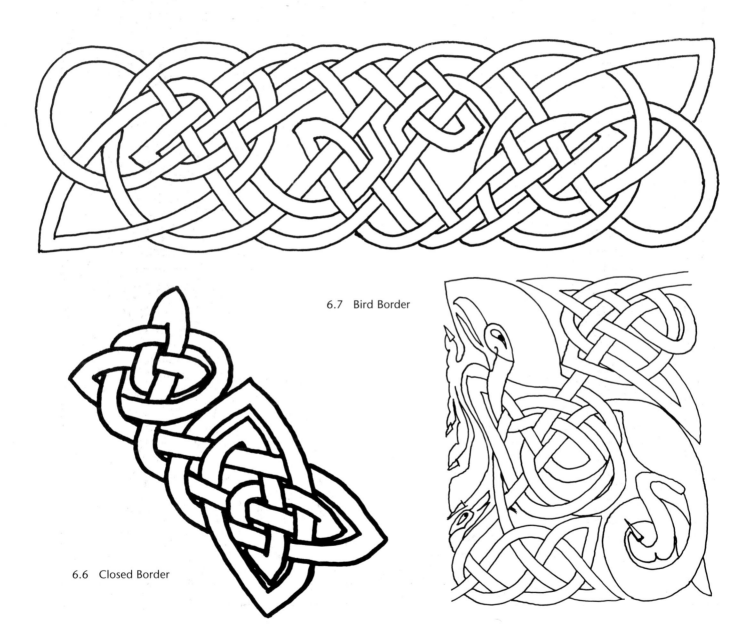

6.7 Bird Border

6.6 Closed Border

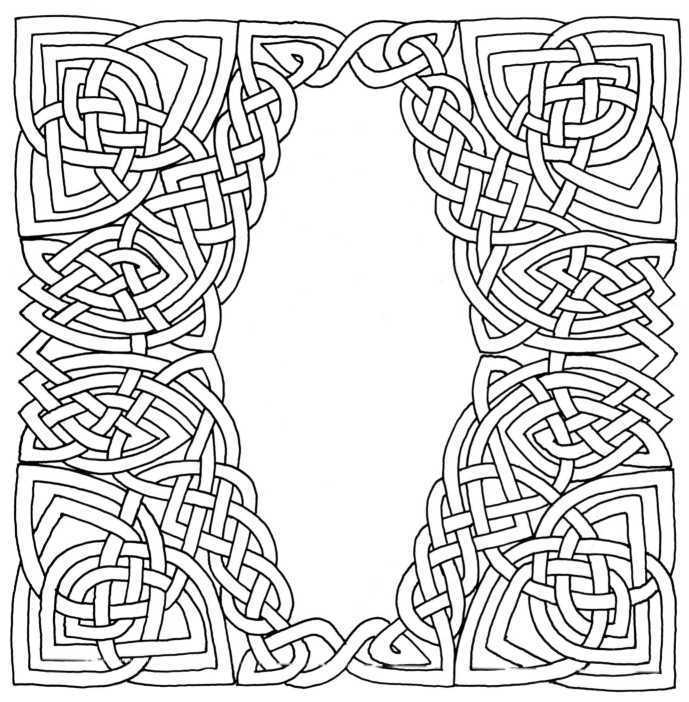

6.8 Dense Border

6.9 Squat Border

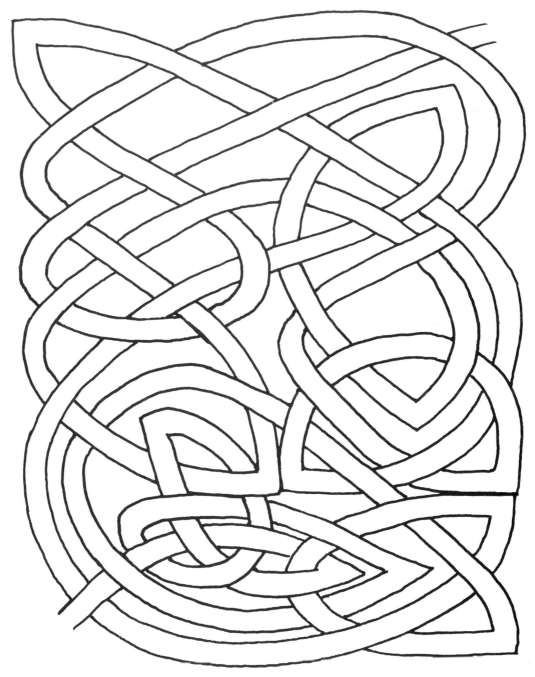

TEMPLATES

A number of the motifs shown throughout this book were drawn within templates that I created earlier. Rather than restrict creativity, as one might think, they can facilitate artistic freedom by providing a framework within which to exercise your imagination.

I have included a number of templates here. They can be used either for copying the images shown in the rest of the book or to create your own. Also they show you the basis of some of the very detailed motifs, so the design process can be seen from start to finish. They also indicate the varying levels of complexity used in the designs, so for example the 'Compass' template (page 166) is very detailed, whereas that for 'Harp' (page 169) is extremely basic and the difference in those two final motifs (shown on pages 42 and 21) is evident as a result.

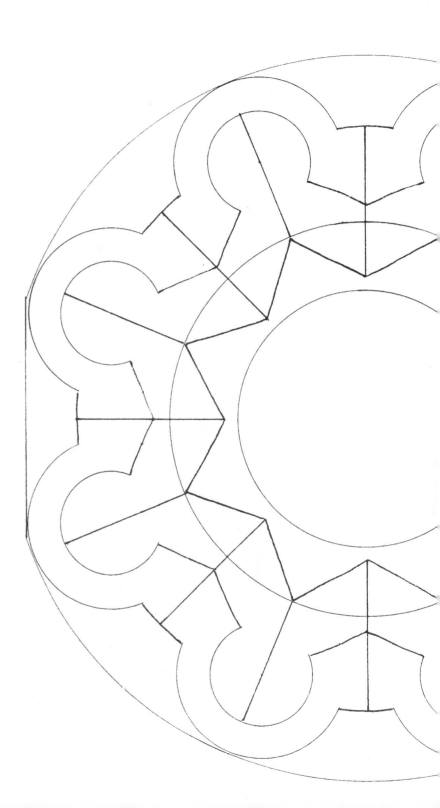

ADAM'S FOLLY
(PAGE 128)

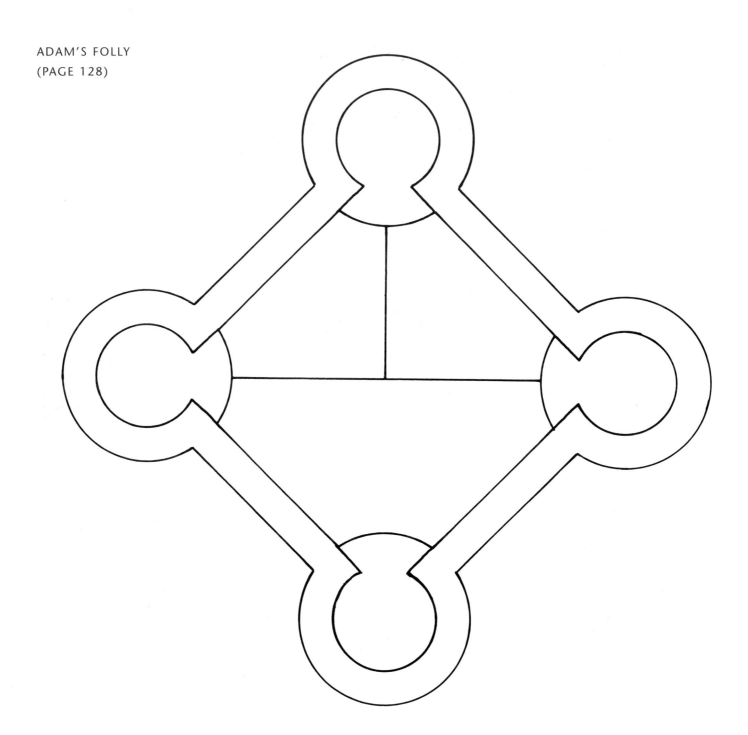

ANIMAL CIRCLE
(PAGE 17)

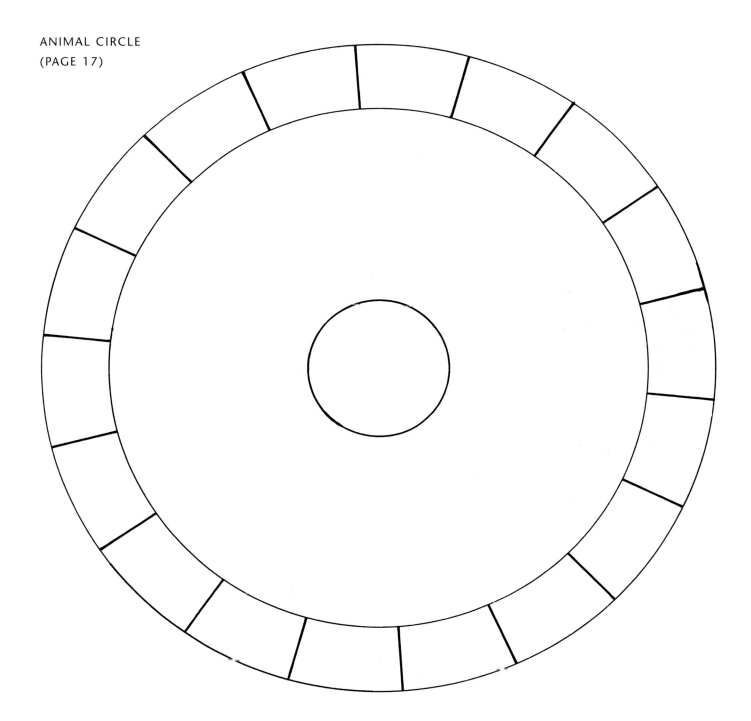

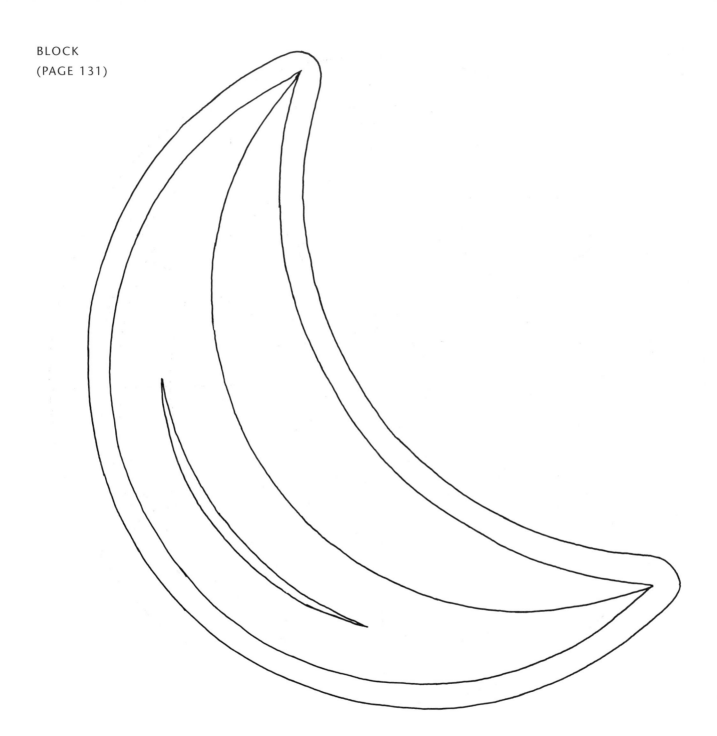

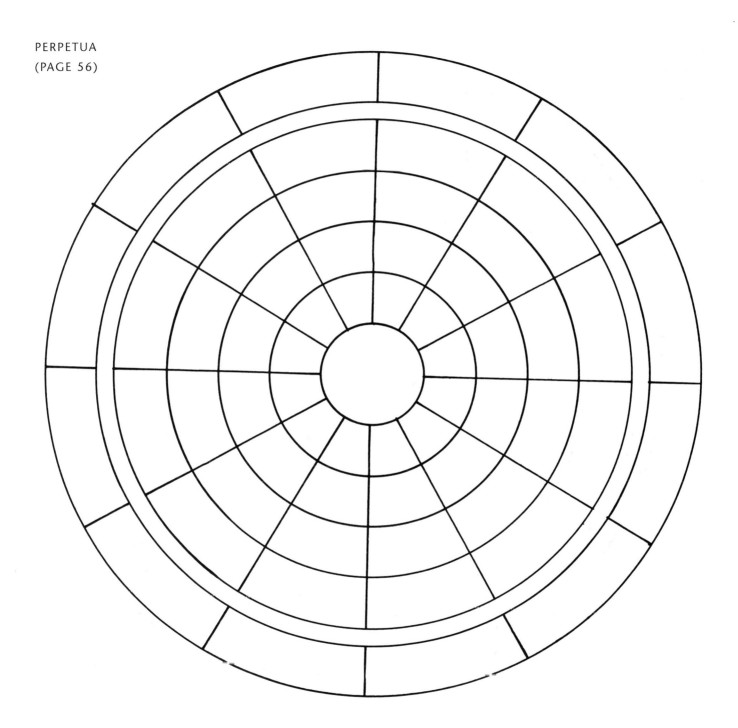

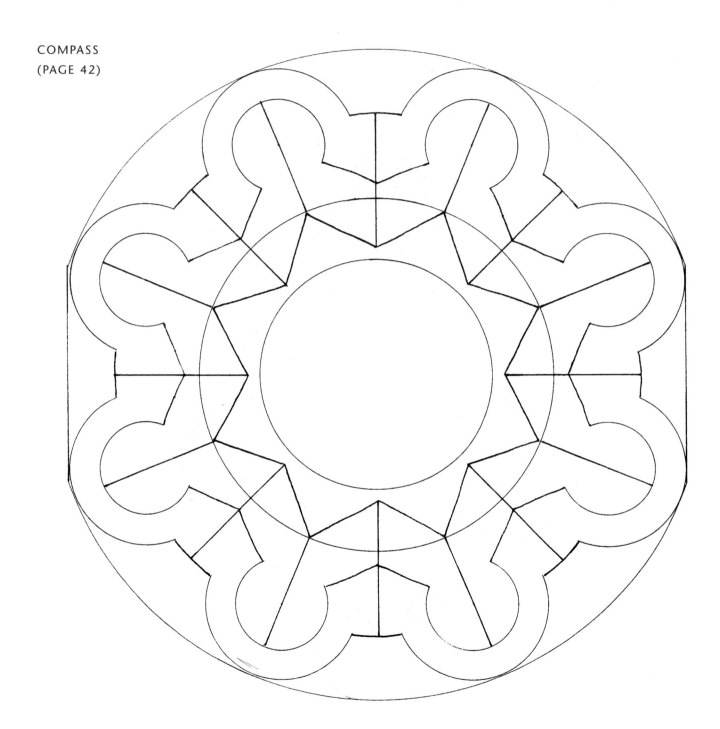

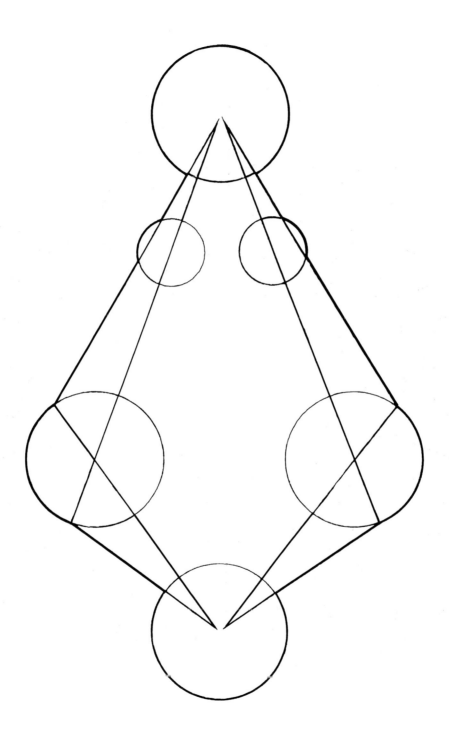

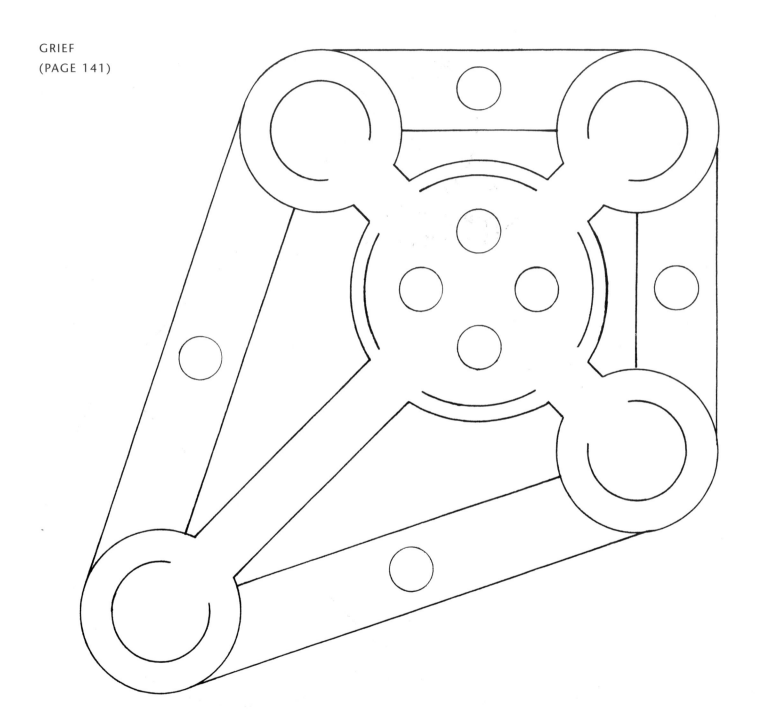

HARP
(PAGE 24)

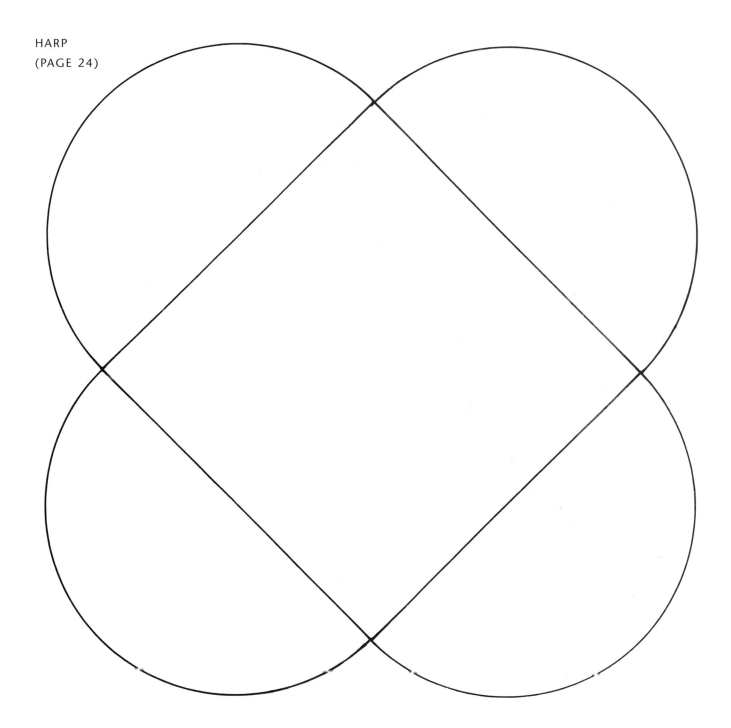

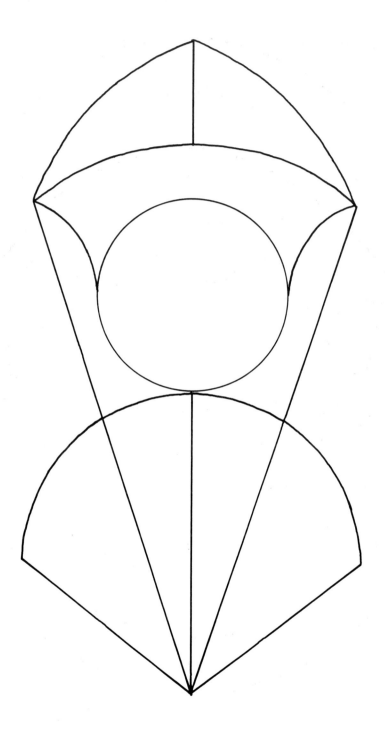

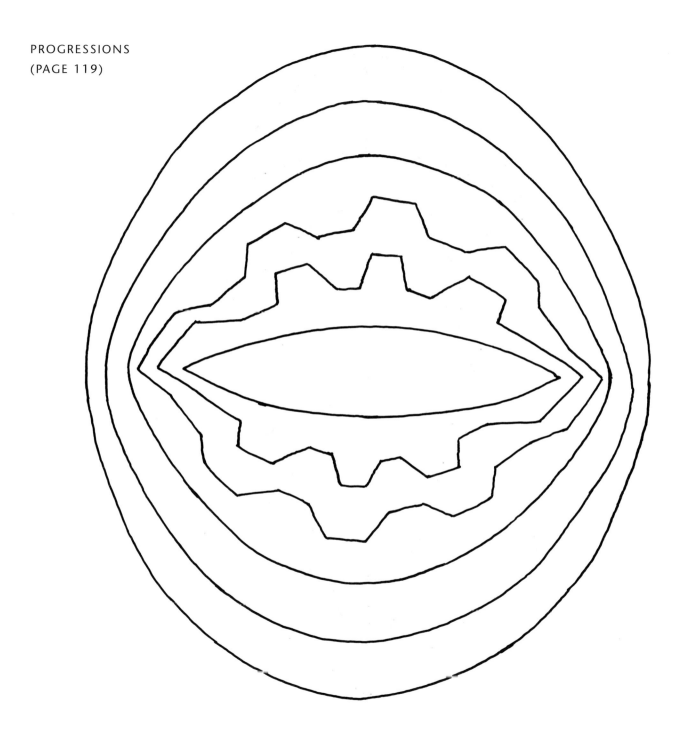

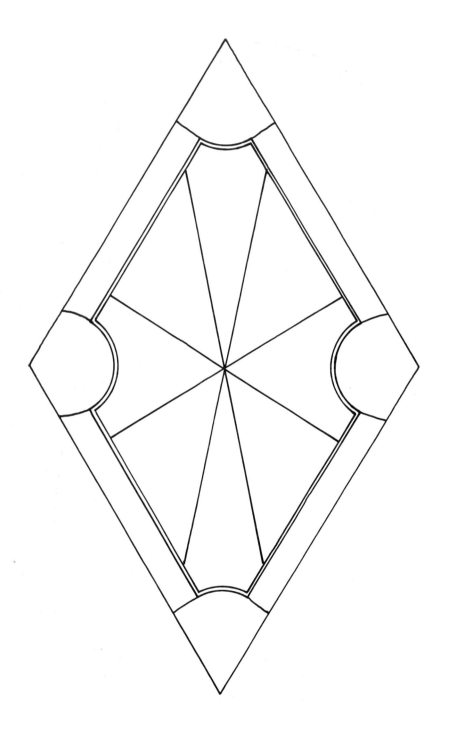

RISE
(PAGE 133)

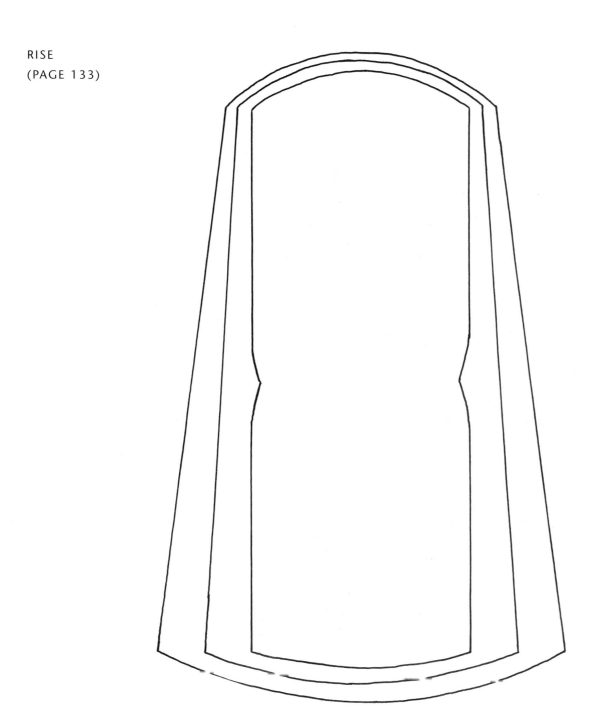

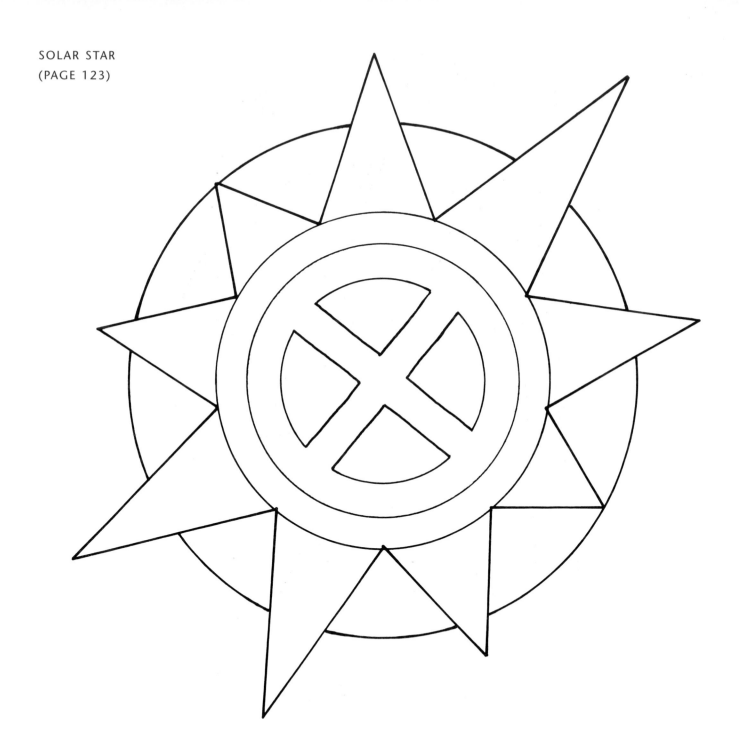

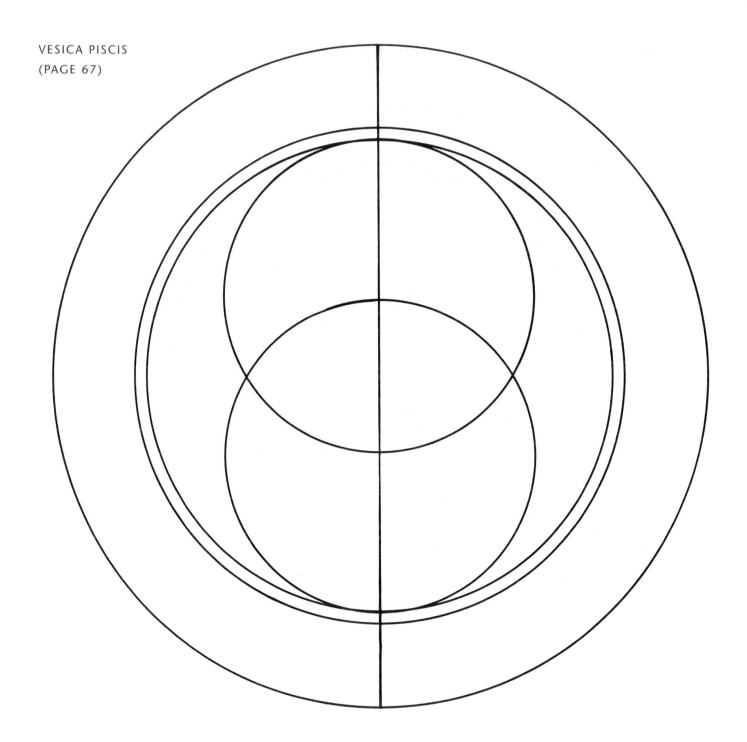

VESICA PISCIS
(PAGE 67)

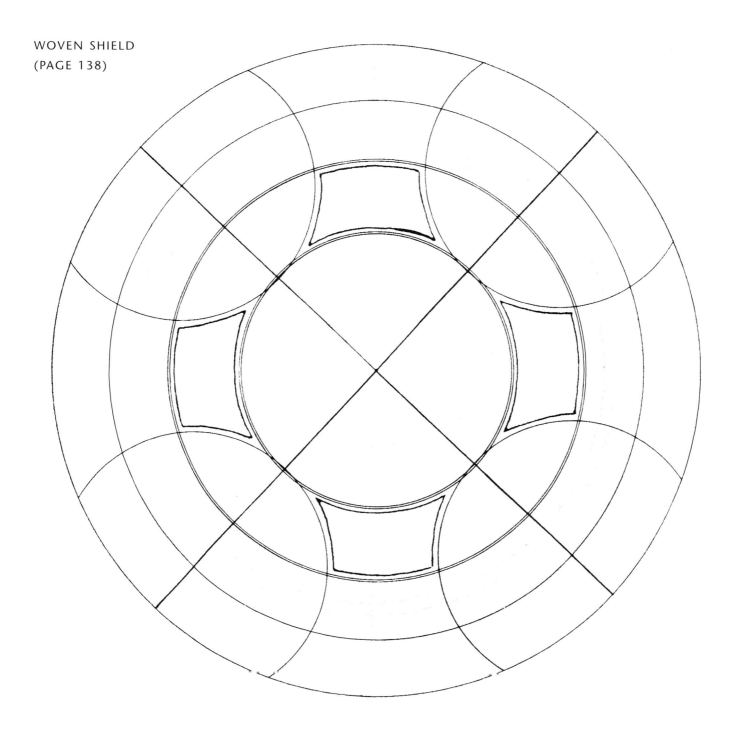

ADDITIONAL MOTIF INFORMATION

ANIMALS

COMUS BEAST (PAGE 14)

Using an outline from an original plate by Arthur Rackham, this motif focuses on a mythical beast whose horns and stomach have been filled with knotwork and animal work. What is striking about this piece is that the outline of the beast itself almost blends in, becoming less important than the knotwork surrounding and filling it.

The design shows how an irregular shape may be made more rounded by filling in sections with complimentary line work. Inside the border are individual knotwork pieces and then the central figure. Each of the individual knots could be used in their own right, but I have focused here on the repeated cell of the border, which is very simple, and the design in the beast's stomach.

ANIMAL CIRCLE (PAGE 17)

The central circle is a pen-and-ink adaptation of a circular motif found on the Hilton of Cadboll Pictish Stone, which can be found in the Museum of Scotland, Edinburgh.

RIVER PARRETT TRAIL LOGO (PAGE 21)

This motif was the last of three that I sketched out – all along the same lines. I was invited to submit a motif that could be used as a logo along the River Parrett Trail, which runs from the mouth of the River Parrett in Somerset some 80km (50 miles) into the countryside. The design, which was intended to represent the fish and the cycle of life in the river, had to be one that could be easily transferred, worked into an iron brand and also easily carved. Unfortunately, it never got further than the design stage.

HARP (PAGE 24)

This design is reminiscent of Art Nouveau, with open, flowing, rhythmic lines and stylized animal work. It falls into distinct areas, with two detailed birds at top and bottom, a small repeated triangular motif and the main knotwork with simplified birds in the interior.

Its shape is straightforward – four semicircles around a central square. Also, a number of the elements can be easily extracted and used in isolation.

CELESTIAL FLARE (PAGE 27)

Celestial Flare is a perfect example of the freehand nature large designs can adopt. Originally this motif followed an almost rhythmic regular shape and was intended to represent the sun and its flares. The flares evolved into tendrils, extending from the outline shape – a rather unusual approach.

This design looks quite simple, but it is challenging to mould shapes while still making them appear rhythmic. The knotwork inside does not follow a standard path due to the asymmetrical nature of the motif, but manages to give the appearance of similarity – indeed, this is the challenge.

The interior bird is the focus of the whole piece. What makes it so dramatic is its relative simplicity compared to the more intricate freehand border of knotwork.

CIRCULATION (PAGE 31)

This is similar to an earlier design – 'Triad' (page 22) – although the two were actually drawn several years apart. This design shows three birds in a cycle, each biting the other, with a freehand surround or halo of knotwork. The interior can easily be separated from the exterior, as shown.

In the main body or wings of the birds are three separate little motifs. These are some basic but attractive knots that I was working with at the time and incorporating into many designs.

TRIBALIC (PAGE 33)

This is also a relatively late piece and easily separates into a number of different segments. In some ways, the main circle and stylized cross resembles the motif used for the Glastonbury Festival, although its simplified dancers are not the actual source.

The design contains many different elements of animal-focused knotwork, along with more standard conventional linework. I have extricated certain elements, although all of the different segments could be used in isolation.

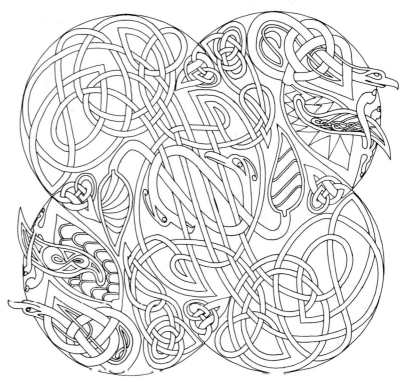

CIRCLES

BIRD TRELLIS (PAGE 40)

These two pages show the same design, drawn in two different ways. The design shows two birds side by side and some central knotwork. In the first version, the plumage of the birds has been stylized and mixes with the main knotwork. The main motif can be filled in with ink in the gaps between linework. The opposite design is a reverse or negative version, drawn in a way that allows the knotwork to be filled in. It is worth experimenting with this different approach; in fact, all designs can be altered in this style.

COMPASS (PAGE 42)

This is a detailed large-scale drawing that represents the main points of a compass. It includes various styles and methods of Celtic design, including knotwork, figure work of birds, and tessellation. This design started with the inner two circles and evolved outwards, the innermost circle being a copy of a quick freehand sketch done previously. Many of my designs have evolved in this manner.

The symmetry and replication of the points of the star and in-between points of the knotwork (in negative from the usual style) make up a design that is reminiscent of compass points. The outer additions of the birds, knotwork and the tessellating compass points developed after I decided to use the axis lines following the tips of the inner eight-pointed star to create circles – accentuating the points of the star. The central section of each of these eight circles is occupied by two birds, with their necks intertwining in the space between the circles. They are framed by a broad border of replicating knotwork. The outer tessellation completes the circle at the eight most commonly used compass points.

Overall, this design was intended to include sections that replicate elements of Art Deco. The bird figure work and the outer tessellation go some way towards this. The simplicity of the birds' bodies effectively softens the intensity of the design and puts the focus on some of the more detailed knotwork.

PERPETUA (PAGE 56)

This motif is highly intricate and consists of one single line of knotwork running through the whole piece, including the border work. Originally I designed it on an A2-sized piece of paper, and I have included the original template that I used. The method to use is to break down the inner circle into twelfths, replicating one segment throughout. The appearance is striking and the knotwork is mesmeric, especially if followed from one point all the way round. The outer border is more variable but has been segmented in the same way. This is not as easy to do as it might sound, requiring tight interlocking of the symmetry of the line and good spatial awareness, but the outcome is worth the effort.

APPRENTICE (PAGE 60)

As a small, quite basic circle, this is a fairly standard piece. I include it because it was my first fully original motif.

RIPPLES (PAGE 62)

This is an extremely simple idea, repeating one single cell of knots in different sizes. There are only eight sections in each of the circles, and in the largest design these shrink like ripples. The main motif shows perfectly how the width of the knotwork line and the corresponding pen line width can alter the effect of the single cell knot and hence the entire motif. On the opposite page there is a smaller two-circle ripple that best shows the simplicity of the knotwork. Overall, this is an exercise in demonstrating how knotwork can be simple but its effect can be quite changeable depending upon line width and density.

VESICA PISCIS (PAGE 67)

Many will recognize the outline of this design as Vesica Piscis, a classical symbol. This is a great example of using a well-known symbol as an outline for a motif. The overall finished motif is very striking and contains many elements that can be used in isolation or together. Most individual elements are very simple but combine to make a complex piece.

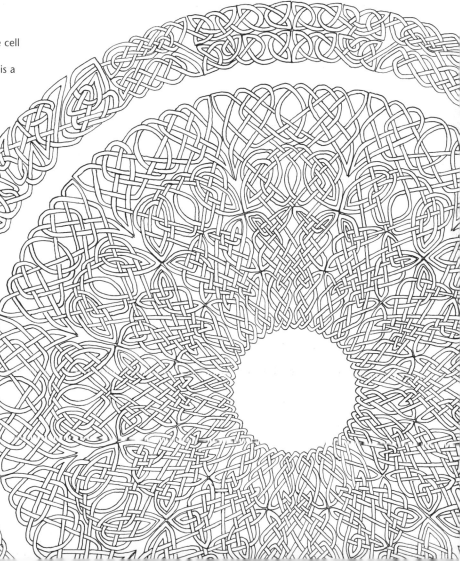

SMALL DESIGNS

AMALGAMATION (PAGE 78)

One of a few motifs created from elements of other larger motifs that were started but never completed. These four individual pieces, which work very well together, were originally all elements of the same large motif. When working on a larger design, I sometimes find I cannot create the right feel or find the momentum to keep going. The individual elements in this design, however, worked well and they go naturally together. The individual elements have now been put in a different order, which demonstrates how important placement can be in a composite final motif.

MARK'S TATTOO (PAGE 80)

This was actually a piece I was commissioned for – a design for a tattoo for the upper arm of a friend. Mark had quite a strong sense of what he wanted, and we were able almost immediately to agree on the end pieces. We could not, however, settle on the central section, so I set up a template and put these four options forward for Mark to make his choice. This is a great example of how different centrepieces can change the feel of a motif.

EMBLEM (PAGE 82)

This is a very emblematic motif with clear and bold linework. Inspiration for this came loosely from the cover of Chalice Well in Glastonbury, which shows two interlocking circles.

SERPENTINE (PAGE 87)

Serpentine is another composite piece using sections of a larger motif that was never completed. The tall bell-like appearance of the motif does, in some ways, mirror the central fish-shaped twist. Each element has also been separated from the whole to show it in its own right. This also highlights how well they work together as a complete motif, as if they were originally designed together.

TRIBAL CROWN (PAGE 93)

This began as the central focus of a much larger design, but I liked the shape so much I abandoned the larger image. The main knotwork is one cell repeated 12 times, contorted to fit the different shapes it fills. Bold large centres draw the eye but also highlight the finer detail around them.

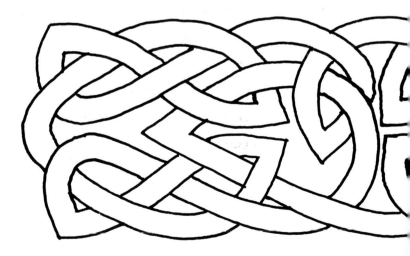

URBAN

REFLECTION (PAGE 100)

Freehand drawing is one of the most pleasing tasks but is also challenging because it means starting with a blank canvas and no guidelines whatsoever.

The initial sketch for this design looked quite limited but I reworked it, and it is now surprisingly complex but free-flowing. It does not follow the same style as the rest of the 'Urban' images, which use variable line width, but its freehand nature made me want to include it in this particular chapter.

There are three different versions of this motif shown. One is in the Lindisfarne-style, which uses two lines instead of one. This creates a weave and intricacy, especially in the centre section, looking almost like tessellation. Below this is just a standard single line knotwork. The third version is shown in reverse or negative, allowing the actual knotwork line to be filled in. All three versions work effectively, demonstrating how a single motif may be interpreted in different ways.

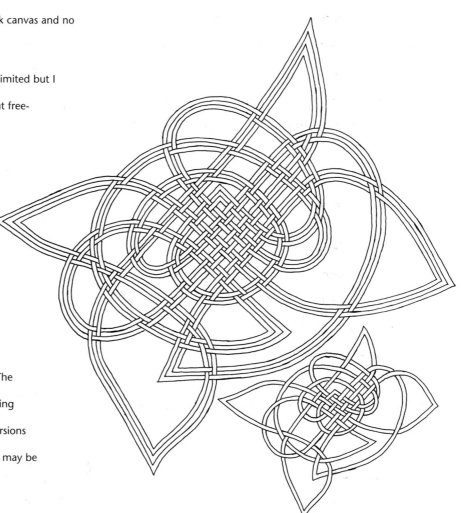

FREEHAND MOTIFS

EVOLUTE (PAGE 117)

Evolute has a central depiction that summarizes the traditional fight between good and evil, heaven and hell. The upper part of the design features feathers and the lower flames, and in between a symbolic battle between the forces of good and evil is waged. Figure work traditionally evolved as a way of drawing religious or moral stories in a meaningful or symbolic way.

The surrounding sections include knotwork in the Lindisfarne style, with two lines following the same path. Alongside is more standard linework – in the highlighted sections of historical manuscripts, this type of fill was common and it was the task of the illuminator to fill the space available most dramatically or effectively.

PROGRESSIONS (PAGE 119)

This piece is so called because this was a larger design that just kept growing, layer on layer. It started off with the central piece, but I knew that I wanted a number of levels and I kept adding more until I was eventually satisfied.

Of particular note are the key work and tessellation styles. I think this was my first experiment with using a same-border segment and manipulating it to different shapes while trying to keep the essence of the original linework. If you look carefully at the line work between the two main tessellation areas, you can pick this out. The complete motif encompasses many styles, including a border of figure-work, a more regularized single-cell repetition border, and a large freehand dragon to finish it. This sort of animal work makes a good end-point to motifs, making it a finite but free-flowing form. The design is a series of layers one after the other, and a freehand design at the outer layer means that a natural conclusion is drawn. Towards the bottom is a very simple spiral leading into an area of knotwork.

KNIGHT (PAGE 120)

This was my second large motif, and it is relatively simple. The central circle in this instance has been omitted, as the first design used was not satisfactory. Although another circle can be inserted, it does also work well as a single white space within a complete motif, which draws attention to the surrounding detail.

SOLAR STAR (PAGE 123)

One of the larger designs, this consists of a nine-pointed star that lies within a circle but extends slightly beyond it. It is one of the most simple of the larger motifs, but it has a particularly interesting and tumbling styled internal border. Overall, despite the symmetry of the design, the approach is freehand – note the innermost border, as well as the spikes of the star and the border connecting them.

ADAM'S FOLLY (PAGE 128)

Some of the larger designs look more intricate than the others. To me, this one does not look particularly detailed although it does contain many elements. I have not extracted all of the elements – for example, the centre of the bottom circle incorporates the first incarnation of the circle 'Swan' (see page 72). This design has a well-structured border surrounding it, as well as some interesting animal work in the left- and right-hand circles in the centre. There is also an interesting almost heart-shaped knot in the Lindisfarne style, with individual knotwork filling in the gaps. Overall many elements can be taken from this design; I tried to extract the most interesting ones.

BLOCK (PAGE 131)

One of my favourites from the larger motifs, this contains many different elements and was an ambitious design. Most noticeable is the arc of animals, which contains 12 individual animals, all entwined. There is also some good tessellation work in the top and bottom circles. This is a tightly styled design, and at first glance the elements seem to be inextricable from each other. They are, however, all individual elements that combine to create the whole.

RISE (PAGE 133)

This is another motif that began as a bold central piece and evolved outwards. It started as the rounded rectangle of bold large linework in the centre, surrounded by a more structured border of knotwork. This is then encircled by some key-type tessellation. The final border is a more freehand piece involving animal and figure work, and it is this freehand element that unites the elements of the piece and also successfully frames it. This design is a simple depiction of the struggle between good and evil, right and wrong. Many areas of the outermost freehand border can be isolated, especially the dragon near the bottom as well as the snakes and individual figures.

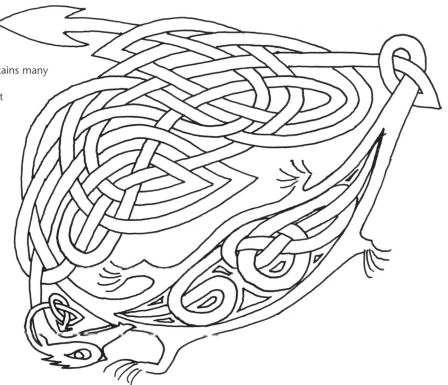

BELIEVE (PAGE 134)

Believe has a simple approach: one word surrounded by bold, vivid knotwork. At first view, the letters of the word do not leap out, although it is possible to add a colour to the outline of the letters to make them more distinct. The design creates some interesting shapes that have been filled with individual knots and animal and figure work. These may all be isolated for use elsewhere.

This design is also an exercise in creating shapes to fill with knotwork and figure work. I tend to feel that a bold or detailed centre surrounded by a very bold and simple knotwork is extremely effective. On the right-hand side of the wording, the knotwork looks almost like flames, showing no real symmetry or repetition but creating a lot of motion.

WOVEN SHIELD (PAGE 138)

This is another design that uses one single line of knotwork throughout the whole motif. The template shows how it was originally started by using a compass to create the bisecting curves and quartering the full circle.

The knotwork appears to evolve, as it is not neatly quartered but fills one small section and moves on to the next. If simplified, the line spirals around the design as a flow. 'Woven' is a good description since the knotwork resembles a weave, softening the look of the harder circular outline.

GRIEF (PAGE 141)

This is another larger motif that evolved – it started off as the centre cross. The cross is a pagan and Celtic symbol that predates Christian use, although it was less important than it is today. The original cross outline was based around a stylized Celtic cross and is filled with a bold knotwork, which was then extended to include a border.

The border is particularly interesting because it is very detailed and actually bifurcates into two segments. Around the extremities of the cross, the two border elements work together. They then separate off to create different borders, before remerging at the next extremity. This was quite a complicated design to complete.

The original finish to this design was as the solid white line that surrounds the border, but I then added additional knotwork to make a much larger complete image. Again this is one of those motifs that has fewer images that can be isolated and extracted. The border would work well anywhere, as would the last few pieces I added – the outermost sections away from the cross.

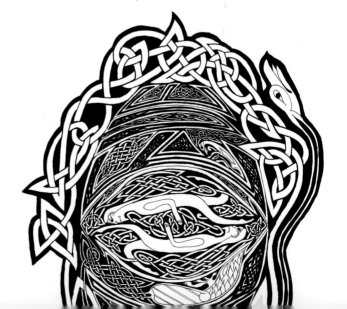

GUINNESS (PAGE 143)

This is an effective motif in which the letters of the word 'Guinness' form the focus, although the individual letters are not immediately apparent. The knotwork and figure work are in line with the letters, which does make them less legible, but the relationship between the letters and the knotwork and figure work become more obvious as one looks at it. Note the initial G – this is the traditional form of the letter, looking more like a J. Note too the E with a lizard, and the final S. Each of the letters may stand alone in its own right.

RETURNING (PAGE 145)

This design shows many different aspects of Celtic design. The repetition of simple knotwork creates complexity in the borders; freehand work at the four points represents creativity; spirals are associated with spiritual focus within many religions; and the central areas show a Celtic cross and a bird, combining religion and nature.

The outline is set as a diamond shape, with sections of circles at the four points. The circles radiate inwards from the tips towards the centre of the design. The outer border comprises freehand knotwork within the circular sections plus a repeating pattern that completes the edge.

When creating knotwork, remember that the requirements for repetition are a standard entrance point and exit point for the line. This rule is repeated in the inner border of knotwork surrounding the inner segments.

Spirals and tessellation are a large part of this motif and break up the regular black and white intensity of the complete design.

THE DREAMING TREE (PAGE 149)

Very simple in approach, this is a motif that was drawn very quickly with a marker pen. My original idea was of a tree that dreams it can move – I feel the design conveys a sense of movement.

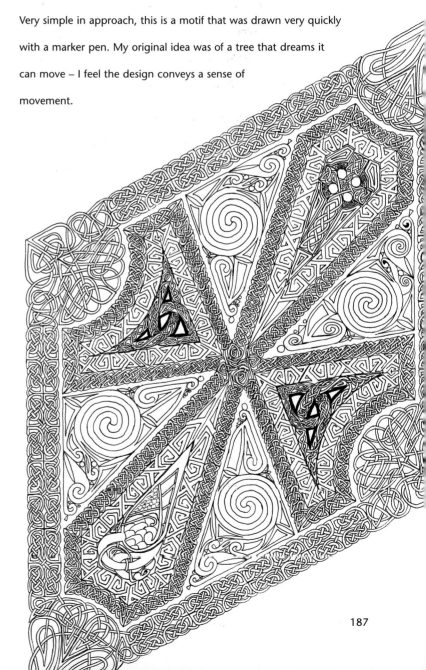

187

INDEX

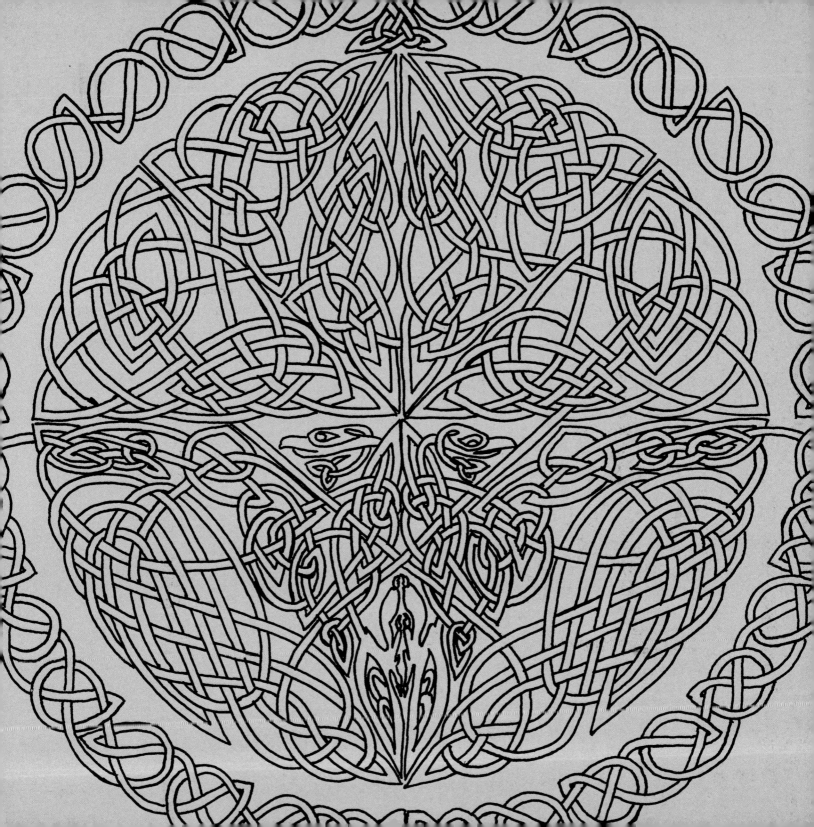